INSIDE THE **Getty**

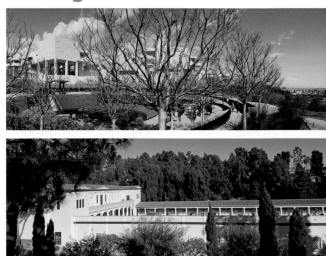

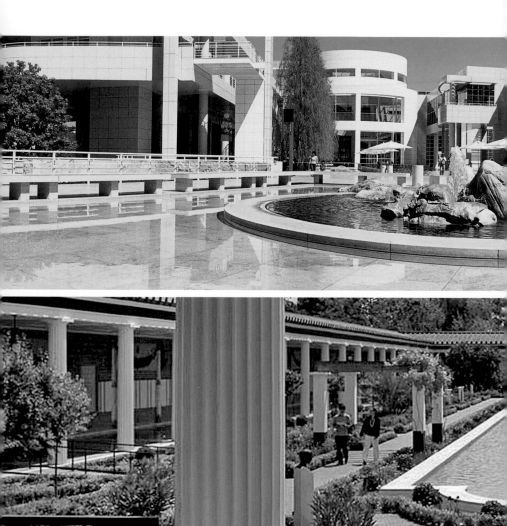

Second Edition

INSIDE THE Getty

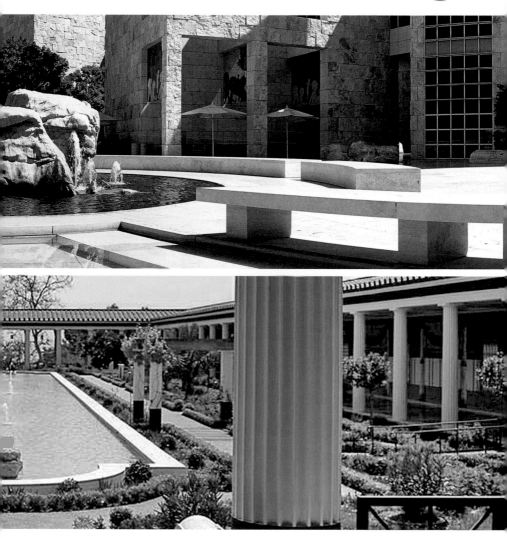

Edited by William Hackman and Mark Greenberg

*Special photography by Richard Ross
and Getty staff photographers*

GETTY PUBLICATIONS

LOS ANGELES

This book is dedicated to the staff, docents, and volunteers—
both past and present—of the J. Paul Getty Trust.

Published by Getty Publications
1200 Getty Center Drive, Suite 500
Los Angeles, California 90049-1682
www.getty.edu/publications

First edition:
Patrick E. Pardo, *Project Editor*
Gregory A. Dobie, *Copy Editor*
Jim Drobka, *Designer*
Elizabeth Zozom, *Production Coordinator*
Elizabeth Chapin Kahn, *Photo Researcher*

Second edition:
Rachel Barth and Laura diZerega, *Project Editors*
Jim Drobka, *Designer*
Victoria Gallina, *Production Coordinator*

Distributed in the United States and Canada
by the University of Chicago Press

Distributed outside the United States and
Canada by Yale University Press, London

Printed in Singapore

Library of Congress Control Number:
2019936903

ISBN 978-1-60606-613-3

Front cover: Aerial view of the Getty Center.

Back cover: A scientist from the Getty
Conservation Institute scans the Mummy
Portrait of a Woman with an XRF scanner.

Half-title page: The Central Garden at the
Getty Center (top) and the Museum and Outer
Peristyle at the Getty Villa (bottom).

Title page: The boulder fountain in the Museum
Courtyard at the Getty Center (top) and the
large pool and gardens of the Outer Peristyle
at the Getty Villa (bottom).

Page vi: The azalea maze in the Central Garden
at the Getty Center.

Page vii: The Barbara and Lawrence Fleischman
Theater at the Getty Villa.

Principal photography for this book was
undertaken by Richard Ross with additional
site photography by the Getty's Imaging
Services photographers.

Every effort has been made to contact
the owners and photographers of objects
reproduced here whose names do not appear in
the captions or in the illustration credits listed
at the back of this book. Anyone having further
information concerning copyright holders is
asked to contact Getty Publications so this
information can be included in future printings.

Editors' Note: The text for this book draws upon
numerous sources, including *The J. Paul Getty
Museum and Its Collections, Guide to the Getty
Villa, Making Architecture*, and *The J. Paul Getty
Museum Handbook of the Collections*, as well
as Getty Trust annual reports, newsletters, and
interviews with current and former Getty staff.

CONTENTS

FOREWORD

In 1954, J. Paul Getty opened to the public a museum of art in a few rooms of his Spanish-style house overlooking the Pacific Ocean near Malibu. His modest collection consisted of Greek and Roman antiquities, Renaissance and Baroque paintings, and eighteenth-century French decorative arts. Today, the educational trust that bears his name is one of the largest art organizations in the world. It encompasses the Getty Villa near Malibu and four operating programs headquartered at the Getty Center: the J. Paul Getty Museum; the Getty Research Institute, with extensive research holdings for the study of the history of art; the Getty Conservation Institute, with scientific laboratories for investigations into the material properties of works of art and professional conservators working both at the Getty and at sites from China to Egypt to South America; and the Getty Foundation, funding advanced art historical and scientific research on every continent in the world.

As we have recently marked the twentieth anniversary of the Getty Center, it is appropriate to reflect on the work of the Getty and celebrate Mr. Getty's gift. His simple wish was to promote "the diffusion of artistic and general knowledge," and our current mission statement indicates the ambitions of that task:

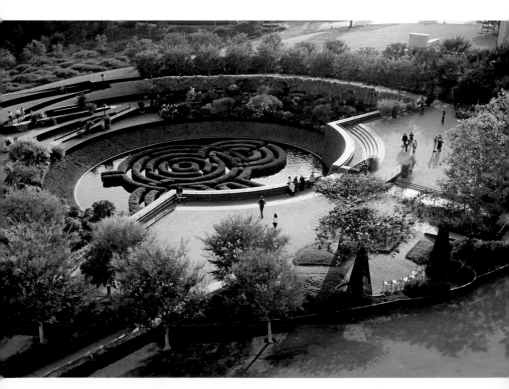

The J. Paul Getty Trust is a cultural and philanthropic institution dedicated to the presentation, conservation, and interpretation of the world's artistic legacy. Through the collective and individual work of its constituent programs . . . the Getty pursues its mission in Los Angeles and throughout the world, serving both the general interested public and a wide range of professional communities in order to promote a vital civil society through an understanding of the visual arts.

This unique volume provides, in words and pictures, an overview of the Getty, the work of its programs, and a behind-the-scenes look at how the institution functions from day to day. The book was prepared by William Hackman and the project staff at Getty Publications and was immeasurably enlivened by the remarkable photographs of Richard Ross and the Getty Imaging Services photographers. We invite the reader to take a tour inside the Getty to learn more about its buildings, grounds, art, archival resources, and worldwide activities, all of which grew out of the "museum, gallery of art, and library" that J. Paul Getty created over a half century ago.

James Cuno
President and CEO
J. Paul Getty Trust

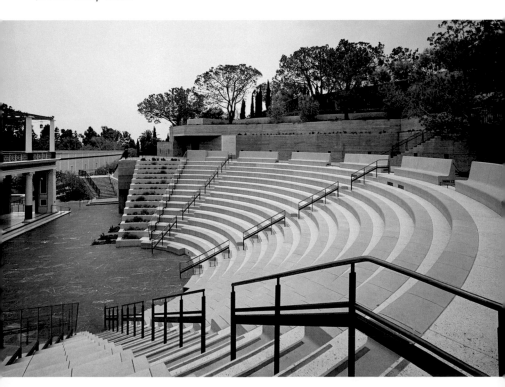

1 A Short History of the J. Paul Getty Trust

THE ORIGINS OF THE J. PAUL GETTY Trust date to 1953 and J. Paul Getty's decision to open a small, private museum in the house he had purchased eight years earlier near Malibu, California. For much of his adult life, Getty was known as the "richest living American," a title bestowed on him more or less officially by *Fortune* magazine in 1957. It was not a rags-to-riches story; J. Paul Getty was born in 1892 to an affluent oil wildcatter and eventually took over his father's business, Getty Oil. At the age of twenty-one, Getty set up shop in Tulsa, Oklahoma; by the time he was twenty-four, he had parlayed an initial investment of five hundred dollars into his first million. In the following years he would move from the ranks of the merely rich to the fabulously wealthy.

As an oilman, Getty had thought big almost from the start; as a collector of art, he had more modest ambitions. His first great coup came in 1938. In addition to having assembled a group of extraordinary pieces of French furniture, he bought a portrait by Rembrandt and the so-called Ardabil Carpet. Getty's other chief interest at the time was antiquities. His most significant purchase in that area was in 1951 with the acquisition of the Lansdowne Herakles, a Roman statue in marble modeled after a Greek original. He bought what interested him. "Few human activities," he remarked, "provide an individual with a greater sense of personal gratification than the assembling of a collection of art objects that appeal to him and that he feels have a true and lasting beauty."

When, in 1945, a parcel of sixty-four acres became available in a canyon at the border of Los Angeles and Malibu, Getty

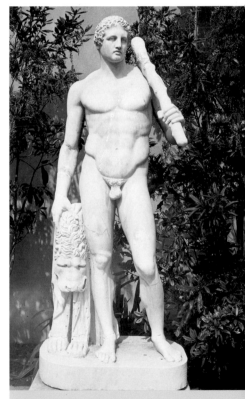

The Lansdowne Herakles, one of Getty's favorite works of art, was first displayed outdoors in a courtyard of the Ranch House.

Portrait of J. Paul Getty (left) by Yousuf Karsh, 1965. Detail from a portrait painting of Getty (inset, top) by Gerald L. Brockhurst, 1938.

1

J. Paul Getty in the mid-1960s at Sutton Place, his English estate, purchased in 1959.

grabbed it. The property included a Spanish-style residence, referred to by Getty as the Ranch House, in which he installed his art collection.

In 1951 Getty left the United States for Europe to be nearer his business interests in the Middle East. Norris Bramlett, one of his closest advisers in Los Angeles, suggested that he open the Ranch House to the public as a museum. Getty agreed, and in 1954 the J. Paul Getty Museum opened. A year before, Getty had formed an educational trust, administered by a board of trustees, that would oversee his art collection. Although he always said he intended to return to his native country, he never did, and thus never saw the museum that bore his name.

In 1968 Getty decided to build a Roman-style villa on the site near Malibu to house his expanding art collection, and six years later the new J. Paul Getty Museum (later referred to simply as the Getty Villa) welcomed its first visitor.

Although his devotion to art was deeply felt, Getty publicly stated on several occasions that he intended to leave little of his fortune to his museum—an endowment sufficient for operating expenses but little more. It came as a great surprise to everyone, therefore, when, following the oil billionaire's death in 1976, it was announced that he had in fact bequeathed the bulk of his estate to the Museum. The institution received four million shares of Getty Oil stock, then worth seven hundred million dollars. Overnight the Getty was transformed from a small, specialized institution hidden away in a canyon, better known for its replica of a classical building than for its collection, to the richest museum in the world.

This unexpected windfall marked a true turning point for the Museum and its trustees. The bequest came with no strings attached. Getty provided few instructions or restrictions on how the money should be spent. He had executed a trust indenture in late 1953, but it simply authorized the creation of a "museum, gallery of art and library" and stated the purpose of the trust as "the diffusion of artistic and general knowledge." Of course, by 1976 the Getty Villa had already been open for two years and was fulfilling its founder's mission—and would continue to display the collection, mount exhibitions, and develop public programming as Getty's bequest was finalized. Due to a number of complex legal and tax issues, the money left to the Museum was not officially

transferred until the spring of 1982; a year before, the trust's name had been legally changed from the J. Paul Getty Museum to the J. Paul Getty Trust.

Given the magnitude of the endowment and Getty's purpose, the trustees realized that the newly endowed trust should have a greater impact on the visual arts than the Museum alone could. Toward that end, they hired Harold M. Williams to be president and chief executive officer of the Getty Trust. A native of Los Angeles, Williams had previously been chairman of the Securities and Exchange Commission during the administration of President Jimmy Carter. A year later, Williams hired John Walsh to be director of the Museum, succeeding Stephen Garrett.

As could be expected, the years 1982 to 1984 were ones of rapid growth and change. The trustees, together with Williams and his colleagues, formulated a proposal that called for—in addition to an expanded museum—a group of independent but related programs devoted to scholarship, conservation, and education. These programs became the Getty Center for the History of Art and the Humanities (now the Getty Research Institute), the Getty Conservation Institute, the Getty Center for Education in the Arts, the Getty Art History Information Program, and the Getty Grant Program (now the Getty Foundation).

It soon became clear that these new programs, along with the attendant desire for the Museum to collect works in other areas, required a larger, unified facility, a main campus to accommodate what the Trust envisioned for its extended mission. Expanding the Villa site for this purpose was impossible. In 1983, a roughly 750-acre property in Brentwood, in west Los Angeles, was purchased by the Trust, and the following year the architectural firm Richard Meier & Partners was chosen to design the Getty Center, which would house the Trust, its five newly created programs, and a second Museum. After three years of design, discussions, and approvals, construction began in 1987. It took a decade of hard work, planning, and collaboration to realize the opening of the Getty Center in December 1997. The dawn of the Center, undoubtedly a crowning achievement, also marked a coda, at least temporarily, for the Getty Villa.

On July 6, 1997, forty-three years after the original J. Paul Getty Museum had opened in Getty's Ranch House, the Villa closed in anticipation of the Center's opening and in order to undergo an extensive renovation campaign—home improvements, so to speak, albeit on a dramatic scale. These were completed in early 2006, and, on January 28 of that year, the Villa reopened as a museum and educational center dedicated to the arts and cultures of antiquity. Today, the J. Paul Getty Trust encompasses two campuses and oversees four separate but interwoven programs: the J. Paul Getty Museum, the Getty Research Institute, the Getty Conservation Institute, and the Getty Foundation. While the Trust and its programs are headquartered at the Getty Center and are active in Los Angeles and all over the world, each has a physical and spiritual embodiment at the Getty Villa, where the Trust was born.

J. PAUL GETTY SCRAPBOOK

Although J. Paul Getty may have had a reputation for being a bit of a curmudgeon, he did know how to enjoy his life, status, and wealth.

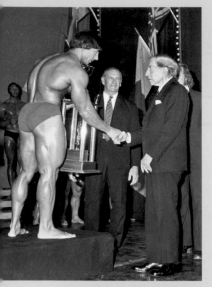

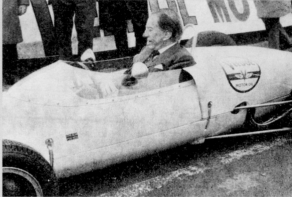

Even at an advanced age, Getty continued to enjoy two unusual passions: competition bodybuilding and auto racing, early 1970s.

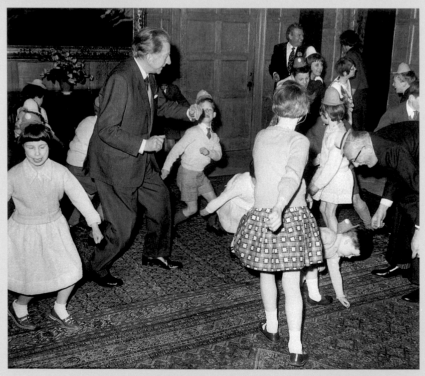

J. Paul Getty at Sutton Place doing the twist with children from a church orphan home, 1963.

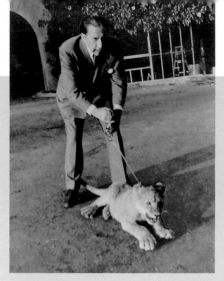

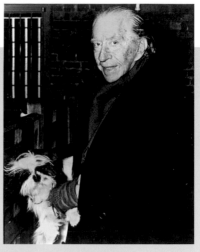

Getty got his first dog, Jip, in 1904, and remained an animal lover his whole life. At left, Getty is shown with his lioness cub, Teresa, part of the small menagerie of animals he once kept at the Ranch House near Malibu, 1950s.

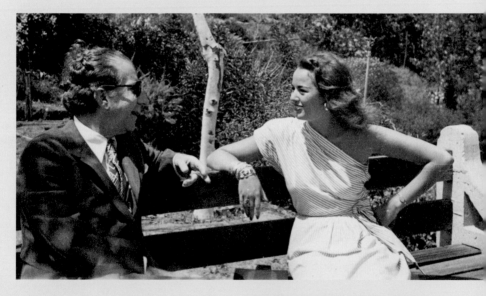

J. Paul Getty with his fifth wife, Louise Dudley Lynch (called "Teddy" after her stage name, "Theodora"), at Inspiration Point, a bluff over-looking the Pacific Ocean, near the future site of the Getty Villa, early 1950s.

"The world's most famous coin-box tele-phone," as Getty amusingly referred to this pay phone, which he had temporarily installed in a room at Sutton Place to curtail calls made at his — and Getty Oil's — expense. This photo was taken by Julius Shulman in 1964.

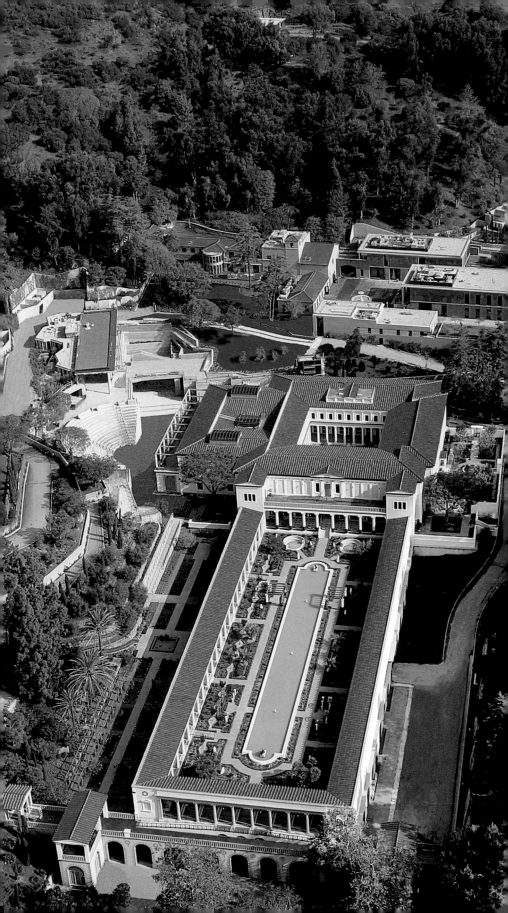

2 The Getty Villa

IN 1934 J. PAUL GETTY BUILT A HOME
next to one constructed by the newspaper magnate William Randolph Hearst
on the beach in Santa Monica. Later, when Getty visited San Simeon, Hearst's
ornate hilltop castle overlooking the Pacific Ocean halfway between Los
Angeles and San Francisco, he was impressed by his host's baronial lifestyle
and ability to buy an incredible variety of things without seeming to give a
thought to the cost. While Getty was much more frugal, the seeds for the
Getty Ranch near Malibu and for Sutton Place, his estate in England, were
nevertheless planted.

THE RANCH HOUSE After Getty's 1945 purchase of the Ranch House and
its surrounding acreage, he filled the two-story structure with his expand-
ing collection of Greek and Roman antiquities and European paintings and
furniture, which he had been steadily collecting since around 1930. He also
created a small zoo on the property, and for a time, bears, lions, wolves, bison,
and gazelles were in residence there.

For about twenty years, after the J. Paul Getty Museum opened to the public
in 1954, Getty's modest but important collection was exhibited in the rooms of
the Ranch House. Hours were three to five on Wednesday and Saturday after-
noons, by appointment only. The Museum was not terribly busy in those early
days, with three dozen visitors constituting a good crowd on any given after-
noon. But those who came could see French furniture and decorative arts,
paintings by Thomas Gainsborough, Titian, and Peter Paul Rubens, as well
as the second-century-A.D. Lansdowne Herakles — the most famous piece in
the collection at the time and one of Getty's favorite works. The sculpture had
been unearthed from the ruins of the Roman emperor Hadrian's villa near
Tivoli in 1790 and symbolized, grandiosely, for Getty the continuation of the
tradition of the great collectors and philanthropists of the past.

By the late 1960s, as Getty's wealth continued to grow, he and his advisers
realized that the collection could no longer be accommodated in what origi-
nally had been a residence, despite the specially built gallery added to the
house in 1957. Although many designs
were presented to Getty (and he was
strongly opposed to any modernist
proposals), he announced in 1968 his
decision to a rather surprised circle of
guests at Sutton Place: the new Getty

Since it opened in 1974, the Getty Villa has
been a popular destination in Los Angeles,
regarded with affection by residents and
amazement by visitors from around the
world. After the move to the Getty Center
in 1997, the Villa was closed for extensive
renovations until 2006. It is now exclusively
focused on the presentation and study of
ancient Greek, Etruscan, and Roman art.

7

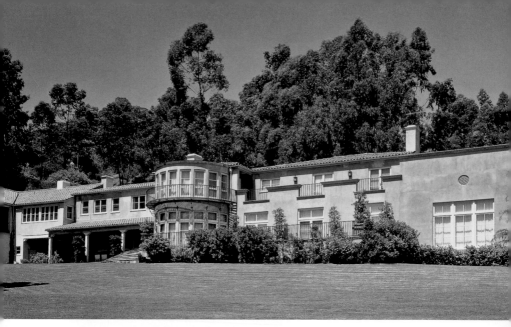

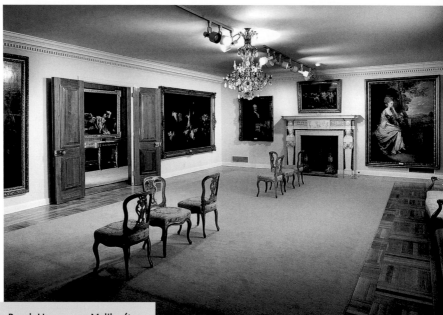

The Ranch House near Malibu (top, as seen in the late 1950s) housed the first galleries Getty installed and opened to the public. The displays included paintings, decorative arts, and antiquities. A long salon in the Ranch House featured paintings (middle). In 1957 a new gallery for antiquities (bottom) was built as an addition to the Ranch House.

Museum would be a re-creation of the ancient Villa dei Papiri in Herculaneum, which had been buried by the eruption of Mount Vesuvius in A.D. 79 and discovered in 1709. The Villa dei Papiri had been the grand home of Lucius Calpurnius Piso, a wealthy Roman collector of literature, hence the "papiri" (papyrus scrolls) found there. Getty, who had traveled extensively in Greece and to Rome and who owned two villas in Italy at this time, had long been attracted to Herculaneum and Piso's villa (in 1955 Getty had even published a novella, *A Journey from Corinth*, about a landscape architect who works for Piso at the villa in Herculaneum).

Getty was also in a sense following an old American tradition of great collectors housing their art in period fantasies: the Venetian palazzo of the Isabella Stewart Gardner Museum in Boston, for example, or the French *hôtel particulier* of the Frick Collection in New York, or the Spanish confection of Hearst's San Simeon. For this project, Getty selected the architectural historian Norman Neuerburg, who, basing his ideas on the original 1754 ground plans of Piso's villa, extrapolated the basic structure for the Getty Villa.

A NEW MUSEUM Ground was broken in December 1970, and construction proceeded rapidly, with Getty making both major and minor decisions from his estate in England. He monitored the process by means of constant reports, large-scale photo boards, and even films, while work on-site was overseen by the Los Angeles architectural firm Langdon & Wilson. The layout of the Museum followed that of Piso's buried house: a large, two-story main block with an atrium, an adjacent inner peristyle with a garden and a triclinium, and a vast 348-foot-long outer peristyle with colonnades, frescoed loggias, garden, and reflecting pool. Inside the Museum, antiquities were exhibited largely on the first floor in a series of small, discrete galleries and around the Inner Peristyle garden, which was modeled

This aerial photo captures the Museum under construction, with its axis perpendicular to the Pacific Ocean, and the residential neighborhoods to the south (early 1972).

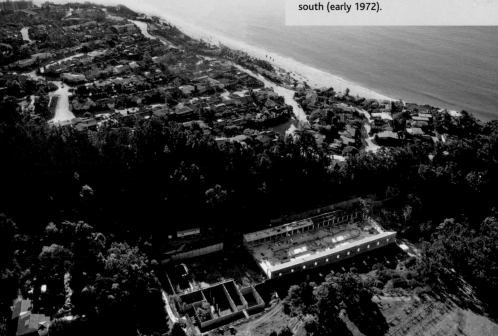

BUILDING THE GETTY VILLA

After J. Paul Getty announced his intention to build at the Getty Ranch a reconstruction of the Villa dei Papiri as an art museum, the next question became "How?" Excavation of the Villa dei Papiri in the 1750s, led by the Swiss engineer Karl Weber, revealed the residence proper, built around a central hall, and a long rectangular peristyle. Weber's detailed plans of the structure provided the basis for the Getty Villa.

To oversee the ambitious project, Getty hired an English architect, Stephen Garrett, and the architectural firm Langdon & Wilson, which converted Weber's plans into blueprints for the museum. Dinwiddie Construction was contracted to build Getty's villa. On December 21, 1970, several hundred yards from the original Ranch House museum, ground was broken for the new J. Paul Getty Museum.

Construction of the Outer Peristyle and underground parking garage began first, and by the spring of 1971, the

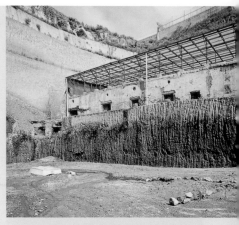

The south side of the excavated section of the Villa dei Papiri just outside of Herculaneum (uncovered between 1986 and 1993).

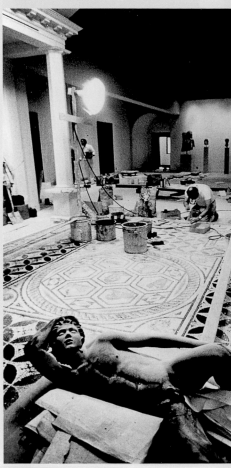

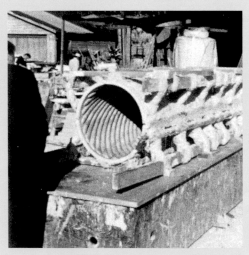

The spiral columns of the West Porch at the Getty Villa were cast in molds such as this one.

Workers toiled night and day, sometimes with sculptures watching, to finalize the galleries.

structural elements for both were in place. As Weber's plan did not mention the building materials of the ancient villa, it was decided that a smooth-finish concrete that simulated plaster be used for the museum building and Outer Peristyle. By January 1972, the columns of the Outer Peristyle and the building's architectural molding were cast in concrete, and the foundation work for the museum building and Inner Peristyle were underway. By the following January, the Outer Peristyle and first floor of the museum were complete, the Inner Peristyle was taking shape, and the construction of the second-floor galleries began.

The subsequent months included the installation of intricate marbles in the halls and galleries, including the so-called Temple of Herakles, built to house one of Getty's most prized works of art, the Lansdowne Herakles. The room's elaborate floor is based on the first one discovered at the Villa dei Papiri and is composed of more than four thousand pieces of three different types of marble, specially cut then sent from Italy.

On January 16, 1974, the J. Paul Getty Museum opened its doors, a fact that greatly pleased its benefactor, who, although he never saw the product of his vision, felt that his money—$17 million of it—was spent wisely.

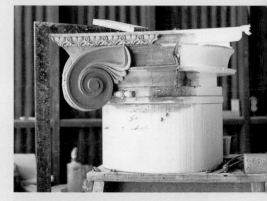

A cast and painted Ionic capital for a column in the Inner Peristyle.

Photo boards, such as the one below documenting the Villa's Outer Peristyle and underground parking garage, were hand-delivered to Getty in England.

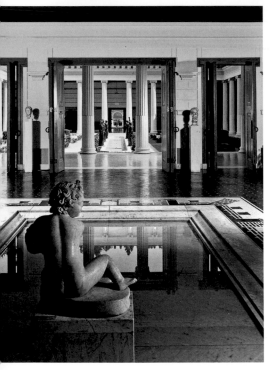

after ancient Roman gardens. Later works of art—primarily late-seventeenth- and eighteenth-century French furniture and old master paintings—occupied the second-floor galleries.

The new J. Paul Getty Museum opened to the public on January 16, 1974. Critics savaged it as historical kitsch; the public adored it. Ultimately, the public's opinion won out, and although Getty never saw the Museum, he was proud of the result, writing in his autobiography, "I felt that the Museum, its Trustees, and I got our money's worth." This statement, from one of the shrewdest businessmen of the twentieth century, was indeed a tribute not only to his own imagination and prodigious wealth but also to all those who conceived, planned, and built the Museum.

Getty's death two years later and his subsequent bequest to the Museum fundamentally changed the scope and reach of the Trust and the Museum. Not only did Getty leave a substantial sum of money, he also placed very few restrictions on how it was to be spent. The Museum was free to purchase works in other media and periods outside of what Getty himself had collected, and it was clear that expanding the holdings and programs would require having a physical home for these works and activities.

Once the decision was made in 1982–83 to select an important site and build on it a center (discussed in the next chapter) for all of the Getty's activities, Trust and Museum officers were faced with another question: what to do with the much-loved Getty Villa and the magnificent property it occupied? While it was no longer large enough to exhibit adequately the expanding collections,

let alone to accommodate the offices and library space required by the newer Trust programs, the Villa clearly was a place people loved to visit and that had always been intended by its founder and its architects as a museum.

A MUSEUM OF ANTIQUITIES As Greek, Etruscan, and Roman antiquities were arguably Getty's first love, and his classical collection—considerably augmented after his bequest—was considered to be one of the finest of its kind in the United States, it seemed clear to everyone that the Villa should reopen as a site in which to exhibit that collection in a setting natural to it, and at the same time to make use of the Ranch House as a place in which to house the antiquities-related activities of the other programs. Preliminary planning began as early as 1987, and while it would be another six years or so before architects were selected and precise designs determined, the increasingly obvious inadequacies of the Villa and its location led curatorial and administrative staff to develop a wish list of improvements.

First, the accessibility of the Museum and the site generally had to be addressed; for example, neither the Auditorium nor the Tea Room could be accessed by the disabled, and the fire roads through the property were too narrow for newer, wider fire trucks. Second, the entry into the Museum was neither especially cheerful nor true to where an entry would have been placed in an ancient suburban villa. Third, the upper floor of the Museum—in which all the collections except antiquities were displayed—lacked natural illumination, owing to the fact that most of the works of art displayed there were light sensitive, and, as wall space there was at a premium as the collection grew, windows were a luxury. Fourth, the upper floor had to be reconfigured so that visitors could move through the rooms rather than in and out of them, and a clearer way of accessing the upper floor had to be devised, as it was then only reachable by an elevator and stairways that, while clearly marked, were hard to locate.

Beyond these basic improvements to the Museum itself, the Trust administration was eager to add such public amenities as an outdoor theater, a larger and more accessible dining area and bookstore, and facilities specially devoted to visiting schoolchildren and families. Furthermore, it was hoped that the site could be altered so as to provide housing for conservation and research activities, specifically offices for the visiting scholars invited by the Getty Research Institute and laboratories and classrooms for the joint conservation-teaching program that the Getty Conservation Institute was developing with the University of California, Los Angeles.

CHOOSING AN ARCHITECT In 1993, about two years after final zoning permits for the Getty Center were approved and construction of the buildings could actually begin, the Trust administration and the directors of its constituent programs decided upon a competition to choose an architect for the renovation of the Getty Villa. Instead of inviting architects to present plans, a short list of candidates was devised, and those on the list were invited to participate together in a two-day session at the site, during which time

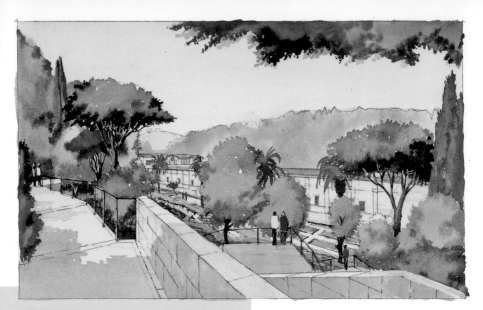

A design rendering by Machado and Silvetti Associates, Inc. from around 1996, showing the hillside gardens with views of the Museum and path leading up to it.

the program directors would describe their activities, and scholars would explain the history of the Getty Villa and of the Villa dei Papiri, its ancient antecedent. Then, each architect or firm would be given an eleven-by-fourteen-inch sketchbook in which, during the following two weeks, to describe in words, drawings, or collage how each would reorganize the site, build the necessary new structures, and reconfigure the interior of the Museum.

On Friday, October 29, 1993, the sessions began. As recounted by the winning architect, Jorge Silvetti, of the American firm Machado and Silvetti Associates, Inc., it was a darkly auspicious beginning for what would prove to be an arduous twelve-year process. As the participants emerged from the darkened Founders Room into the California sun, ash from a major brushfire nearby fell from the sky, eerily evoking what it must have felt like to have been in Herculaneum as Mount Vesuvius began its devastating eruption almost two thousand years earlier.

THE VILLA REOPENS Although the reopening of the Villa was originally planned for 2001, a long and sometimes contentious process of zoning approval, as well as the challenges of the site and the changing requirements of the Trust, delayed that opening by five years. Finally, on January 28, 2006, the Getty Villa reopened, and the staff, critics, and public have agreed that it was worth the wait. And it would be fair to say that the much-loved—and, indeed, much-maligned—Museum building and the breathtaking Villa environs grew more beautiful, more useful, and truer to their ancient prototype in the hands of Machado and Silvetti, and guided by the Museum's then curator of antiquities and Trust Coordinator of Villa Programs, Marion True. The new suite of twenty-three galleries housed more than twelve hundred objects from the Museum's antiquities collection, filling both floors of the Museum. Six additional galleries offered a year-round schedule of changing and international

The art-support system (left), hidden behind every gallery wall, allows very heavy objects and cases to be attached simply and safely. The photo below documents the construction of the Villa's compluvium, which, in ancient homes, allowed in rainwater. The Villa's compluvium, however, unlike those in antiquity, can be closed by means of a mechanical shutter.

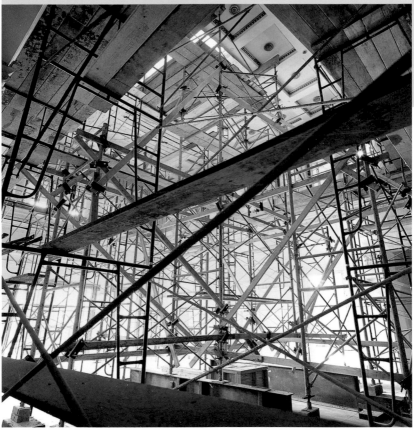

loan exhibitions, bringing treasures from around the world to Los Angeles. The special collections of the Getty Research Institute, rich in materials on the classical world, were, and continue to be, regularly featured.

Today, visitors to the Villa still enter from Pacific Coast Highway but park in an expanded and largely hidden structure instead of underneath the Museum. After leaving the garage, visitors proceed to the Entry Pavilion and then along a path whose rough-hewn and multilayered retaining wall intentionally resembles the gouged-out stratigraphy of an archaeological excavation. Looking down at the extensive landscaping, visitors experience the type of gardens that the Romans themselves would have designed, with the Southern California air and light standing in for those of the Bay of Naples.

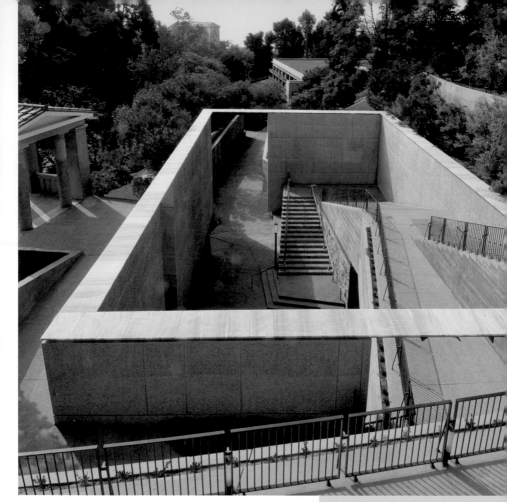

Continuing on, visitors see the Museum's roof and walls. The formal entry begins near the top of the semicircular outdoor Barbara

and Lawrence Fleischman Theater—from which practically the whole site and the Pacific Ocean beyond are now clearly visible. On summer evenings, the theater does indeed host performances, but daily it offers itself as a grand descent to the West Porch, the entrance to the Museum. The porch leads into the Atrium, which itself opens onto the Inner Peristyle—exactly as visitors might have entered a dwelling such as the Villa dei Papiri in ancient times.

Once inside the Museum, visitors familiar with the old Villa will be struck by how everything seems the same as it was before, only somehow brighter and more finished. The wall paintings, first completed in the mid-1970s by the artist Garth Benton, were restored and then refreshed by Benton himself. The marble floors and wall cladding are largely as they were originally. The first—and only major structural—change is the grand East Stair at the end of the Inner Peristyle and directly in the line of sight from the entrance, thus making clear the entire layout of the building. It leads to the second floor, which is bathed in the natural light flowing from new skylights and now-opened windows.

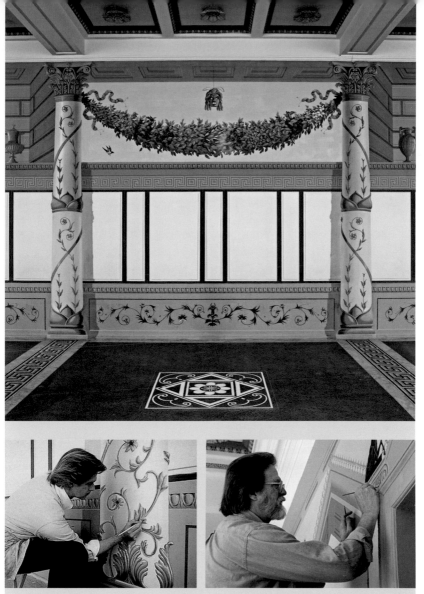

The wall paintings in the Outer Peristyle (above) were modeled after those found in antiquity and were originally painted by the artist Garth Benton (at left, around 1973). For the new Villa, Benton (at right, in 2005) retouched some of the existing frescoes and created an original design for a newly renovated wall.

In April 2018, the Getty Villa completed a three-year renovation that resulted in the addition of more than three thousand square feet of gallery space. With its objects now organized chronologically in thirty-three galleries over two floors, the Villa's new visual arrangement promotes an understanding of artistic, cultural, and historical developments over time and geographic space, from the Neolithic and Bronze Age of Cycladic, Minoan, and Mycenaean art through the Archaic, Classical, and Hellenistic epochs of Greek art and architecture up to Ancient Rome. Displays organized by period and culture are paired with thematic excursions, permitting visitors

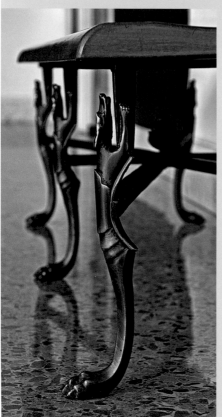

The entrances to the Villa's galleries are marked with bronze Roman numerals that are incorporated into the elaborate designs of the floors, made of mosaic, cut stone, and terrazzo, a composite of stone chips polished to a high sheen. This modern chair (left) contains legs inspired by ancient Roman works of art. In the photo below, sculptures in the Inner Peristyle may resemble ghosts but were merely covered to protect them during construction.

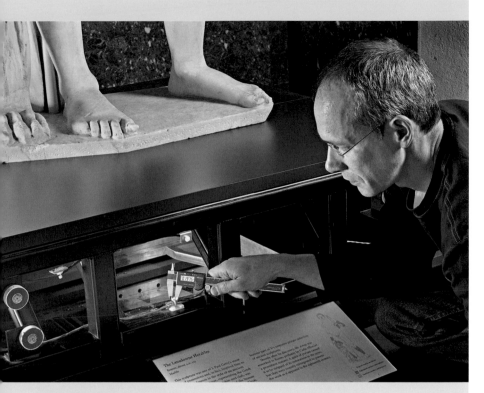

SEISMIC PROTECTION

Nature has the power to unleash great force—a fact that the ancients knew all too well. Despite its tranquil setting, the Getty Villa sits on ground at risk for some of the most destructive earthquakes in the world. Long-term preservation is one of the primary efforts of the Antiquities Conservation Department and encompasses collections care and disaster mitigation. Museum conservators and mount makers for antiquities have worked for over two decades to develop a variety of methods aimed at reducing the risk of earthquake damage to the collection. These include installing sculptures on bases fitted with specially designed seismic isolators (above) and securing works to the floor with anchors or plugs, shown in the photo below during construction before the gallery floor was finished.

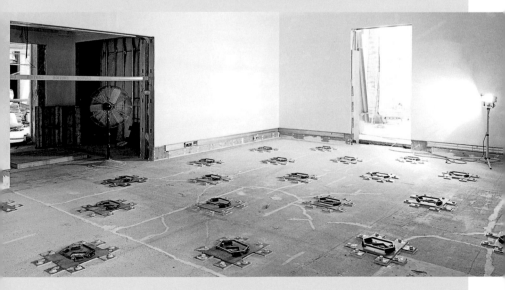

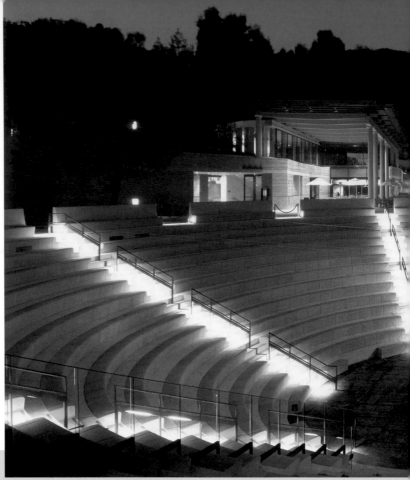

Night at the Villa (above) with a view of (clockwise from left) the Fleischman Theater, Cafe, Auditorium entrance, and Museum. The East Stair (left), clad in yellow marble from Spain, provides easy access between the two floors of the Museum.

to consider cultural production in the context of historical events and aspects of daily life in antiquity, or through a focus on works in particular media, such as gems, coins, or glass. *The Classical World in Context*, a new, multi-year Getty initiative, features exhibitions, publications, research programs, and educational activities exploring cultural exchanges between Ancient Greece and Rome and other Mediterranean, Middle Eastern, and Asian cultures.

There are also numerous public events at the Villa. The Auditorium hosts an ambitious performance and lecture program. Opposite the Auditorium is

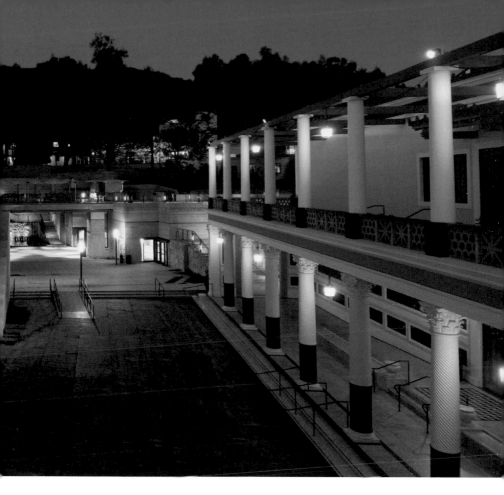

a spacious Museum Store and Cafe with indoor and outdoor seating. From here and across a broad lawn, visitors can see the old Ranch House, but it, as well as the new structures for conservation and administrative offices nearby, is closed to the public. These are the spaces in which the work of curators, visiting scholars, staff, and student-conservators takes place.

GETTY'S LEGACY J. Paul Getty's connection to the lives of the ancients, his love of the arts of antiquity, his great philanthropy, and his intellectual curiosity permeate the Villa even today, more than forty years after his death. It was his wish that "every visitor at Malibu feel as if I had invited him to come and look about and feel at home.... I hope it will prove to be as beautiful as I imagined it and that everyone who wants will have a chance to see it." Getty also stipulated that admission to the Museum be free of charge. Although Getty died without ever personally experiencing the Villa, there is something oddly comforting and poetic about the fact that he is buried at the site, on a bluff overlooking the Pacific Ocean. About the original institution that opened in 1974, Getty wrote: "Museums do not just happen. Nor are they the work of any one person. Numerous dedicated people contributed thought, time, energy, and work—and above all expertise and talent—to the building and success of the Getty Museum."

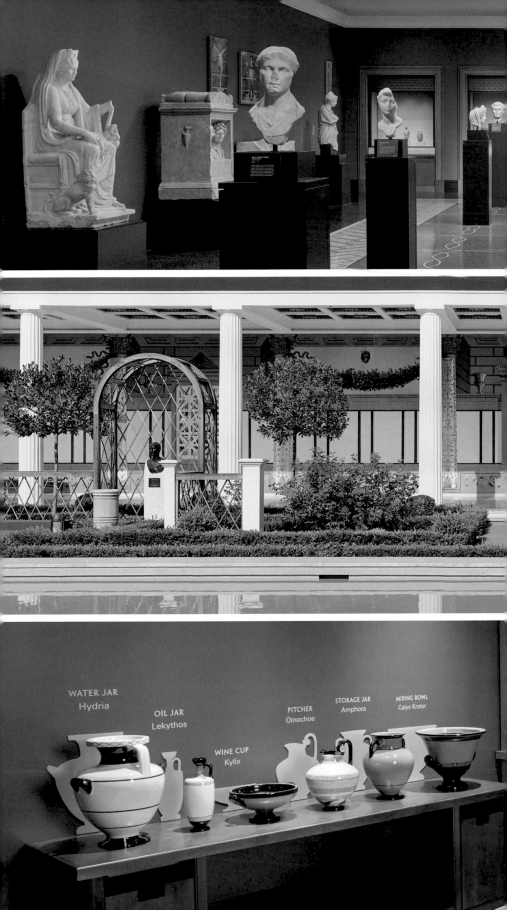

WATER JAR
Hydria

OIL JAR
Lekythos

WINE CUP
Kylix

PITCHER
Oinochoe

STORAGE JAR
Amphora

MIXING BOWL
Calyx Krater

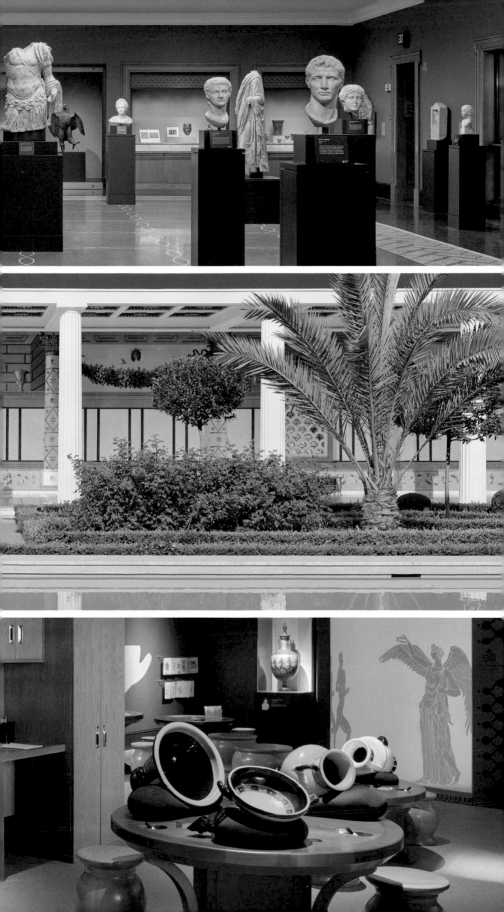

3 Building the Getty Center

THE DECISION TO BUILD THE GETTY
Center was a defining moment in the history of the J. Paul Getty Trust. The reasons for that decision were both practical and philosophical.

During their first few years, the new Getty programs found temporary housing in rented space around Los Angeles. The Trust's administrative offices were in Century City, the Center for the History of Art and the Humanities occupied several floors of an office building in Santa Monica, and the Conservation Institute worked out of facilities in an office park in Marina del Rey. It was clear from the start, however, that the programs would require specialized facilities in order for their activities to move ahead. It was equally evident that, in order for them to interact in ways that would generate creative new thinking and innovative approaches to their fields, they should be housed together. Moreover, as the Getty Museum expanded its collections to include four new curatorial departments—Drawings, Manuscripts, Photographs, and Sculpture—it became apparent that the existing Getty Villa would not offer adequate space to display the collections and could not be easily enlarged.

Hilltop purchase, roughly 750 acres, 1983.

SELECTING THE LOCATION Beyond simply finding a location to house the Getty's growing departments and programs, Trust President and Chief Executive Officer Harold Williams and the trustees recognized that they had a rare opportunity to provide a unique cultural resource for the city of Los Angeles. They understood that whatever they finally decided to build should place memorable architecture on a remarkable site. Just as important, in a city as large and sprawling as Los Angeles—and in deliberate contrast to the Villa—the facility needed to be someplace central and accessible.

Several possibilities were considered, including a large tract at the Veterans Administration Medical Center in Westwood and on the grounds of the Ambassador Hotel near downtown. But when a plot of land in the foothills of the Santa Monica Mountains became available, it was the instant front-runner.

A north-facing view from 1944 of the pass through the Santa Monica Mountains, the future home of the San Diego Freeway and the Getty Center.

The opportunity to build on such a large hilltop property—the site, together with an adjacent parcel was 742 acres in all—was unusual to say the least; it seemed unlikely that a similar tract would be offered again in Los Angeles. The Trust bought the land in September 1983.

SELECTING AN ARCHITECT In the fall of 1983, the Getty empaneled an advisory group, chaired by Bill Lacy, then president of New York's Cooper Union for the Advancement of Science and Art, to guide the Trust in selecting an architect. Rather than hold a design competition, the standard practice for cultural institutions and other major architectural projects, the committee instead recommended a unique process that included interviews with architects and their clients as well as visits to the designers' most important previous buildings. The trustees agreed. The committee compiled a list of thirty-three candidates whose firms ranged in size and location and who had produced consistent and distinguished bodies of work.

The invitation to the architects included a site map and explained the Trust's major requirements: "The buildings must be technically sound in construction. They must serve and enhance the programmatic purposes of the institutions and their relationship to each other. They must be appropriate to the site and responsive to its uniqueness. They must achieve the above three qualities in a manner that brings aesthetic pleasure to the building's occupants, visitors, and neighboring community."

In the fall of 1983 the committee sent the invitation to the selected architects, asking the recipients to submit background materials and slides of their firms' completed projects, a list of clients, and, most important, a short essay describing how they, if chosen, might approach the commission. Seven semifinalists were then invited to visit the site and discuss their ideas with the committee. In turn, the committee toured at least two buildings by each architect and, with the architect as guide, visited the firms' offices and spoke to past clients.

After several months, three finalists were selected: Fumihiko Maki, of Japan; James Stirling, of Great Britain; and Richard Meier, of the United States. In October 1984—thirteen months after acquiring the property—the Getty named Richard Meier & Partners as architect. Meier had recently

HIGH MUSEUM, ATLANTA
Before selecting the final architect, the committee visited projects completed by the three finalists. They also talked to previous clients. Here the committee takes in the High Museum, designed by Richard Meier.

been named the winner of the 1984 Pritzker Prize, widely regarded as the highest professional honor in architecture, and he had garnered international accolades for his design of cultural institutions, such as the High Museum in Atlanta and the Decorative Arts Museum in Frankfurt.

VISITING OTHER MUSEUM SITES Over the course of several months, Meier and his associates, accompanied by the Getty's leadership, journeyed to museums and research institutions throughout the United States and Europe. Their itinerary ranged from the Frick Collection in New York and the Freer Gallery in Washington, D.C. to the Alte Pinakothek in Munich, Germany; the National Gallery in Edinburgh, Scotland; the Herzog August Bibliothek in Wolfenbüttel, Germany; and the Certosa del Galuzzo, a monastery in Florence, Italy.

Of their shared research mission, John Walsh, then director of the J. Paul Getty Museum, said: "The objective was not to find features to copy, but to study sites that have particular suggestive power for us, to see buildings that we think especially successful in one way or another. Away from our daily routines, stirred by common experiences, we were able to push ideas for our own project further. It was valuable just to compare our reactions with the architect's and vice versa and in the process begin to know one another's minds and vocabularies."

Among the many highlights of the trip was the visit to the Herzog August Bibliothek, a research center and library that was a close parallel in terms of function to the Getty Center for the History of Art and the Humanities (today the Getty Research Institute).

The gardens and hill towns of Italy also inspired elements that would all prove essential in the design of the Getty Center: the scale and textures of outdoor spaces, the sensory impact of moving water, the relationship between intimate alcoves and open plazas, and the entire dialogue between buildings and their surrounding garden spaces.

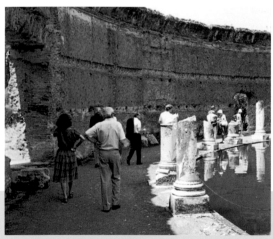

EUROPEAN VISITS
Once Meier was selected in October 1984, the committee and architect toured other museums internationally over the following months. The goal of these trips was to experience the character and spirit of the places. Among the sites visited were the Alte Pinakothek (left) in Munich and Hadrian's Villa (above) in Tivoli, about nineteen miles outside of Rome.

UNIQUE CHALLENGES OF THE GETTY SITE The hilltop location was both an inspiring and controlling factor. When Meier first described his concept for the site plan in 1986, he was clear that he saw the land and the buildings as an integral part of the urban fabric of Los Angeles. "The spectacular site," he wrote, "invites the architect to search out a precise and exquisitely reciprocal relationship between built architecture and natural topography." His vision was that of "a classic structure, elegant and timeless, emerging, serene and ideal, from the rough hillside, a kind of Aristotelean structure within the landscape. . . . The two are entwined in a dialogue, a perpetual embrace in which building and site are one."

Developing the site, however, which had been zoned for residences, depended on securing the approval of local residents as well as of the Los Angeles Planning Commission. The Getty worked closely with elected officials and homeowner representatives to establish a basic framework for the design and operation of the Center. A Conditional Use Permit created a set of 107 written conditions, and the master plan was approved in 1987.

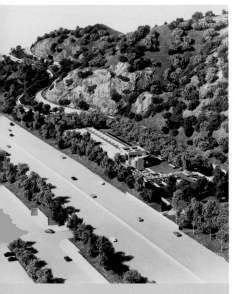

It required six months for the Getty's staff to evaluate all their buildings' requirements and integrate them into a comprehensive written program. The document handed over to Meier in early 1986 stressed the objective of locating Getty programs together so that each could be strengthened by the others. It called for structures that responded "functionally and aesthetically to the distinctive nature of each program" and emphasized the need for buildings with a human scale that would lend themselves to the humanistic pursuits at the heart of the Getty's mission.

Preliminary work such as this maquette examined the impact the Getty Center would have on the surrounding landscape.

MANY MODELS ARE PREPARED Meier's office created many meticulous three-dimensional models and preparatory drawings from the time Meier was selected as architect for the Center in 1984. These included the site master plan, approved by the Los Angeles Planning Commission in 1987; the schematic design of the Center, approved by the Getty the following year; and the final design of the Center, approved in the spring of 1991. During this period there were also in-depth discussions with Getty personnel to ensure that all the buildings would fulfill the needs of their occupants.

Despite the many changes to the plan in the course of the architect-client dialogue, Meier's original vision for the Center stayed true. After the completion of the building of the Center, he wrote: "When I compare early sketches

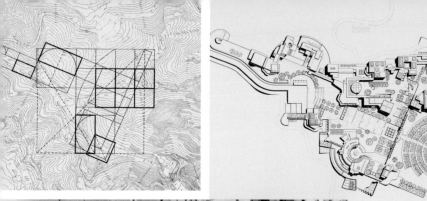

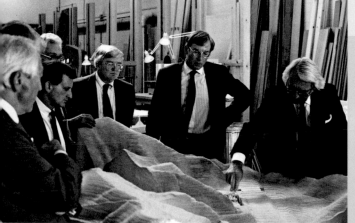

Meier responded to the natural topography of the site, situating the buildings along the ridges that form a Y-shaped axis. The site plan at top left shows how geometric relationships were developed along the two ridges to establish placement of building masses. At top right is an overall site plan. Both plans were made in September 1988.

Meier, at far right in the photo above, articulating his designs to Trust and program leaders. Architectural and site models were crucial for developing the arrangement and flow of the buildings and establishing the nature of the experience for viewing art in the galleries. The model at right shows an early concept for the louvers that control natural light in the upper-level galleries. The model below depicts (clockwise from top left) the Museum, Research Institute, Restaurant/Cafe, Arrival Plaza, and East Building.

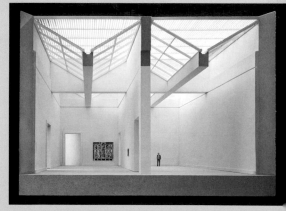

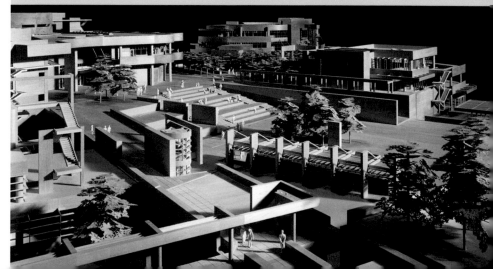

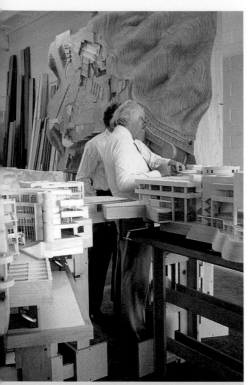

Surrounded by topographical and architectural models, Meier and an associate discuss details of the Getty Center plan.

and design models with what has been built, it is remarkable how the original conceptual ideas remained intact—particularly since every piece of the complex was discussed, scrutinized, redesigned, reworked, and repriced."

FEATURES OF THE FINAL PLAN
The layout of the buildings, gardens, and open spaces follows the site's physical topography. A twenty-four-acre plot in the southernmost part of the site had been chosen for the buildings and campus even before Meier was selected as architect. This plot was divided naturally by a canyon into a Y, with two ridges diverging to the south. Meier's plan positioned the Museum on the eastern ridge—thereby visible to its potential audience—and the Research Institute on the more secluded western ridge, facing the ocean. A grand garden was to go in between the ridges in the former canyon. Where the ridges met, Meier located the main public service areas: the Tram Arrival Plaza, Auditorium, and Restaurant/Cafe; adjacent to those, on the northeast side, would be two buildings to house offices for the Trust, Conservation Institute, Grant Program, and Education Institute.

At the outset of the design process, the Museum was the most established part of the Getty. Four pavilions present paintings, sculpture and decorative arts, drawings, manuscripts, and photographs from the thirteenth century to the present day. A fifth pavilion features special exhibitions. The idea of housing those collections in a series of discrete but connected buildings set around gardens and terraces took shape in early discussions between the architect and the Museum's staff. Such a design contributes to a sense of intimacy as well as improved circulation; visitors are encouraged to stop, rest, and enjoy a change of perspective.

The Research Institute presented the most striking instance of the design process influencing not only the building's form but also its content. In many ways the Institute, still in its formative years, was defining itself at the same time its home was being designed and built. Meier's first schematic presented a variation on a traditional form, with clearly appointed areas for books, archives, visiting scholars, and staff functions. A central reading room would serve as the primary spot for intellectual and social interaction.

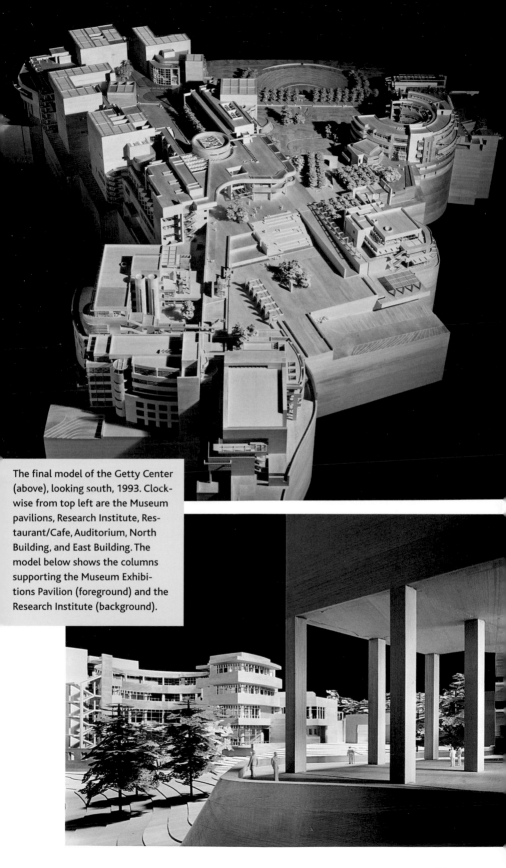

The final model of the Getty Center (above), looking south, 1993. Clockwise from top left are the Museum pavilions, Research Institute, Restaurant/Cafe, Auditorium, North Building, and East Building. The model below shows the columns supporting the Museum Exhibitions Pavilion (foreground) and the Research Institute (background).

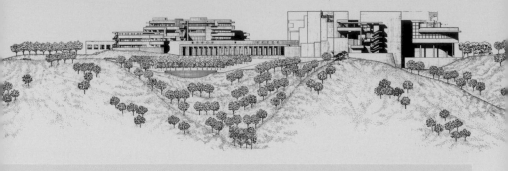

Due to the height restrictions of forty-five feet on the west side of the site and sixty-five feet on the east imposed by the Conditional Use Permit, more than half the space of the Getty Center was placed underground. Most of the buildings are three stories above ground and three below.

The plan responded to the original conception of the Research Institute but lacked its desire for fluidity, adaptability, and means for integrating the scholars, staff, and collections. The final result, arrived at after numerous productive collaborative sessions between Meier and Institute leaders, was a circular building with dynamic, flexible spaces that allowed for both privacy and transparency.

Meier described the L-shaped East Building that houses the Conservation Institute and the Foundation as "the most 'Californian' building in the complex." Many of the corridors—even the elevators—are on the exterior. Covered passageways connect offices to the Conservation Institute's Information Center and the building as a whole to the public walkway. He sought to capture the "qualities of light and openness" that characterize the Southern California buildings by Richard Neutra, Rudolf Schindler, and Frank Lloyd Wright, as well as the historic Case Study houses of the 1950s and 1960s.

MATERIAL SELECTION The travertine cladding on the site's retaining walls and the bases of buildings recalls the materials used on great structures since antiquity. At the same time, it grounds the Center in the hillside, emphasizing the relationship between the natural and the built. Porcelain-enameled metal panels and glass curtain walls stretch around the buildings' upper stories. These materials are more pliable than stone, making them an ideal fit for many of the structures' fluid, sculptural forms. The beige tone of the panels complements the stone, while their smooth surface provides a contrast to the stone's rough texture. White metal panels cover walls not visible from off-site.

CONSTRUCTION BEGINS Building a large complex on the hilltop site presented numerous logistic and engineering challenges. There were no paved roads, utilities, or water source. Dinwiddie Construction Company, which had been selected in February 1987 to be the general contractor for the Center (and had built the Getty Villa in the early 1970s), began preparing the site for construction. The first steps were to establish a staging area at the bottom of the site and to build both a million-gallon water reservoir and a parking structure for the construction workers and project staff. In 1989 construction of the lower parking structure was launched, followed by the grading for the main

Mock-ups of proposed materials (above and right) were reviewed for surface quality and texture. Travertine is the most memorable material used on the site, but glass and metal are also employed and were carefully considered as important contrasts to the rough stone.

buildings in 1990 and the foundation work on the North Building, East Building, Auditorium, Restaurant/Cafe, and Museum in 1992. The next year, workers began installing the structural steel for the East and North Buildings and Auditorium, and the first piece of travertine was set in the East Building.

On January 17, 1994, however, a 6.7-magnitude earthquake struck the San Fernando Valley community of Northridge, thirteen miles to the north of the Center project. Years earlier, geologists completing a study of the future Center site had identified an ancient, inactive fault but ultimately concluded that the terrain was stable and could withstand the shaking of a large temblor. Their predictions were proven right by the Northridge quake, which brought a relatively small amount of damage to the foundations and frames of the buildings under construction. However, cracks in the steel frame of the North Building were detected, causing the Getty to halt construction and to confer with its structural engineers, Robert Englekirk Consulting Structural Engineers, Inc., about how best to proceed. After conducting a series of tests—which resulted in the landmark formation of new, higher standards in the construction of steel-frame buildings—from May to August of 1994 the building team retrofitted the erected steel joints that were shown to be vulnerable by the Northridge earthquake.

Later in the year, the foundation work for the Research Institute was initiated, the installation of the structural steel for the Museum commenced, and the lower parking structure and tram station were completed.

TRAVERTINE

Although Richard Meier is famous for the white metal panels he has often used as the outer skin of his formally elegant buildings, he knew early on that he wanted to clad the Getty Center in stone. Because of the way it grounds built structures in the earth, stone brings a sense of permanence. For this reason, stone has been used throughout history as the primary material for public buildings.

Meier, however, rejected the smooth granite that is so often used for buildings today. He wanted what he described as "a stone that looks like stone, that feels like stone." Finding it—especially the 1.2 million square feet needed to cover the Getty Center—required a worldwide search. Meier eventually settled on travertine from Bagni di Tivoli, near Rome.

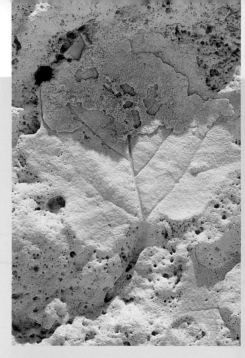

Cleft cutting the travertine revealed fossils and iron-stained cavities that show the stone was formed in a bubbling, mineral-rich lake. Detailed impressions of leaves, feathers, fish, and shells can be seen in the Center's walls and floors.

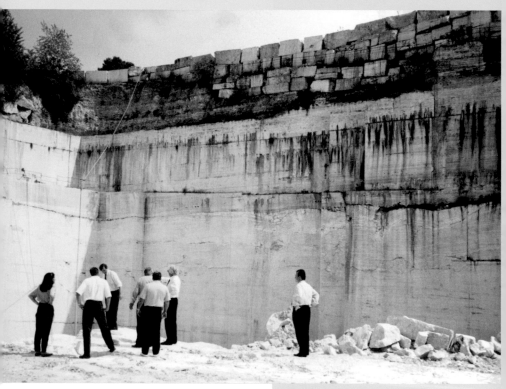

The quarries that supplied the Getty Center were those used by the Romans to build the Colosseum.

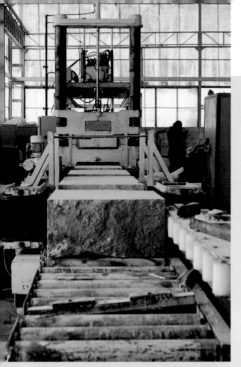

Special machinery at the Mariotti factory cuts the stone, February 1993.

Meier designed a special mortar-free mounting technique for use on the Center's facade. Each block is fitted with stainless steel wall anchors that hook the stone into place. A special backing wall protects the buildings from rain, which runs through the open joints between each stone. This shields the surface of the travertine from streaking and wear. The separation also prevents the blocks from touching in the event of an earthquake.

Travertine, a type of limestone, weighs less than granite or marble and is more plentiful. At the family-owned Mariotti quarries, Meier's team worked closely with Carlo Mariotti and his sons for more than a year to develop a technique that would yield the rough texture the architect envisioned. The method they settled on used a guillotine to split blocks of travertine along their natural fissures.

In all, nearly 16,000 tons of travertine were transported by barge from Italy in 100 trips—via the Atlantic Ocean and the Panama Canal—to build the Getty Center. Most of the more than 295,000 blocks are 30-inch squares and between 1.6 and 5.3 inches thick; each weighs about 250 pounds. Several large pieces of travertine, including benchlike slabs quarried in the nineteenth century and weathered for over a hundred years, struck Meier as especially beautiful.

Meier selected some stones based on their texture, color, and fossils to be displayed in public areas throughout the site. About a dozen are incorporated into the regular grid "to break things up and mark a key point," according to Meier.

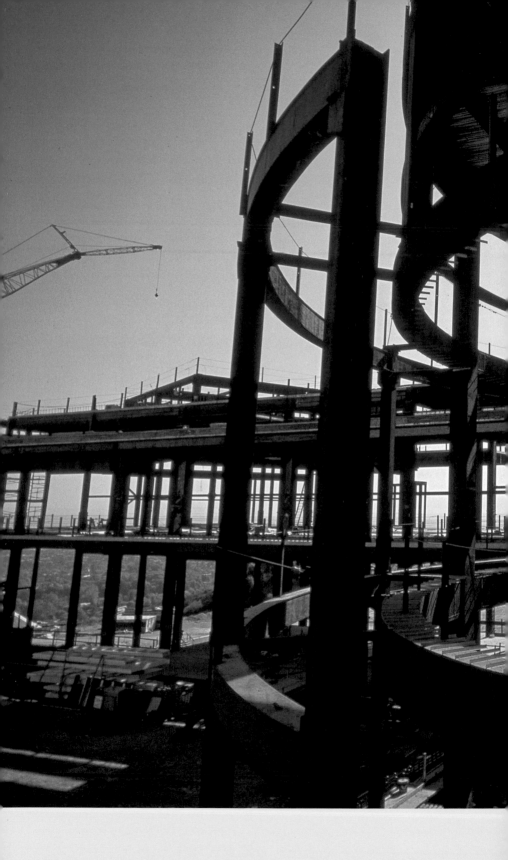

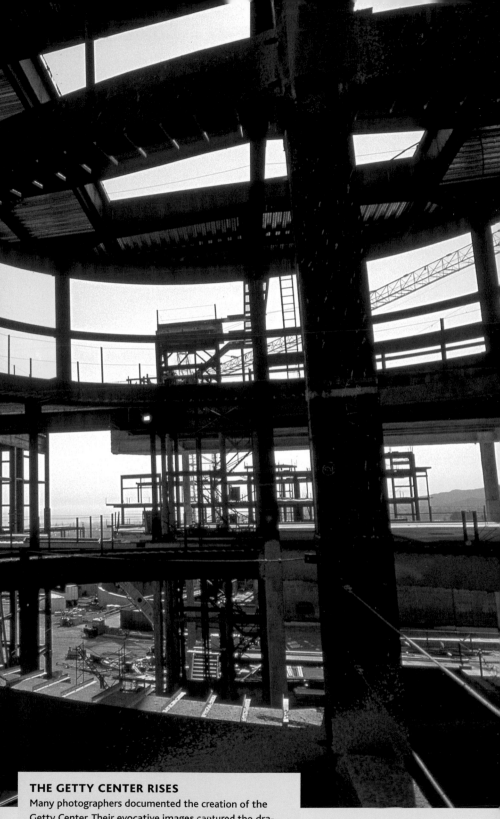

THE GETTY CENTER RISES

Many photographers documented the creation of the
Getty Center. Their evocative images captured the dra-
matic transformation of the site during the ten years
of construction. This shot by Vladimir Lange shows the
building of the cylindrical Museum Entrance Hall (fore-
ground) and the Exhibitions Pavilion (left).

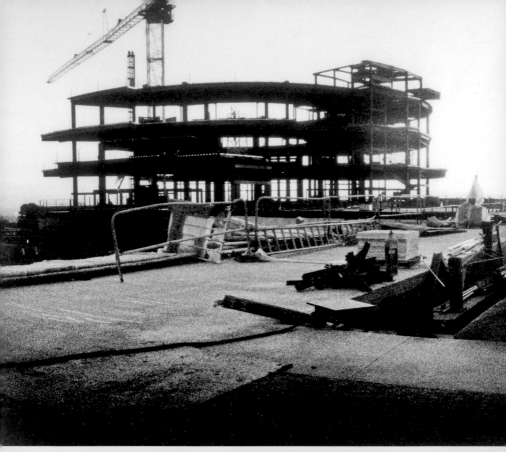

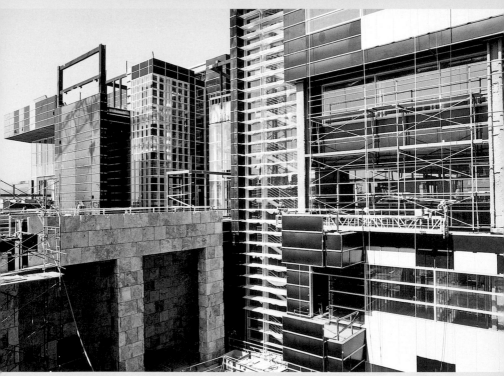

Photos by Dennis Keeley (top), Howard Smith (bottom left), and Joe Deal (bottom right) record, respectively, the construction of the Research Institute and Restaurant/Cafe, Auditorium and North Building, and Museum Entrance Hall.

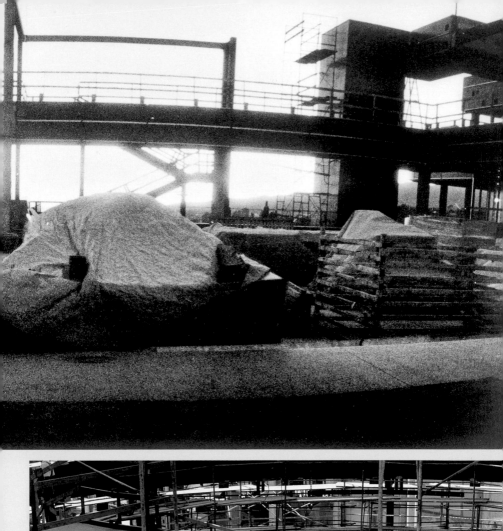

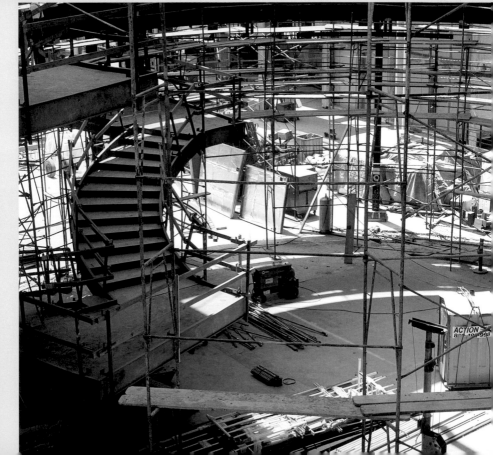

LANDSCAPING THE GETTY CENTER SITE In consultation with Richard Meier, the landscape architecture firm Olin Partnership, with Emmett L. Wemple & Associates, developed plans for landscaping the 110-acre perimeter zone that encircles the central 24-acre campus. (The remainder of the site was left in its natural state.) Some three thousand native oaks, one hundred large Italian stone pines, nearly two thousand other saplings, and acres of shrubs and ground cover were planted—stabilizing and greening the hillside surrounding the Center. Many large trees growing on the property before construction began were boxed and replanted. Extensive conservation and preservation measures help protect the site from fire, soil erosion, and the effects of earthquakes.

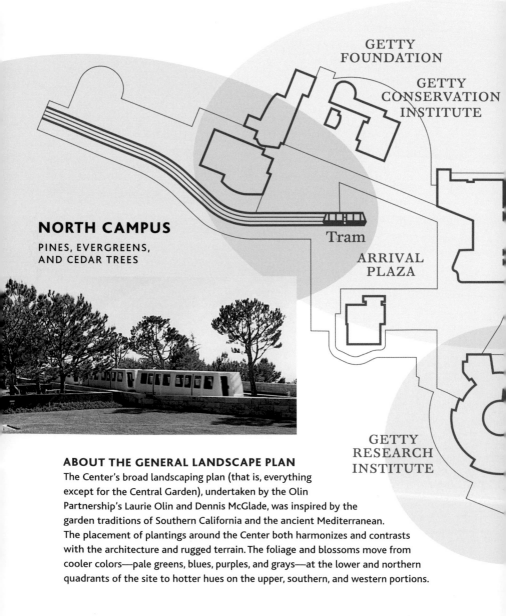

GETTY
FOUNDATION

GETTY
CONSERVATION
INSTITUTE

NORTH CAMPUS
PINES, EVERGREENS,
AND CEDAR TREES

Tram

ARRIVAL
PLAZA

GETTY
RESEARCH
INSTITUTE

ABOUT THE GENERAL LANDSCAPE PLAN
The Center's broad landscaping plan (that is, everything except for the Central Garden), undertaken by the Olin Partnership's Laurie Olin and Dennis McGlade, was inspired by the garden traditions of Southern California and the ancient Mediterranean. The placement of plantings around the Center both harmonizes and contrasts with the architecture and rugged terrain. The foliage and blossoms move from cooler colors—pale greens, blues, purples, and grays—at the lower and northern quadrants of the site to hotter hues on the upper, southern, and western portions.

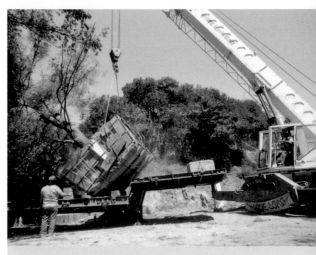

Thousands of trees and native shrubs were planted to minimize the threat of fire and erosion and in response to the need for drought-tolerant materials. To save the site's California live oaks, fifteen mature trees were moved out of the path of construction and transplanted to other locations on the property.

MID-CAMPUS
SWEET GUM, CYPRESS, AND CAMPHOR TREES

J. PAUL GETTY MUSEUM

SOUTHERN PROMONTORY
CACTUS AND SUCCULENTS, REMINDERS OF LOS ANGELES'S DEPENDENCE ON WATER IMPORTED FROM MILES AWAY

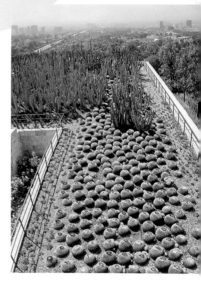

CENTRAL GARDEN

GETTY RESEARCH INSTITUTE
EDIBLES AND FRUIT-BEARING PLANTS, A METAPHOR FOR THE FRUIT OF KNOWLEDGE

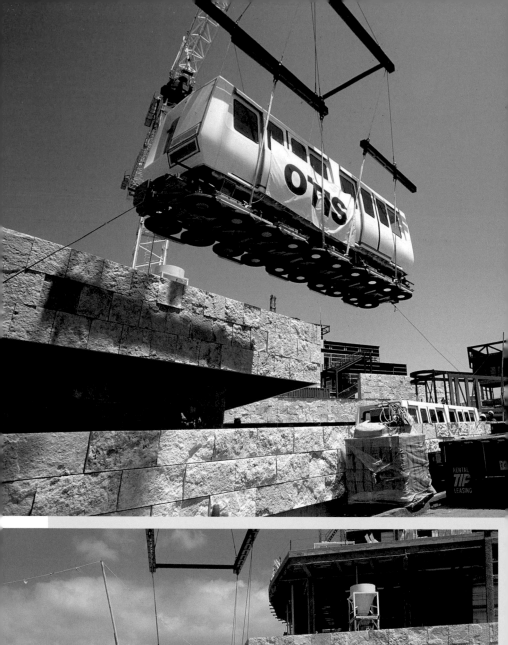

TRAM

Whether they come by car, by bus, or on foot, visitors begin their experience of the Getty Center with a five-minute ride on a driverless, computer-operated electric tram. The ride begins at the Lower Tram Station, which stands over a twelve-hundred-car underground parking structure by the Center's main entrance. As visitors travel along the winding, wooded route to the top of the hill—about three-quarters of a mile— they are treated to constantly changing views of the hillside, city, and Center.

This transportation system was designed for the Center by Otis Transit, a division of the Otis Elevator Company. The tram might best be described as an elevator that runs horizontally instead of vertically. There are actually two separate trams, each with three cars. The quiet, pollution-free vehicles glide on a cushion of air generated by electric blowers. The cars are attached to a cable along a single elevated guideway. As one tram travels uphill, the other runs downhill, bypassing the first at the wider center portion of the guideway. The system was the first of its kind on the West Coast.

The trams arrive for installation in late 1994, above and left. Shown below are the large cables and wheels (located beneath the Museum, near the Central Security office) that work to move the tram cars.

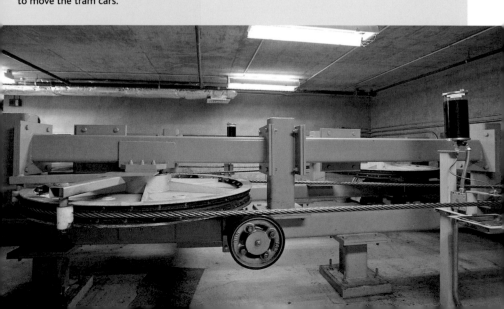

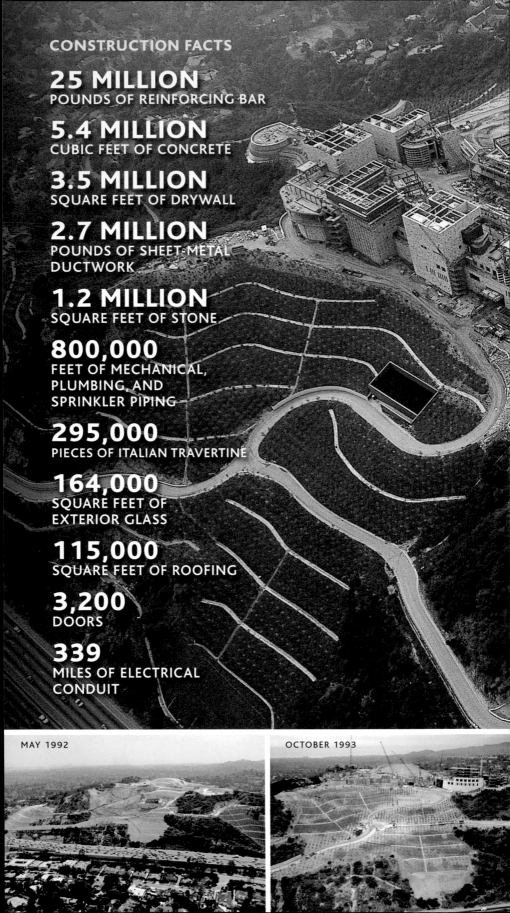

CONSTRUCTION FACTS

25 MILLION
POUNDS OF REINFORCING BAR

5.4 MILLION
CUBIC FEET OF CONCRETE

3.5 MILLION
SQUARE FEET OF DRYWALL

2.7 MILLION
POUNDS OF SHEET-METAL
DUCTWORK

1.2 MILLION
SQUARE FEET OF STONE

800,000
FEET OF MECHANICAL,
PLUMBING, AND
SPRINKLER PIPING

295,000
PIECES OF ITALIAN TRAVERTINE

164,000
SQUARE FEET OF
EXTERIOR GLASS

115,000
SQUARE FEET OF ROOFING

3,200
DOORS

339
MILES OF ELECTRICAL
CONDUIT

MAY 1992

OCTOBER 1993

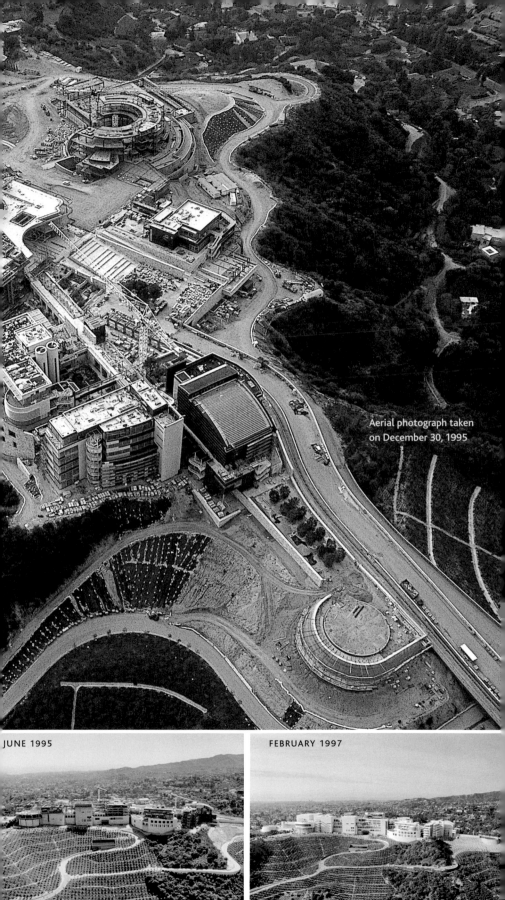

Aerial photograph taken
on December 30, 1995

JUNE 1995

FEBRUARY 1997

Alfred Galvan

Don Guzzi

Joe Deal

Ernest Lerma

Jay K. Choi

WORKERS' PORTRAITS

On any given day, there were six to seven hundred workers on-site (at peak construction, twelve hundred), pouring concrete, hauling steel, welding joints, and installing the mechanical and electrical systems. By project's end, the building of the Center had created over thirteen thousand construction-related jobs. These photographs of construction workers and artisans were taken by Bruce Bourassa, a Dinwiddie Construction Company foreman, on the Getty Center site.

Kevin M. O'Brien

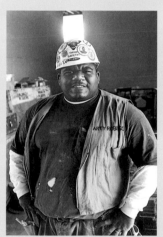

Edmundo Lopez

Chris Schienle

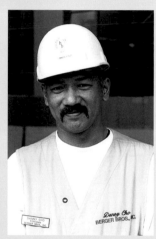

Will Anderson

Marty Robinson

Danny Cho

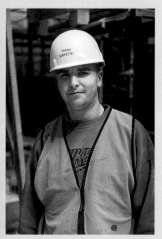

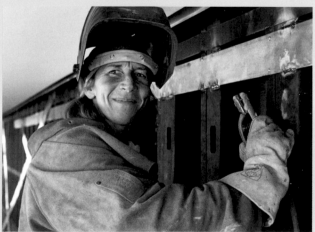

Robert Mendoza

Roxanne Klatt

THE CENTRAL GARDEN In 1992, as Getty administrators reviewed Meier's preliminary concept for the Central Garden, they concluded that they wanted something that was a work of art in its own right, rather than simply a backdrop for the architecture. This presented an opportunity to incorporate an additional aesthetic sensibility into the design of the Center—one that would

contrast with Meier's classic modernism, with its rigorously geometric forms—making the visitor's experience richer and more meaningful overall.

That goal led to the commissioning of a site-contextual piece by the artist Robert Irwin for the Central Garden. Not surprisingly, the tensions—creative or otherwise—between architect and artist were present throughout the planning and building stages. Over the next year, however, Irwin created a plan for the area that sprang from his response to the powerful, controlled geometries of the architecture and the site itself.

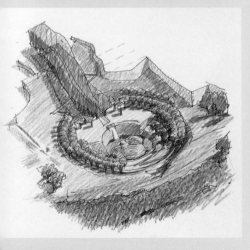

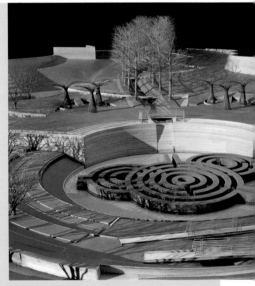

Irwin's plan for the Central Garden was rendered as a series of separate drawings to express the various components of the area (middle and bottom left). An early model (above) shows the azalea maze and overall terrain. Irwin also made a series of photo collages of plants and flowers (top left) that explored different ground-cover configurations and color and texture relationships.

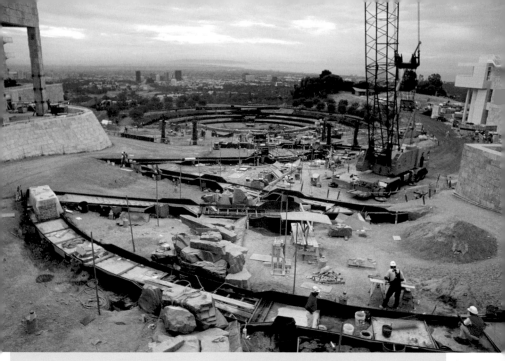

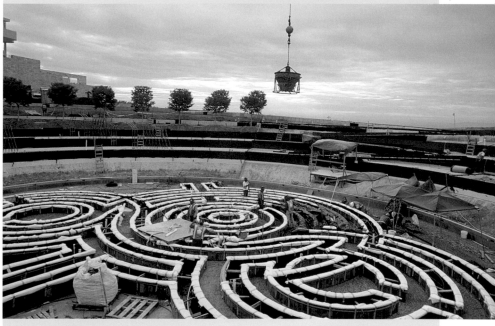

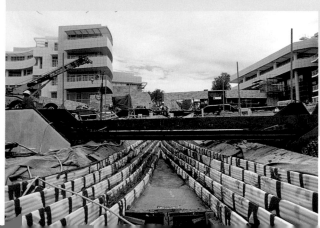

Construction views of the Central Garden walkway (top), floating azalea maze (middle), and streambed that passes under a bridge (bottom).

GALLERY INSTALLATION The staffs of the Museum and Research Institute did not move to the Center until 1997, a year after their colleagues. Much of that time was required for the transportation and installation of the artworks. The J. Paul Getty Museum at the Getty Villa officially closed on July 6, 1997, the upper-level galleries having closed in April of that year in order to transport many of the non-antiquities collections to the Getty Center. Art could not be installed at the Center until the Museum's galleries had been cleared of the destructive chemicals found in new construction materials. In December 1997, with the entire staff in place and the art in the galleries, the Museum was nearly ready to welcome its first visitors.

Gallery preparation included the advance planning of the installation aesthetics, such as selecting fabric and wall colors (above). Installation of the art took eight months.

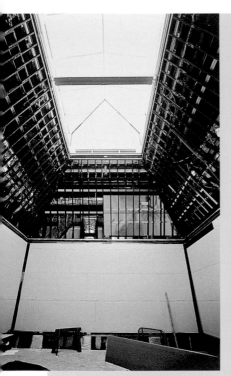

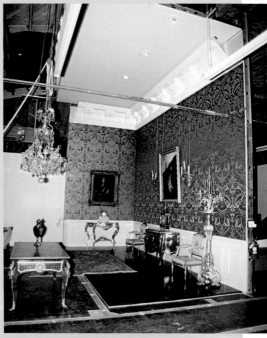

A paintings gallery under construction (above). The design of the Museum's French decorative arts galleries (right) was a critical issue debated early on by Meier and the curatorial staff. Eventually, the architect and interior designer Thierry Despont was brought in to design these specialized spaces.

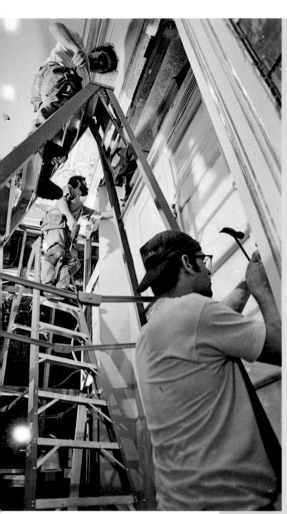

Workers (left and above) installing period paneling in the decorative arts galleries.

Moving the huge James Ensor painting *Christ's Entry into Brussels in 1889* from the Getty Villa (below) to the Getty Center in 1997.

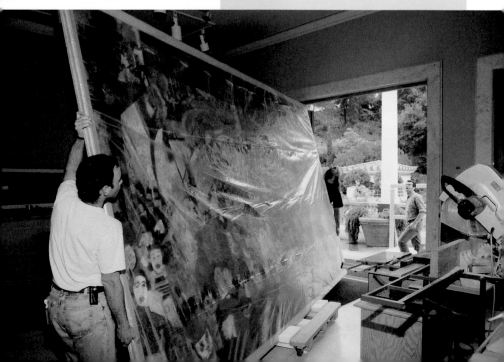

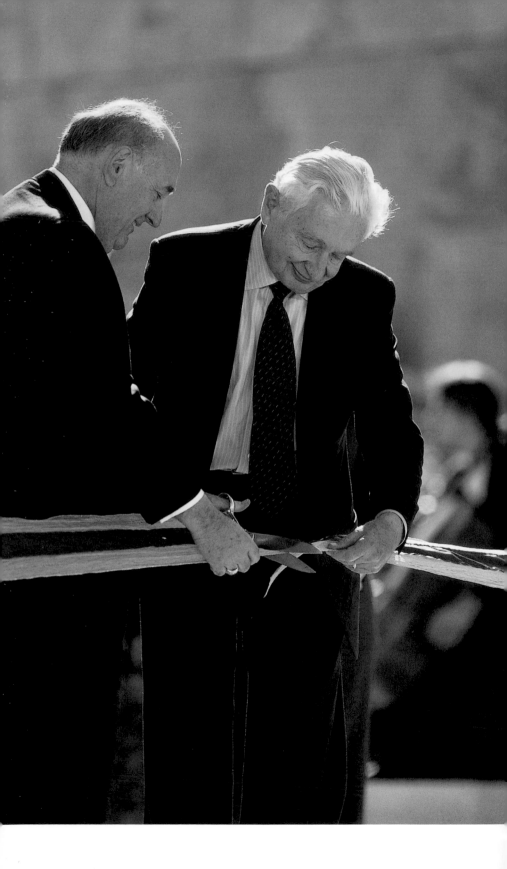

OPENING DAY The Getty Center officially opened to the public on December 16, 1997. Addressing the crowd of attendees at the dedication ceremony, Museum Director John Walsh said, "May this place give joy to you and your children and all the generations to come." Over 10,000 people arrived at the Getty Center on opening day.

Opening-week festivities included colorful giant puppets (inspired by the Getty Museum's painting *Christ's Entry into Brussels in 1889* by James Ensor) greeting visitors as they exited the tram, performances by the Crenshaw High School Elite Choir and the East L.A. band Los Lobos, and festive parties for neighbors, staff, and Trust leaders.

For everyone involved in planning and building the Getty Center and for all the employees of the Trust, the opening was a milestone to be celebrated. Fourteen years after the hilltop site was purchased, the Center was finally open. In its first week the Center received 47,514 visitors. By 2015, more than 20 million people had visited.

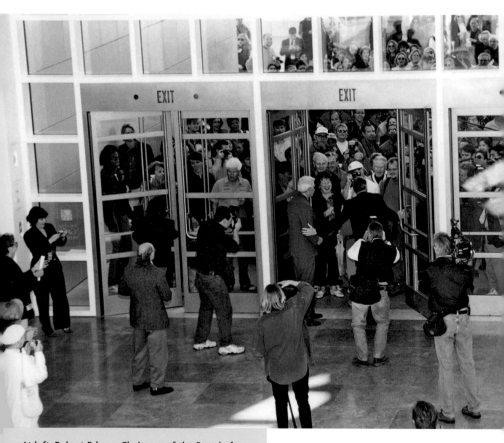

At left: Robert Erburu, Chairman of the Board of Trustees (left), and Harold Williams, Trust President and Chief Executive Officer (right), at the ribbon-cutting ceremony to inaugurate the opening of the Center. Above: Harold Williams (left) and Museum Director John Walsh (right) open the doors to greet the first public visitors to the Museum.

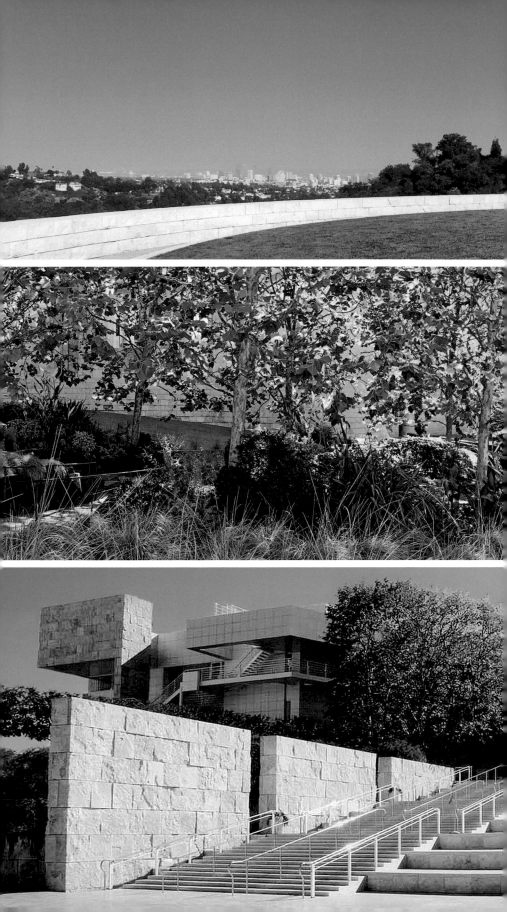

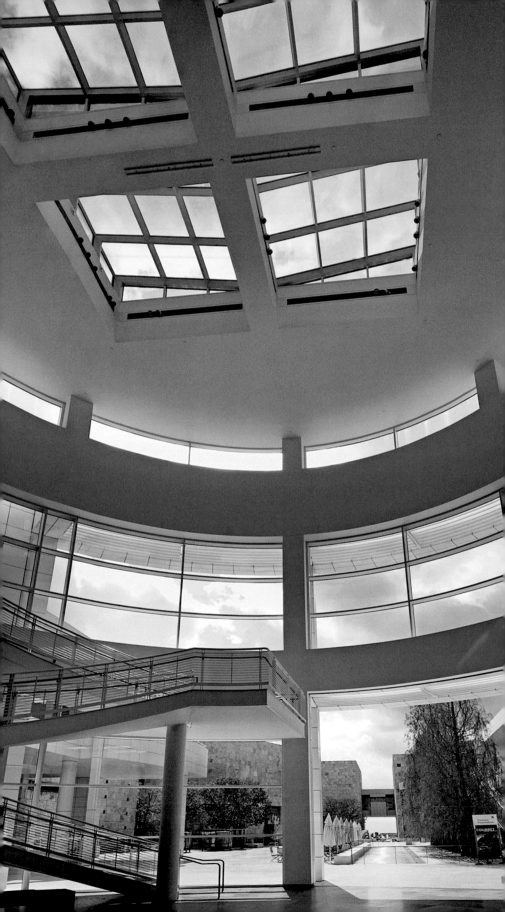

4 The J. Paul Getty Museum

FOUR LARGE TRAVERTINE-CLAD pavilions at the Getty Center house the Museum's permanent collection of European art from before 1900 and photographs and sculpture that date up to the present. Galleries for special exhibitions are on the upper floor of an additional pavilion. Visitors can walk from the Museum Entrance Hall directly to any of the pavilions. They are each two stories high and connect to one another by indoor and outdoor corridors that open up to sweeping vistas of Los Angeles. The galleries are organized by period and medium: a clockwise progression around the courtyard provides a chronological survey that begins in the thirteenth century and terminates in the nineteenth century (or, in the case of photographs, the twenty-first). Twentieth-century sculpture is placed throughout the site.

Paintings are exhibited in twenty galleries on the upper floors, where their viewing is enhanced by the natural lighting afforded by a complex system of louvered skylights. Illuminated manuscripts and drawings, which demand more carefully controlled lighting, are shown on the ground floors, as are decorative arts and most sculpture. Photographs are now displayed in the Center for Photographs, on the terrace level of the West Pavilion.

Despite Meier's staunchly modernist aesthetic, the galleries—which he designed with the participation of the New York architect and interior designer Thierry Despont—are traditionally proportioned rooms, supported by such classic elements as coved ceilings, colored walls, and wainscoting. Despont was also primarily responsible for the design of the fourteen decorative arts galleries, including four rooms with original eighteenth-century paneling.

The Museum Entrance Hall (left) at the Getty Center is a sixty-five-foot-high cylinder that evokes the rotundas in many classical buildings. It is highlighted by a dramatic spiraling staircase. Opposite the main doorway, a curved glass wall opens to reveal the Museum Courtyard and, around it, the separate pavilions that house the galleries. The Museum at the Getty Villa (above), inspired by an ancient Roman country house, now displays the antiquities collection.

ANTIQUITIES AT THE VILLA

The Museum's antiquities collection at the Getty Villa began with J. Paul Getty's purchase of a small terracotta sculpture at a Sotheby's auction in London in 1939. The thirty-seven years that passed between that acquisition and his last, the three-figure sculpture *Seated Orpheus with Two Sirens*, witnessed the formation of a collection of ancient Greek, Etruscan, and Roman art that continues to be one of the most important in the United States.

Initially, the collection's greatest strength was in sculpture, which formed the core of the collection when Getty was alive. Many of the Museum's most interesting examples of ancient sculpture were acquired under his personal direction. Since his death, the collection has grown considerably. The 1985 purchase of over 400 Greek vases and vase fragments from Walter and Molly Bareiss was a major addition. The accession of 300 objects from the Bronze Age to late antiquity from the collection of Lawrence and Barbara Fleischman in 1996 and more than 350 striking pieces of ancient glass from the collection of Erwin Oppenländer in 2003 substantially deepened the Museum's antiquities holdings. Recent acquisitions include rare first-century engraved gems and a second-century-A.D. marble head, now reunited with its body already in the Getty's collection.

The Temple of Herakles (right) was designed specifically to showcase the Lansdowne Herakles, which dates from the second century A.D.

Prehistoric objects (below), the oldest in the Museum's collection, were made by various cultures in the eastern Mediterranean and date from the Neolithic period to the end of the Bronze Age (ca. 6500–1000 B.C.).

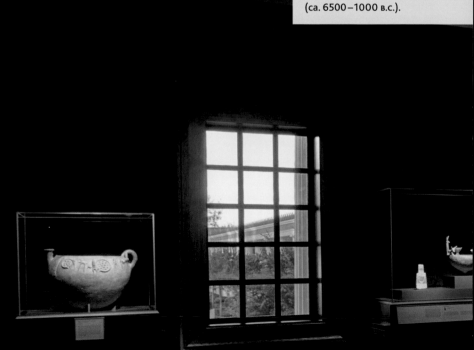

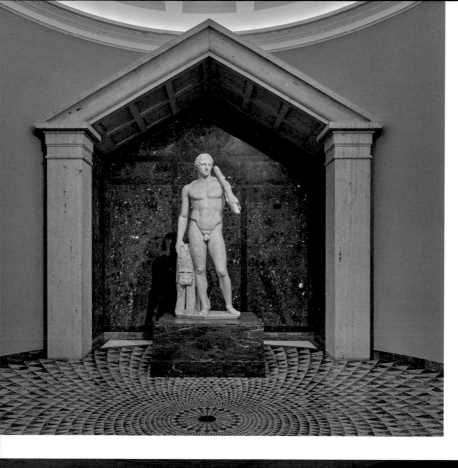

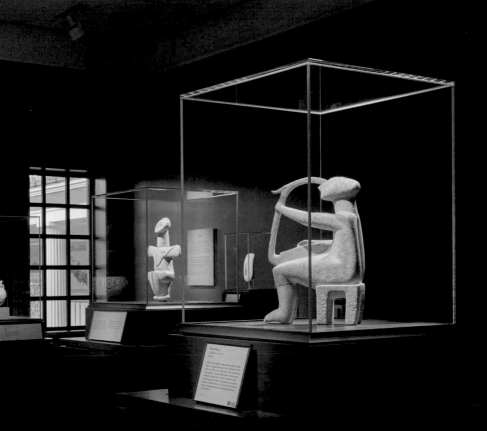

PAINTINGS

During his lifetime J. Paul Getty purchased paintings from every major European school of art between the fourteenth and twentieth centuries. He did not, however, consider himself a collector of paintings. His writings, especially his diaries, repeatedly name the decorative arts as his first love. Nevertheless, Getty began his painting and decorative arts collections at about the same time—during the 1930s. When he left the bulk of his estate to the Museum at his death in 1976, the opportunity presented itself to acquire major works on a wider scale. Since then, the Museum has added canvases from the seventeenth-century French and Dutch schools, the Impressionists and their successors, and eighteenth-century French painters, as well as small groups of important German and Spanish oils. Recent acquisitions include Édouard Manet's *Jeanne*, Rembrandt's self-portrait *Laughing Rembrandt*, and Orazio Gentileschi's Italian Baroque masterpiece *Danaë and the Shower of Gold*.

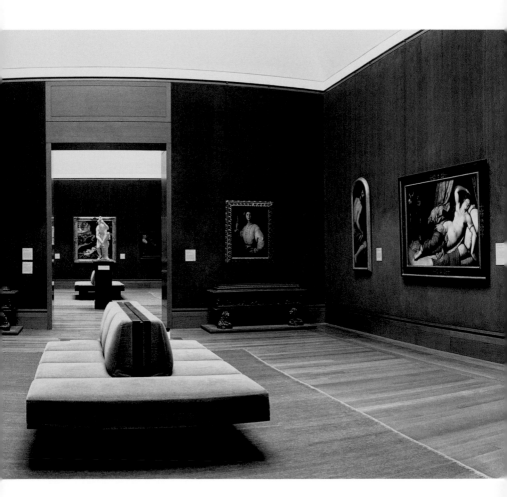

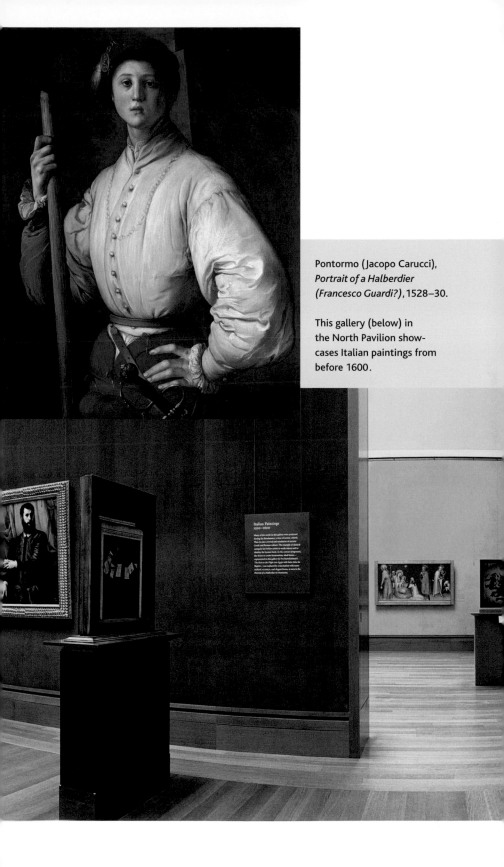

Pontormo (Jacopo Carucci),
*Portrait of a Halberdier
(Francesco Guardi?)*, 1528–30.

This gallery (below) in
the North Pavilion show-
cases Italian paintings from
before 1600.

IN THE GALLERIES

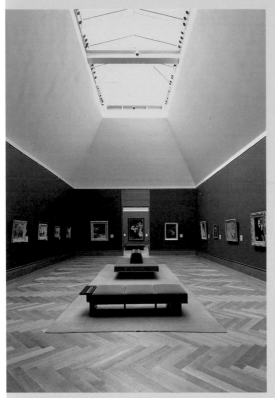

GALLERY SKYLIGHTS

The skylights were built with computer-controlled louvers, which adjust to the position of the sun during the course of the day, ensuring optimum levels in the light's quality and intensity. There are also special filters to prevent damage to the artworks. Artificial lights are activated in late afternoon to maintain consistent illumination levels in the galleries after the sun has begun to set.

FRAMES HAVE STORIES TOO

The way a work of art is framed is an important part of the presentation and aesthetic experience. Frames and paintings must be matched to appropriate styles and periods. Antique frames are often purchased for this purpose. Some frames have been restored and some portions re-created based on historical reference material.

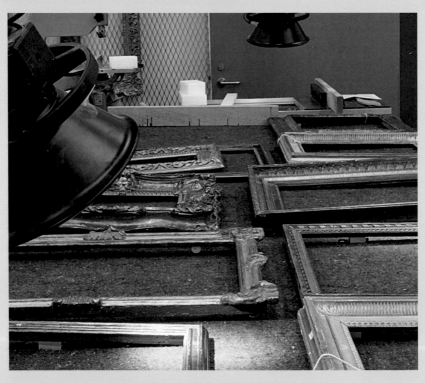

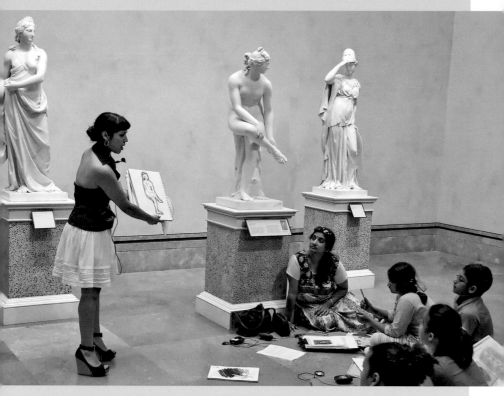

SKETCHING IN THE GALLERIES
Visitors of all ages sketch from artworks in the Museum's collection.

SECURITY OFFICERS SPEAK MANY LANGUAGES
The security officers at the Museum collectively speak more than thirty different languages, including Bulgarian, Hindi, Ilocano, Farsi, Urdu, and Kiswahili.

SCULPTURE AND DECORATIVE ARTS

The sculpture and decorative arts collections were unified as a single department in 2004. J. Paul Getty began acquiring eighteenth-century French decorative arts in the 1930s, and today the objects made between 1650 and 1800 count among the Museum's finest. Included in this assemblage are furniture, silver, ceramics, textiles, clocks, and objects in gilt bronze. The seventeenth-century Borghese-Windsor cabinet, of ebony with sumptuous stone inlay, is a recent acquisition. The European sculpture collection, formed in 1984, comprises works from the fifteenth through the nineteenth centuries in a wide range of media. Renaissance and Baroque bronze, French eighteenth-century terracotta and marble, and British Neoclassical marble sculpture predominate. New acquisitions include bronze sculptures by French artists Camille Claudel and Auguste Rodin. The Fran and Ray Stark Sculpture Collection, with twenty-eight twentieth-century works, joined the department's holdings in 2005.

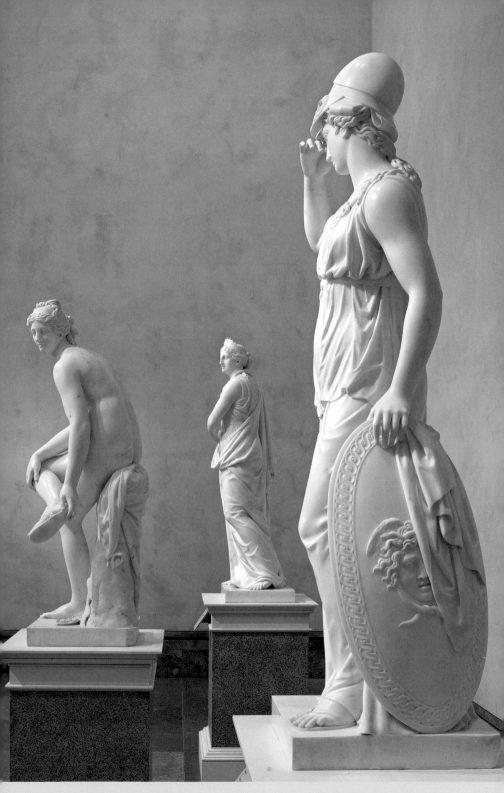

The above trio of marble Neoclassical goddesses represent Juno, Minerva, and Venus. Although the figures have a cool remoteness, a powerful narrative engagement animates the group. Opposite is a detail of a bronze sculpture depicting the goddess Venus by followers of Jacopo Sansovino, ca. 1550.

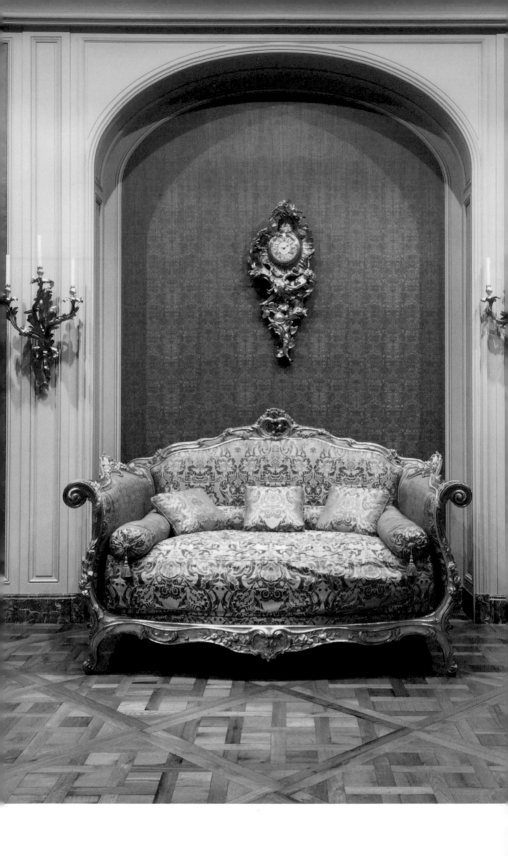

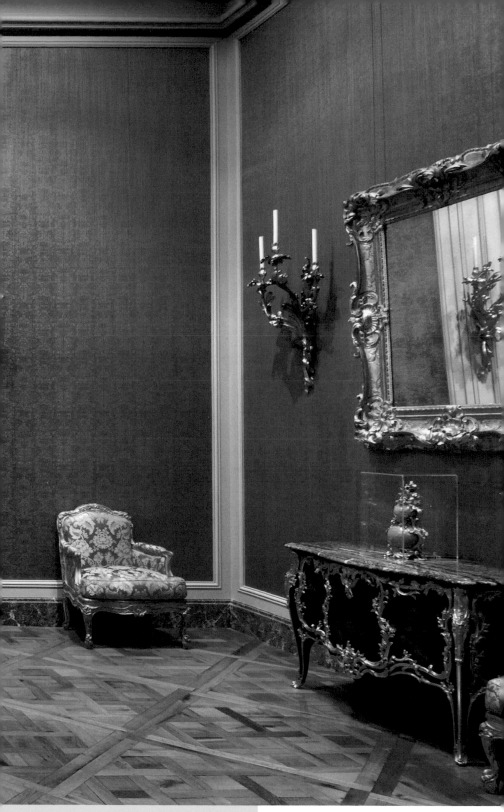

This period room in the South Pavilion contains decorative arts from eighteenth-century France, including a wall clock, Turkish-style bed, mirror, commode, and wall lights.

A CLOSER LOOK

Looking closely at works of art can yield wonderful treasures, such as an artist's signature or thumbprint, a hidden compartment, or a tiny painting.

This painting bears the distinctive signature of the French Impressionist painter Claude Monet.

The base of this ceramic bowl contains impressions of its maker's fingers.

Cabinets often have secret doors or drawers, which are usually not opened while works are being exhibited. These features are valuable to scholars, conservators, and researchers because they reveal what the original colors looked like, since the exterior may have faded due to centuries of exposure to light.

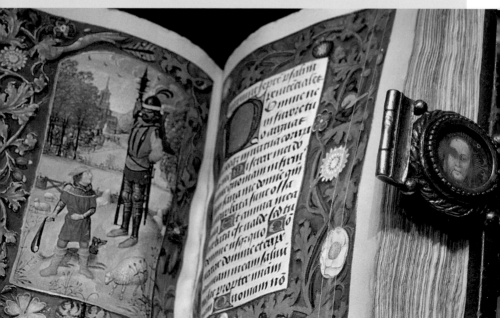

The clasp of this medieval prayer book holds a small round portrait.

DRAWINGS

The Museum began its collection of drawings in July 1981 with the purchase of Rembrandt's red-chalk study *Nude Woman with a Snake*. A year later, the Department of Drawings was formed. The purpose of the collection is to assemble the different schools of western European drawing and to illustrate

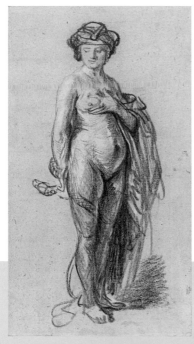

the many varied techniques and styles achieved in the medium. Recent acquisitions include Michelangelo's *Study of a Mourning Woman*, a pen-and-ink drawing dating to 1500–1505, and George Seurat's dramatic, black Conté crayon portrait entitled *Madame Seurat, the Artist's Mother* of 1882.

As drawings are sensitive to light and may deteriorate after prolonged exposure, they cannot be exhibited for an extended period. Those on display at a given time are selections brought together to illustrate a common theme or a particular period within the history of art.

Rembrandt van Rijn, *Nude Woman with a Snake* (left), ca. 1637.

Paul Cézanne, *Still Life* (right), ca. 1900, shown informally in a storeroom.

A view of the drawings galleries, located in the Museum's West Pavilion.

MANUSCRIPTS

The artistic impulses of medieval and Renaissance painters often found their purest expression in the pages of manuscripts, books written and decorated entirely by hand. In 1983, the Museum initiated its collection with the purchase of the holdings of Dr. Peter and Irene Ludwig of Aachen, Germany. Hundreds of acquisitions since 1984 include entire codices as well as cuttings or groups of leaves from individual books.

The Getty's manuscript collection comprises masterpieces of illumination spanning the ninth to the sixteenth century from Europe and the eastern Mediterranean. Recent acquisitions include a rare sixteenth-century Flemish manuscript recounting the tales of a celebrated knight, and the magnificent Rothschild Pentateuch, a spectacular thirteenth-century illuminated Hebrew Bible. Created by an unknown artist, the pages of the Rothschild Pentateuch are filled with lively decorative motifs, hybrid animals, humanoid figures, and virtuosic displays of tiny, elaborate calligraphy.

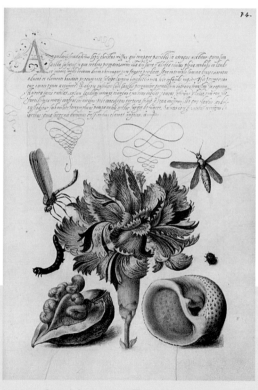

A researcher examines Martín de Murúa's *Historia general del Pirú* (1616) (above). Illuminated manuscripts—some created more than a thousand years ago—require special lighting when exhibited to preserve their delicate contents (left).

Joris Hoefnagel, from *Mira calligraphiae monumenta*, ca. 1591–96.

PHOTOGRAPHS

In 1984, the Museum established a new curatorial department dedicated to the art of photography, simultaneously acquiring the collections of Samuel Wagstaff Jr., Arnold Crane, Bruno Bischofberger, André Jammes, and Volker Kahmen/George Heusch. These holdings, along with other key acquisitions, established the Getty as having one of the foremost collections of photographs, with works from the dawn of the medium to the present. International in scope, major photographers from the United States, Asia, Africa, Europe, and South America are represented. Recent acquisitions include work by Diane Arbus, Garry Winogrand, Graciela Iturbide, Paul Shambroom, and Seung Woo Back. In 2011, the Getty and LACMA jointly acquired the archive of Robert Mapplethorpe, bringing 2,000 works by the artist to the Museum's collection.

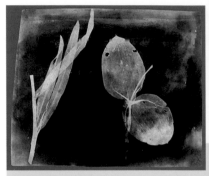

William Henry Fox Talbot, *Leaves of Orchidea*, 1839.

The Center for Photographs opened in 2006 in the Museum's West Pavilion. With seven thousand square feet of display space in its galleries, it is one of the largest venues devoted to photography in North America.

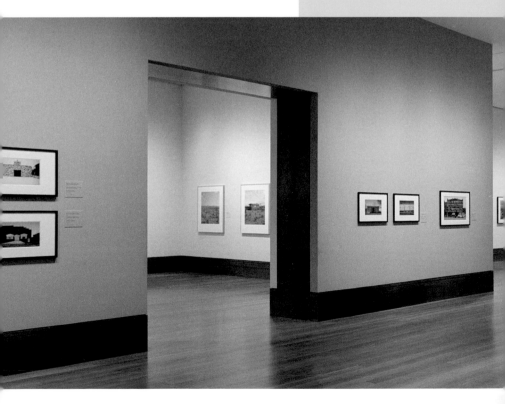

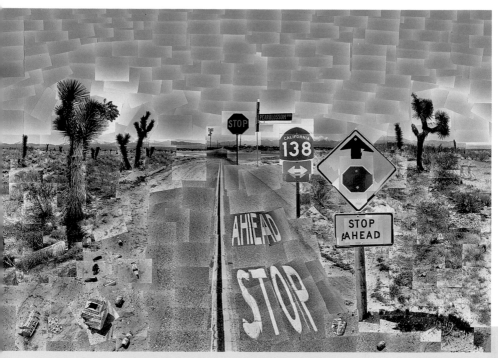

David Hockney, *Pearblossom Hwy., 11–18th April 1986, #2*, 1986.

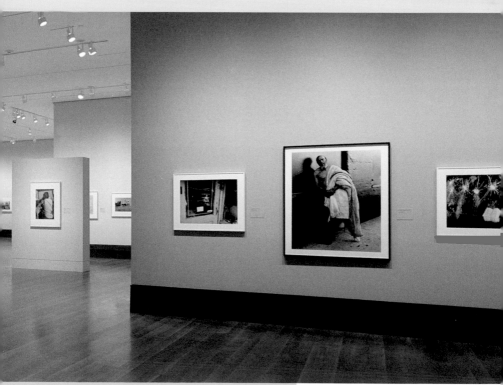

Where We Live: Photographs of America from the Berman Collection, which opened on October 24, 2006, was the first exhibition in the Center for Photographs.

BEHIND THE SCENES AT THE MUSEUM

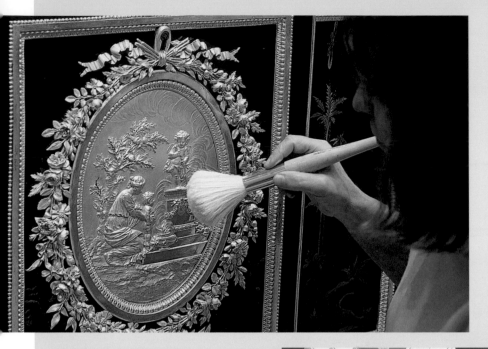

DUSTING EVERY WEEK

Every object on display in the Museum is dusted once a week when the galleries are closed. Special care must be taken not to scratch or abrade any surfaces during cleaning. Special brushes and other tools are used.

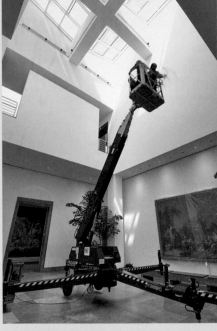

FIRM SUPPORT

In many instances the cushions of chairs are replaced with a block of foam to give the upholstered fabric a firm shape. The seats, therefore, may not be as comfortable as they look.

COMPLEX HOUSEKEEPING

Special equipment is brought into the galleries to access difficult-to-reach spaces. The painting in the photograph is covered with plastic to protect it while staff members touch up paint in the upper atrium.

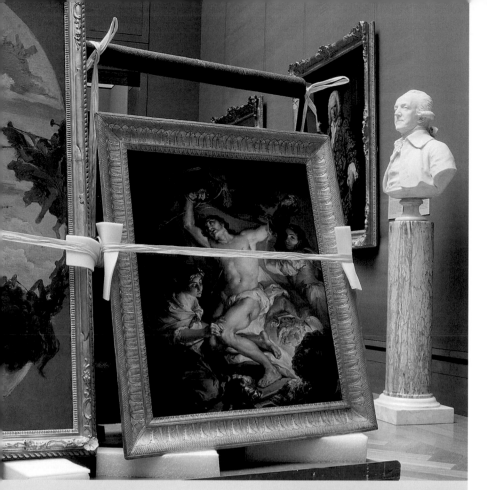

ALWAYS PROTECTED

Works of art must always be protected, not just when they're secured to the wall but during transportation, installation, and storage as well. Paintings being moved through the galleries are strapped to a cart (above), and a table in storage (right) is secured to a platform that has cushioned pads to absorb the vertical movement of an earthquake.

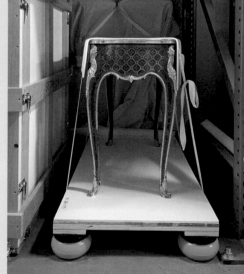

VAULTS FOR STORAGE

The Museum has more than twelve thousand square feet of storage space for paintings, sculpture, decorative arts, and works on paper.

MUSEUM CONSERVATION LABORATORIES

Conservation is central to the Museum's mission. The four conservation departments—paintings, sculpture and decorative arts, paper, and antiquities—occupy specially equipped studios at both the Center and the Villa. Staff conservators combine the most current scientific information about materials with extensive knowledge of and proficiency in centuries-old art-making techniques and processes. Museum conservators work in concert with the Getty Conservation Institute's Science Department, which conducts scientific analysis of works from the collection and studies technology and materials.

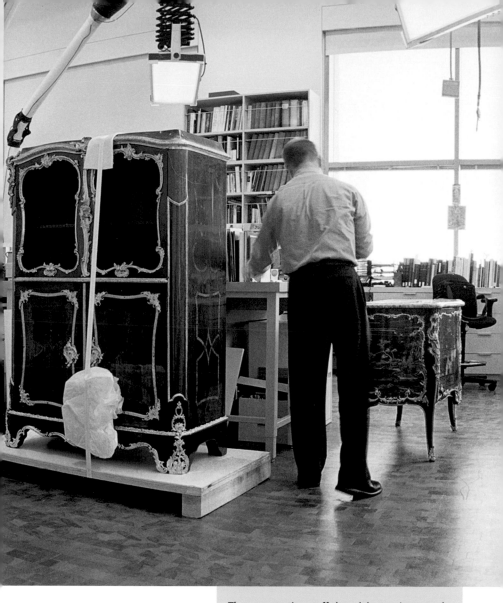

Conservation also entails employing important preventive measures. These include climate control and environmental monitoring, design of mounts and display cases, pest

The conservation staffs have laboratories to work on treatments for the objects in the Museum collection and in collaboration with other institutions. Analyzing materials, stabilizing, cleaning, and restoring are all activities undertaken before a work can be exhibited. Here, in the decorative arts conservation lab, a conservator prepares to work on an eighteenth-century French cabinet in the Museum's collection.

management, and improving storage, packing, and shipping methods. Mitigating the effects of earthquakes is a particular challenge in California, and the Museum is recognized around the world for the solutions it has developed and published to address this problem.

CONSERVING WORKS OF ART

Conservators are like doctors for works of art. They wear gloves, often use cutting-edge technology to determine treatment, and have been known to bring a "patient" back to life. For Museum conservators, this might be a magnificent painting, a rare cabinet, a priceless silver bowl, or a delicate illuminated manuscript. Conservators support the Museum's efforts to preserve works of art for the enjoyment and education of future generations.

A scientist studies a material sample through a laser ablation ICPMS (inductively coupled plasma mass spectrometer) in the Getty Conservation Institute lab at the Getty Villa.

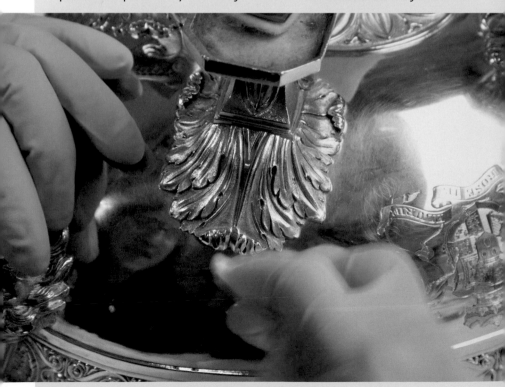

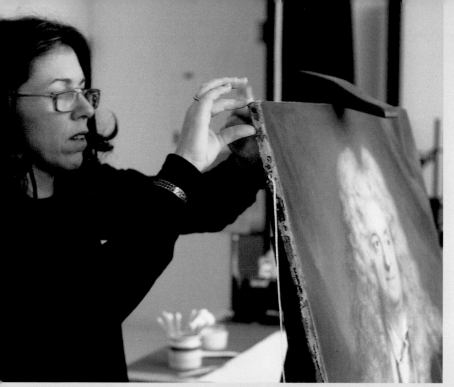

A museum conservator repairs edge tears to a pastel, Joseph Vivien's *Portrait of a Man*.

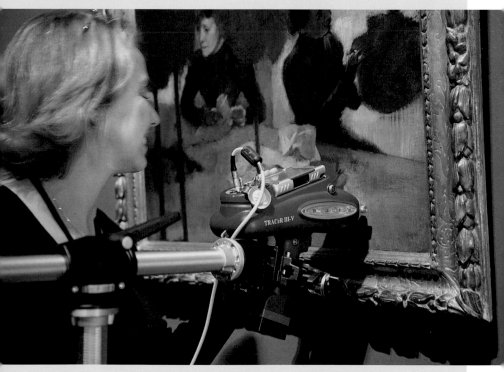

A Conservation Institute scientist examines Edgar Degas's painting *The Milliners* with the aid of an X-ray fluorescence spectrometer, used to identify the chemical elements found in the paint.

A conservation intern cleans a silver tureen in the Museum's decorative arts collection.

EDUCATION

Educational programming at the J. Paul Getty Museum embodies the principle that if visitors know more about works of art, they can more deeply enjoy them and relate the works to their own experiences. The Museum's Education Department offers a range of programs for families, students, teachers, arts professionals, and general visitors. The Education Department recently launched two new internship programs for teens: the Getty Teen Docent Program and the Getty Teen Lab.

The Museum contains dedicated spaces and resources at both the Center and the Villa for educational opportunities. Daily talks, artist-run workshops and demonstrations, tours of the architecture and gardens, and lectures on the collection and special exhibitions provide engaging ways for visitors of all ages to learn about art. At the Center, the Family Room offers innovative activities, while the Villa's Family Forum encourages young and old alike to explore ancient art.

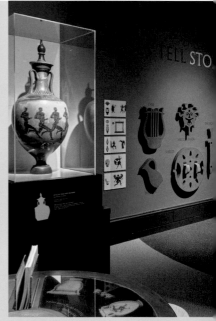

At left: A school group at the Center engages in an activity inspired by Georges de La Tour's painting *The Musicians' Brawl*. At right: The Villa's Family Forum provides a fun, hands-on space for families to learn more about antiquities.

PUBLICATIONS

Furthering J. Paul Getty's wish to promote "the diffusion of artistic and general knowledge," the Museum also publishes, on average, thirty books each year, ranging from exhibition catalogues and children's titles to scholarly

publications and reference volumes. The Publications Department oversees the editing, design, production, marketing, sales, and distribution of Getty books.

Getty Publications produces a wide range of books on many topics for audiences of all the Getty programs (below). Books print domestically and internationally, depending on the budget, schedule, and quality required of each project. A series of special silk-screened volumes were printed in India (at left).

SPECIAL EXHIBITIONS AT THE GETTY

Both the Getty Center and the Getty Villa host numerous temporary exhibitions that complement the Museum's collection areas and those of the Research Institute as well as the work of the Conservation Institute. At the Center, the seven-thousand-square-foot Exhibitions Pavilion has housed all manner of art media and epochs, including rarely seen medieval icons from Sinai, large-scale contemporary video pieces by Bill Viola, Flemish illuminated manuscripts of the Renaissance, the late religious portraits of Rembrandt, works from the heralded exhibition *Pacific Standard Time, Los Angeles Art 1945–1980*, and luxury arts from the Ancient Americas. Since the Villa's reopening in 2006, galleries for changing exhibitions have featured Athenian vases, antique glass objects, and a collection of Ancient Roman mosaics assembled from across its vast empire. Special exhibitions at the Getty allow the Museum to collaborate with institutions around the world and tell a more complex narrative about the history of art.

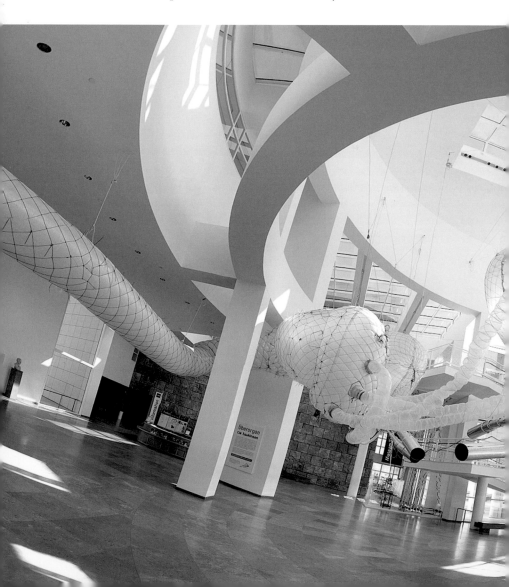

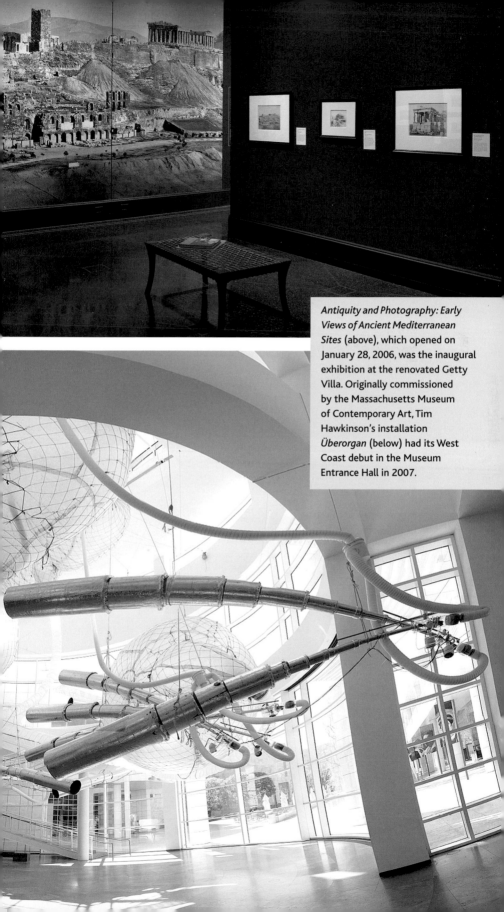

Antiquity and Photography: Early Views of Ancient Mediterranean Sites (above), which opened on January 28, 2006, was the inaugural exhibition at the renovated Getty Villa. Originally commissioned by the Massachusetts Museum of Contemporary Art, Tim Hawkinson's installation *Überorgan* (below) had its West Coast debut in the Museum Entrance Hall in 2007.

Devices of Wonder: From the World in a Box to Images on a Screen (opposite top), a 2001 collaboration between the Museum and the Research Institute shown in the Center's Exhibitions Pavilion, featured over four hundred objects from the 1600s to the present. *The Colors of Clay: Special Techniques in Athenian Vases* (opposite bottom) at the Getty Villa in 2006 presented exquisitely potted vases. *Holy Image, Hallowed Ground: Icons from Sinai* (above) showcased rarely seen Byzantine icons from the Holy Monastery of Saint Catherine in Egypt. The exhibition was on view in the Exhibitions Pavilion from November 2006 through March 2007. At middle, a Getty ceremony for the Triumph of the Orthodoxy and below, a blessing led by monks from the monastery.

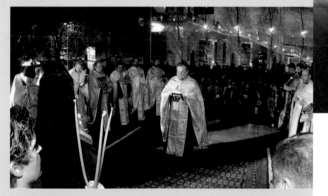

PLANNING AND INSTALLING AN EXHIBITION

Putting on an exhibition calls upon the expertise of virtually every department in the Museum.

The initial idea for an exhibition usually comes from a curator, who chooses which works of art will be shown. If works are being borrowed from other institutions, loan request letters are sent out. Approximately a year and a half before an exhibition opens, a team is assembled, consisting of members from numerous departments: curatorial, design, registrarial, preparations, conservation, education, publications, communications, museum store, security, exhibitions, and other content experts for interactive and digital platforms. In the months leading up to the exhibition, loans for works of art are finalized; the design of the exhibition is decided upon; didactic texts and labels are written and edited; a catalogue is produced; conservation work, if necessary, is undertaken; opening and press events are organized; and, finally, the artworks are received and installed in the galleries. Through this collaborative and creative ferment an exhibition comes together.

The following sequence of pictures focuses on the 2006 exhibition *Rubens and Brueghel: A Working Friendship*, held at the J. Paul Getty Museum at the Getty Center and organized in partnership with the Royal Picture Gallery Mauritshuis, The Hague. The show explored the collaboration between two seventeenth-century Flemish painters, Peter Paul Rubens and Jan Brueghel the Elder.

EXHIBITION PLANNING

Planning for an exhibition can begin many years in advance of the opening. As that date approaches, staff teams meet often to review schedules, budgets, logistics, and any special requirements. Meetings are also convened to review exhibition plans, graphics, and promotional and educational components. A miniature mock-up (third from top) of the show helps to visualize the placement of works.

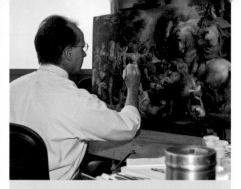

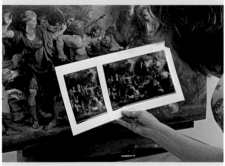

DOCUMENTING WORKS OF ART

After any required conservation is completed on a Getty object or, under special circumstances, a loaned object, the artwork is then digitally documented. Prints are created and compared to the original work to ensure the best possible color match. These images can be used in publications or marketing materials related to the exhibition.

CONSTRUCTION

For major loan shows such as *Rubens and Brueghel*, paintings are sent from all over the world in special crates. The works of art are then unloaded, inspected, and recorded by the Registrar's Office. Once the design and installation plans are approved, the in-house construction staff begins to build cases, employ special mounting devices, and select options for covering display surfaces.

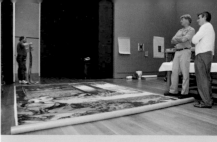

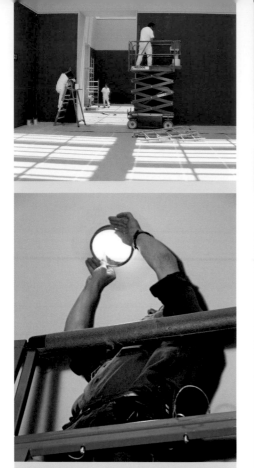

GALLERY PREPARATION

Gallery spaces are customized for each exhibition, including building and painting walls, setting up lighting, and installing cases. All this must be completed before any works of art are allowed into the galleries, to ensure against damage.

INSTALLING GRAPHICS

In the galleries the photo murals, didactic texts, and labels are installed, all having been written in the respective curatorial departments, designed in the Museum's Exhibition Design Department, and vetted by the Museum's education and editorial staffs.

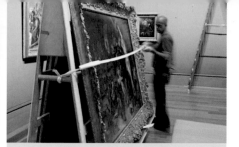

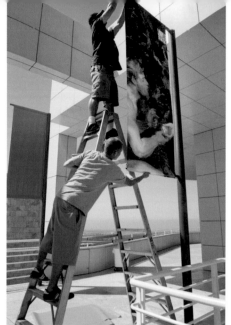

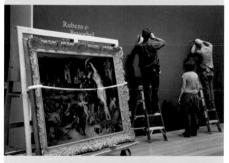

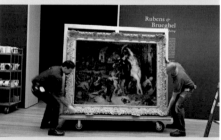

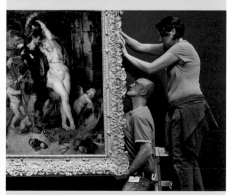

MOUNTING WORKS OF ART

Works of art are secured to dollies and moved to the exhibition gallery. Large elevators are used to move oversize works. The staff preparators are trained to handle and install the works with the care that priceless objects deserve.

PROMOTION

Outdoor signage announces the show to visitors and directs them to the galleries. Street banners are also hung around the city to promote special exhibitions.

PUBLIC PROGRAMS

Day and night, there is usually something going on at both the Getty Center and Getty Villa. The two campuses offer numerous public programs, including tours and gallery talks, lectures and conferences, courses and demonstrations, family and school activities, and readings and book signings. The Center's busy programming schedule includes the summer concert series Off the 405 along with exceptional film, music, dance, theater, and spoken word events such as Selected Shorts, with noted actors reading classic and new short fiction, and Gordon Getty Concerts, which showcase world-class musicians in performances that complement exhibitions at the Center. At the Villa, musical and dramatic performances related to the ancient world are held in the Auditorium or the Fleischman Theater. Recent productions have included modern interpretations of such Greek classics as Aeschylus's *Oresteia*, Aristophenes's *The Birds*, and Euripides's *The Bacchae* and *Hippolytos*.

A 2005 Selected Shorts performance (above) at the Harold M. Williams Auditorium at the Getty Center featured (left to right) Alec Baldwin, Steven Gilborn, Dawn Akemi Saito, and Michael York. At the podium is Isaiah Sheffer, director and host of Selected Shorts. Euripides's Greek tragedy *Hippolytos* (right) inaugurated the Getty Villa's Fleischman Theater in September 2006.

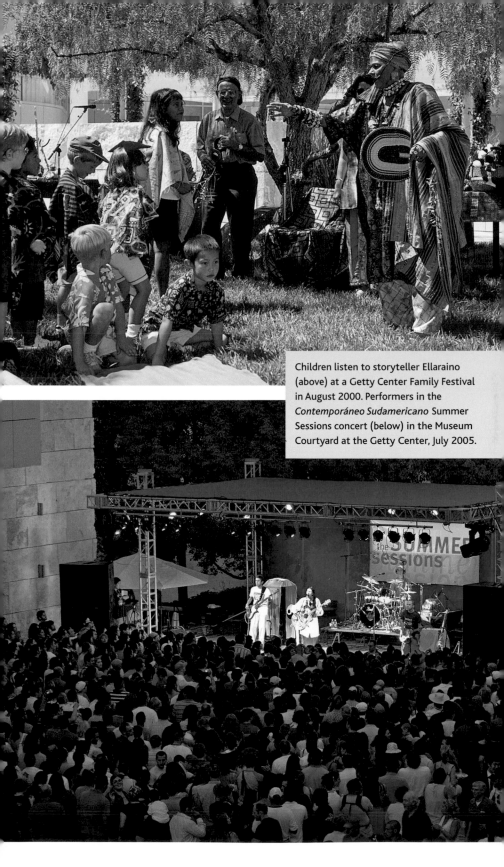

Children listen to storyteller Ellaraino (above) at a Getty Center Family Festival in August 2000. Performers in the *Contemporáneo Sudamericano* Summer Sessions concert (below) in the Museum Courtyard at the Getty Center, July 2005.

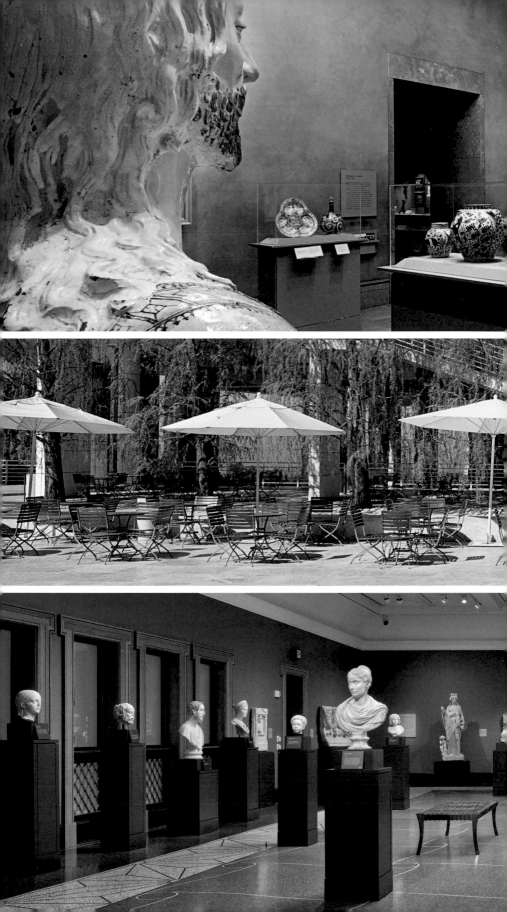

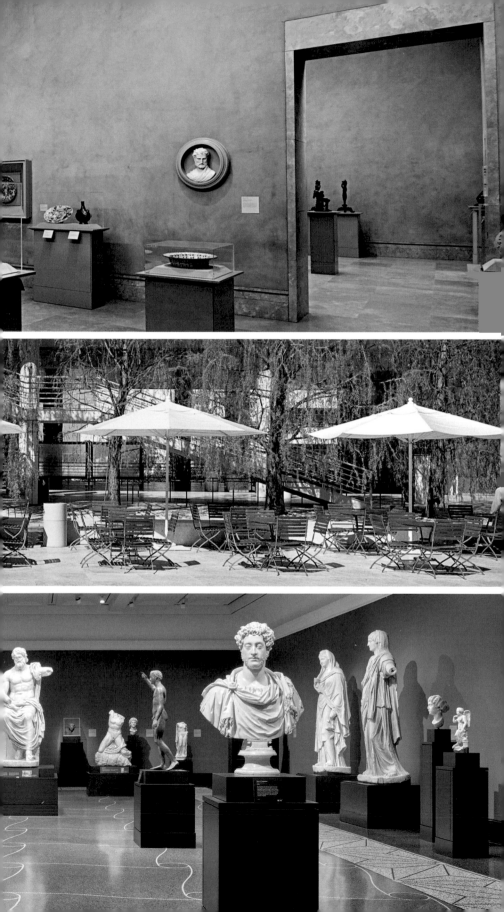

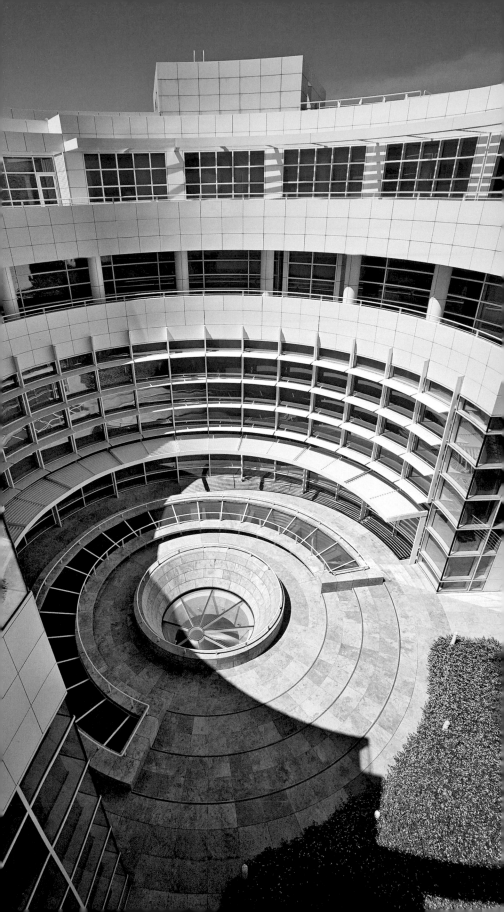

5 The Getty Research Institute

DEDICATED TO STUDYING THE VISUAL
arts in broad historical and cultural contexts, the Getty Research Institute
provides a unique setting for scholarly investigation and debate. The Research
Institute's foundation lies in the special collections of original documents and
objects from the Renaissance to the present, held in its vast library.

The Research Institute's international residential scholar program each year
brings together some of the best minds from all disciplines, including creative
artists, to address and debate themes of particular urgency. Publications, both
print and electronic, disseminate the work of the Institute and foster innova-
tive research wherever it is found. Exhibitions, conferences, workshops, and
lectures give compelling expression to inventive scholarship and thought.

The circular Research Institute building occupies 201,000 square feet
arranged on five levels and houses the library, meeting facilities, an exhibi-
tion gallery, lecture hall, and offices for over two hundred scholars and staff.
Its flexible design encourages an open exchange of ideas and discoveries.

THE RESEARCH LIBRARY

The Research Library at the Getty Research Institute is one of the largest
art libraries in the world. It focuses on the history of art, architecture, and
archaeology, with relevant materials in the humanities and social sciences.
The general library collections (secondary sources) include more than one
million books, periodicals, and auction catalogs. The range of the collections
begins with prehistory and extends to contemporary art.

The Photo Study Collection contains approximately two million photo-
graphs of art and architecture from the ancient world through the twentieth
century. The Research Institute's online databases provide essential resources
for scholars, librarians, and museum professionals all over the world. The
Research Library also contains the Getty's Institutional Archives, which doc-
ument the Getty's founding and development.

At the Getty Villa, the Research Library is a twenty-thousand-volume-
capacity annex, housed in the Ranch House, where scholars can conduct
research related to Greek and Roman culture and history.

A view of the Research Institute's oculus,
which admits sunlight into the lower level
and is the building's geographical center.

SPECIAL COLLECTIONS

The library's special collections contain rare books and unique materials such as personal papers, journals, letters, sketchbooks, and other archival documents. Artists' papers and archives include a volume of drawings by the fifteenth-century artist Francesco di Giorgio Martini; a bound album of drawings made in Italy by the great French Neoclassical painter Jacques-Louis David, selected and pasted in by the artist; and the first full draft of *Noa Noa* by Paul Gauguin, written in 1893, during his stay in Tahiti.

The twentieth century is especially well represented, with archives of major figures in Dada, Surrealism, Futurism, and other avant-garde movements from early in the century, as well as important materials on Fluxus, Conceptual Art, Minimalism, and related developments in the postwar period. The collection of video art, which includes the most extensive holding of such works produced in Southern California, is one of the largest in the world. There are also more than six thousand contemporary artists' books.

Modern architecture is another strength. There are sketches, notes, and unpublished manuscripts by Le Corbusier and others associated with the Bauhaus; drawings by Frank Gehry for Los Angeles's Walt Disney Concert Hall; and over 260,000 negatives, prints, transparencies, and related materials from the archive of Julius Shulman, who photographed modern architecture in postwar Southern California.

Inventories and catalogues of private collections and museums and the archives of collectors, dealers, and galleries shed light on the business of art and the history of collecting. The library holds the papers of the late Marcia Tucker, founding director of New York's New Museum of Contemporary Art;

Giovanni Battista Piranesi, *Veduta del prospetto principale della Colonna Trajana* (detail), etching in *Trofeo o sia magnifica colonna coclide di marmo composta di grossi macigni ove si veggono scopite le due guerre daciche fatte da Traiano...* (Rome, 1774–79). 90-B22638

Marcel Duchamp, *Boîte en valise*, 1958, mixed media. Jean Brown papers, 890164

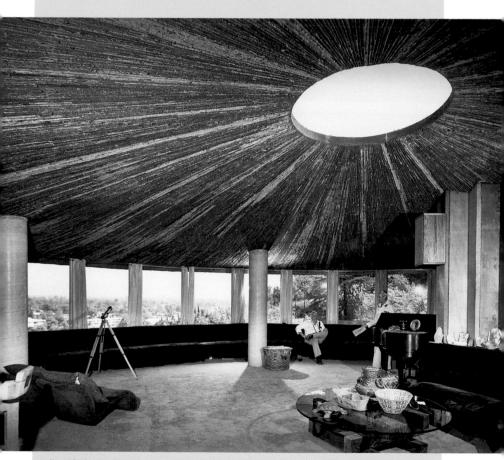

Julius Shulman, *Zimmerman House by John Lautner, Studio City, California* (1968), photographed 1980, gelatin silver print. Julius Shulman photography archive, 2004.R.10

Bernard Picart, *Convoi funebre d'un grand de la Chine*, etching in *Ceremonies et coutumes religieuses de tous les peuples du monde* (Amsterdam, 1729). 1387-555

Francesco di Giorgio Martini, *Construction Machines*, ca. 1475–ca. 1480, brown ink and wash. In manuscript *Edificij et machine*, fol. 27. 870439

Jackie Matisse Monnier, *Underwater Kite, Nassau, Bahamas*, for *Sea Tails*, 1983. Jackie Matisse Collection. Photograph © Robert Cassoly. David Tudor papers, 980039

Coop Himmelb(l)au, *Model #15 (Rehak House, Malibu, California)*, 1990–ca. 1995, foam core, paper, wire, and photographic Mylar mounted on Plexiglas sheet inside case. 2002.M.2

invoices and ledger and stock books from Duveen Brothers, among the most important dealers in the world for much of the twentieth century; and the archives of Count Giuseppe Panza, whose collections provided a foundation for the Museum of Contemporary Art, Los Angeles.

There are rare books, manuscripts, and archives from influential scholars such as Johann Joachim Winckelmann who helped shape the discipline of art history; Nikolaus Pevsner, a pioneer in the field of architectural history; and twentieth-century critics Clement Greenberg and Harold Rosenberg.

The special collections also include travel guides, photographs of archaeological monuments and international expositions, and historic maps of important cities. More recent acquisitions focus on works related to the art and architecture of Southern California that reveal Los Angeles's significant role in the postwar era.

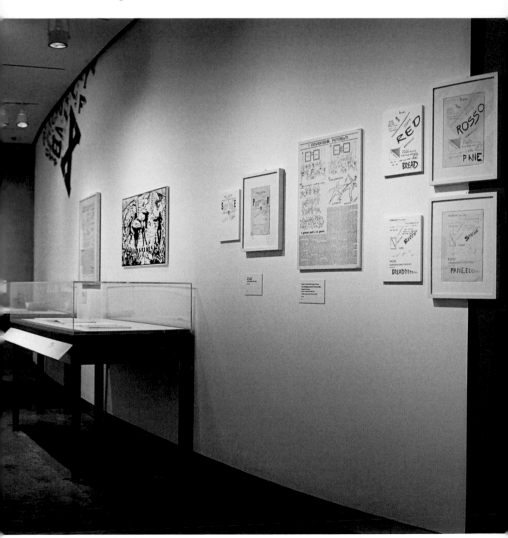

EXHIBITIONS

Exhibitions at the Research Institute are designed to showcase the rare and unique materials in the Research Library's collections. These presentations provide a pathway into, and represent all periods in, the collections—from classical to contemporary—with an eye toward critical analysis and reinterpretation. Curators include Institute staff and outside scholars and artists.

The exhibitions are displayed in the gallery on the Plaza Level of the Research Institute as well as online. Exhibitions are occasionally developed by Research Institute staff for the major temporary exhibition spaces at the J. Paul Getty Museum at the Center and Villa.

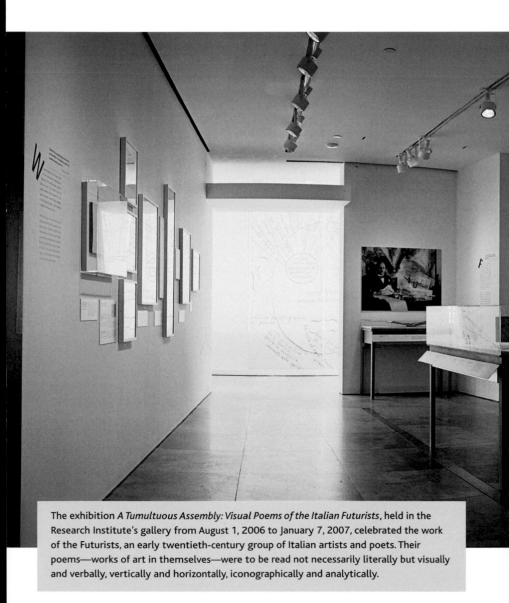

The exhibition *A Tumultuous Assembly: Visual Poems of the Italian Futurists*, held in the Research Institute's gallery from August 1, 2006 to January 7, 2007, celebrated the work of the Futurists, an early twentieth-century group of Italian artists and poets. Their poems—works of art in themselves—were to be read not necessarily literally but visually and verbally, vertically and horizontally, iconographically and analytically.

PROGRAMS

The Research Institute offers a broad range of public programs—including lectures, panel discussions, performances, and film screenings—for diverse audiences. Past programs have explored connections between dance and the visual arts and between architecture and music. Many events are followed by discussions with artists, architects, filmmakers, choreographers, and critics,

among others. The recent Art of Food Lecture Series explored culinary history and practices, the artistic display of food, and its preparation.

Photographer Julius Shulman (at right) in conversation with Research Institute curator Wim de Wit about Shulman's work and the Research Institute's exhibition *Julius Shulman: Modernity and the Metropolis*, October 2005.

"Feel Like Going Home: Musicians in Print, On Film, and In Concert" panelists (left to right) Thomas Crow, then director of the Research Institute, and authors Robert Gordon, Gerri Hirshey, and Peter Guralnick discuss music and biography, May 2003.

Members of the LA Art Girls (below) in "An Evening of Short Performances" at the Harold M. Williams Auditorium, presented in conjunction with the "Movement and the Visual Arts" conference organized by the Research Institute, June 2006.

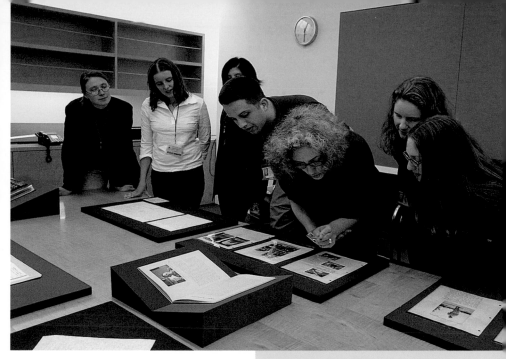

SCHOLARS

The Research Institute provides support for scholars at the senior and pre- and postdoctoral levels. Academicians, artists, architects, composers, filmmakers, and writers come from around the world to work on their own projects as well as participate in seminars and other aspects of the intellectual life of the Getty. Getty scholars are in residence at the Center or the Villa, where they pursue their own work, make use of Getty collections, and join their colleagues in talks and discussions devoted to the year's scholarly theme.

Getty residential scholar Sally Stein, associate professor of art history at the University of California, Irvine, leads the Research Institute's first graduate consortium seminar, "Biography in Visual Studies: Contested Theories and Practices," which coincided with the 2002–3 research theme of "Biography."

Echoing the building's shape, a ramp (left) connects the public reading room to the Research Library reference desk.

PUBLICATIONS

The Research Institute's publications advance critical inquiry in the visual arts, promoting experimental and multidisciplinary investigations. Series emphasize scholarship and research emerging from the Institute's conferences, workshops, and seminars and make available primary materials from its special collections. The Research Institute also publishes previously unavailable or untranslated works and new editions of landmark books of modern scholarship.

CONSERVATION

Because many of the works in the Research Library's special collections have a unique character, the staff must possess expertise in a wide range of areas. This might involve the reconstruction and preservation of delicate architectural models to making mounts for exhibitions of rare books to conserving correspondence dating to the Renaissance.

Unlike the works of art in a museum, objects in special collections are regularly handled by scholars who have come to study them, and must therefore be able to withstand frequent exposure to air, light, physical movement, and human contact. The most fragile items are protected from overuse through microfilming and digitizing, making it possible for scholars and researchers to study these sources while preserving the works themselves.

The Research Library's holdings present a host of conservation challenges. Many artists, from the mid-twentieth century onward, have turned to unorthodox materials and modern media to create their works. The archives of artists and collectors often include films, videos, Polaroid photographs, and architect's models, which can be made of wood, metals, resins, and other newer synthetic materials. Additionally, scholars are eager to examine and interpret these unconventional items, which are available in few other library holdings. Such complex objects, often damaged or dismantled over their lives prior to entering the Research Library, demand precise detective work, painstaking craft, and scrupulous recording of the restoration process on the part of conservators.

Physical deterioration of any kind can erase an object's record of its time, place, and conditions of construction. Conservation is a critical link in the chain of knowledge production. When a fragile piece is needed by a scholar or is slated for exhibition, it moves to the head of the line for treatment, in the course of which new information often comes to light.

ARCHITECTURAL MODELS

The special collections include more than one hundred architectural models. Many of these were quickly constructed and not meant to survive much longer than the time needed to realize an architectural commission. Here a conservator treats a model made by the architect Daniel Libeskind.

HANDLING AND TREATMENT

As the bulk of the Institute's collection materials exist for the purpose of being studied and handled by researchers, it is crucial that the materials be evaluated and treated for durability. This may include ridding a rare book of mold spores (above) or using a spectrodensitometer (left) to measure an object's density and color values. Conservators work in specially equipped labs (below) to carry out their work.

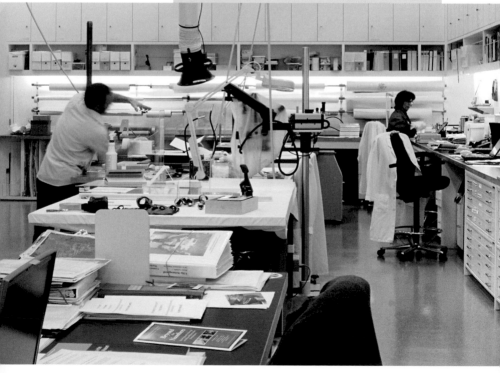

DOCUMENTATION

The process of repair and restoration also entails the creation of an archival photographic record (left)—a high-resolution document that can be used in any number of digital applications. In this way, one unique object can have many uses in a worldwide network of communication and information sharing. The documentation process can often extend to creating facsimiles of books or manuscripts when the originals are too fragile for loan or display.

STORAGE

The Research Institute is equipped with twenty-six linear miles of shelving (below) for its ever-expanding general collections and rare books, photographs, prints, drawings, and archival materials. In the Institute's cold-storage facility, staff must wear parkas (right).

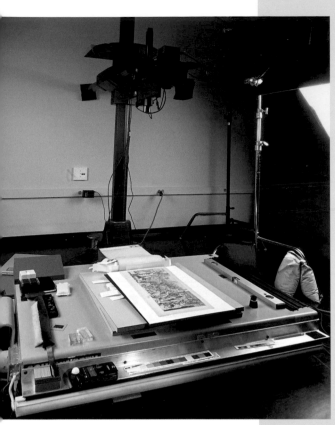

FILM AND VIDEO COLLECTION

The Research Institute is now home to one of the largest institutional collections of film, video, and performance art in the world after the acquisition of the vast Long Beach Museum of Art video archive in 2006. This addition of nearly five thousand tapes—including pieces by pioneering video artists such as Nam June Paik, Joan Jonas, John Baldessari, and Bill Viola—bolsters the Institute's holdings of video work in the archives of musician David Tudor, artist Allan Kaprow, and collector Jean Brown. "Artists have always sought novel and innovative means to express their ideas, particularly in ways that connect with the culture around them," said Thomas Crow, director of the Research Institute from 2000 to 2007. "Video art has expanded since its beginnings in the 1960s to become the dominant art form of our time. We want to make sure this legacy is preserved."

Preservation efforts for these films and videos include cleaning and producing viewable copies of each work, storage in a temperature-controlled environment, and creating a master list of all items. Another conservation challenge is that artists may have used 8-millimeter, Super-8, or 16-millimeter film stock or made videos in beta, PAL, or another format. Conservators at the Research Institute preserve such works and transfer them to more stable media. Additionally, because scholars need the right equipment, such as projectors and recorders, to view these works, the Institute has acquired an impressive array of vintage audiovisual devices in order to play them.

Analog archival masters and digital copy masters are generated in a reformatting lab (above).

Clockwise from top left: Video stills from Eleanor Antin, *Caught in the Act*, 1973; Nancy Buchanan, *Tech-Knowledge*, 1984; Patti Podesta, *Stepping*, 1980; and Tony Labat, *Solo Flight*, 1977.

6 The Getty Conservation Institute

PRESERVING THE WORLD'S CULTURAL heritage, not only works of art but also buildings, monuments, archaeological sites, and other artifacts, is the mission of the Getty Conservation Institute. The Institute does not focus on the treatment of individual works per se; rather, it seeks to have a broader impact by conducting scientific research, training professionals in new methods and technologies, and making valuable information about conservation available worldwide to those who need it. The Conservation Institute often participates in collaborative undertakings to treat objects and sites around the world and has conducted field projects in Asia, Africa, North and South America, and Europe.

The Conservation Institute occupies most of the Getty Center's East Building, next to the Museum, on the city side of the campus. There its international team of scientists, conservators, archaeologists, and others conducts research in laboratories, develops and coordinates field and education projects, and disseminates critical information through publications, online databases, lectures and conferences, and a conservation information center. The Institute also maintains facilities at the Getty Villa.

The Conservation Institute formally began operation in 1985. Its first director, Luis Monreal, had advocated, in a meeting with Trust leaders two years prior, that the Institute devote its resources not only to the conservation of objects and collections but also to immovable cultural property, such as archaeological sites and monuments, particularly in countries rich in heritage but lacking the technical or financial resources to conserve it. The Trust ultimately embraced this direction, in what Harold Williams, then president and chief executive officer, later called a "transforming moment" for the Institute.

Since then, the Institute has embarked upon and helped to sustain a number of ambitious projects, including the conservation of the thirty-two-hundred-year-old wall paintings in the tomb of Queen Nefertari, Egypt; the ancient Buddhist grotto sites at Mogao and Yungang, China; and the oldest extant bas-reliefs from the Royal Palaces of Abomey, Benin. Other work has included such diverse projects as Conservation of Mosaics in Situ, Contemporary Art Research: Modern Paints, the Earthen Architecture Initiative, and Research on the Conservation of Photographs.

A view into a laboratory at the Conservation Institute, whose scientific personnel has expertise in fields such as biology, chemistry, geology, materials science, physics, and engineering.

RESEARCH

Conservation science brings together research in various scientific disciplines in order to understand many of the causes for the deterioration of the objects, art, architecture, archaeological sites, and monuments that make up the world's cultural heritage. Scientists at the Conservation Institute work to develop approaches that can slow the decay of materials and prevent further damage. In association with conservators, the scientists design conservation solutions and evaluate treatment performance.

By adapting instruments and technologies originally developed in such realms as medicine and aerospace, staff scientists are able to analyze both organic and inorganic materials. The research laboratories are equipped with an array of sophisticated instruments to help scientists determine, first of all, what objects are made of, as well as when, how, and why they were made. Additional investigations explore possible causes of deterioration and ways to prevent or reduce them.

The Institute has also conducted extensive research into the properties of "binding media"—the substances that bind pigments together in paints and dyes. Many, such as linseed oil and egg tempera, have historically been derived from organic materials. Advanced methods such as gas chromatography-mass spectrometry, a powerful analytical tool widely used in biomedical work and environmental studies, allow scientists to identify proteins and other components of organic materials, discoveries that can lead to safer and more effective conservation approaches. The Institute has also begun to focus on the synthetics, such as acrylic, used in many modern paints.

Common mortars, plasters, and stuccos, samples of which are seen in the photo above, are susceptible to deterioration from salt, which can also contribute to the corrosion of bronze and other metals. Because there are many kinds of salt, which can be found in everything from seawater and various soils to air pollutants, they present complex conservation problems for archaeological sites, historic buildings, outdoor monuments, and wall paintings. Using advanced technologies, such as time-lapse video microscopy and environmental scanning microscopy, Institute scientists can study salt crystallization and dissolution.

SPECIAL EQUIPMENT

Conservation Institute scientists employ sophisticated technologies and instruments. A scanning electron microscope in the laboratories uses a beam of electrons to magnify objects one hundred thousand times or more and produce detailed three-dimensional images. This equipment has enabled staff scientists to analyze weathered stone, bronze, and glass surfaces; determine the composition of ancient silver and gold objects; and identify rock art pigments.

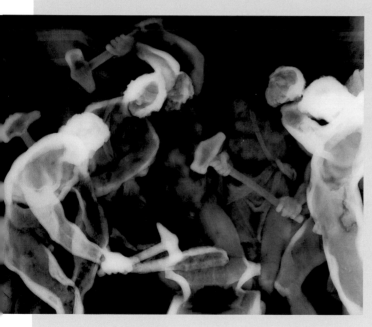

X-RAY TECHNOLOGY

By partnering with the University of Bologna, Italy, which has expertise in the field of computerized axial tomography— CT scans—scientists at the Conservation Institute were able to adapt its current X-ray equipment to scan bronze sculptures in order to analyze and record their structural makeup.

AGING

The laboratories at the Conservation Institute include an Accelerated Aging facility, which can simulate the effects aging poses to various materials and surfaces.

Accelerated Aging
C215
No food or beverages

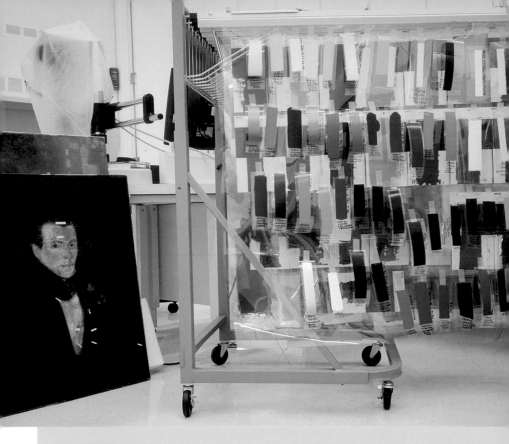

MODERN PAINTS

Painters once relied on a limited supply of materials. Pigments came from mineral deposits or were extracted from plants, insects, and animals; they were mixed in such media as waxes, plant gums, egg, milk, animal hides, vegetable oils, and plant resins. Artists today may turn to a variety of commercial paint products that often are not even intended for artists' use and that utilize new media—such as acrylics, vinyl, nitrocellulose, alkyds, and polyurethanes—as well as a profusion of synthetic pigments. The proliferation of new materials, and the novel ways in which they are applied, has created corresponding conservation challenges. Conservators have limited information on these products in terms of how they might alter with age or be affected by conservation treatments.

To help answer essential questions about modern paints, the Conservation Institute is working on a long-term project to improve methods of analyzing modern paints, seeking to increase knowledge of their physical properties and surface characteristics, and to assess the effects of cleaning treatments. This research is then presented at professional conferences and workshops, and disseminated via publications, books, and exhibitions.

Much of this is done in collaboration with other research labs, both in the United States and overseas. Each organization brings its own particular area of expertise and specialized equipment to bear on a different aspect of research. The combined results will enable conservators to utilize appropriate conservation methods and approaches for modern paints and will increase their understanding of the problems that can develop over time.

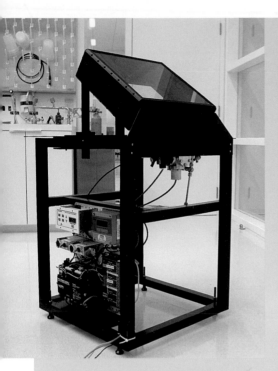

EDUCATION AND INFORMATION

The UCLA/Getty Master's Program on the Conservation of Archaeological and Ethnographic Materials, a three-year program that includes classes and lab work at the University of California, Los Angeles, and the Getty Villa, is the only graduate-level academic conservation program on the West Coast and the only U.S. program to focus solely on ethnographic and archaeological materials.

The Conservation Institute's Information Center provides expertise and support for the work of conservation professionals worldwide, offering customized research services, reference assistance, access to conservation literature, and visual resources. It manages a collection of approximately fifty thousand volumes, including hundreds of current serial subscriptions available online in the Research Library's catalog. The Information Center also maintains a reading room and reference collection of approximately two thousand titles.

The Abstracts of International Conservation Literature, AATA Online, is a free online resource that includes more than one hundred thousand abstracts of articles from almost five hundred journals, with quarterly additions of both current and historical conservation literature.

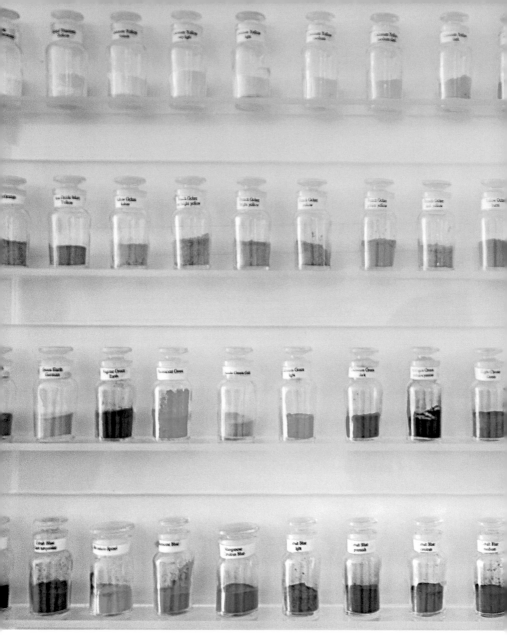

REFERENCE COLLECTION

The Conservation Institute's Reference Collection comprises more than nine thousand materials used in the analysis of art objects. Housed in an environmentally controlled room, the collection includes pigments and dyes, raw plant and mineral samples, wood and stone samples, natural and synthetic resins, varnishes, and examples of photographic chemicals and related materials. Scientists can search for information about the collection in an electronic database.

Above, a display of bottled pigments hangs on a wall outside the Institute's Organic Materials Analysis lab. As the world enters the digital age, it has become important to acquire obsolete photography supplies (left) in order to preserve analog photographs.

FIELD PROJECTS

To conserve even a fraction of the world's cultural heritage demands resources beyond those available to the Getty. By joining with other organizations, the Conservation Institute can take on a greater variety of projects around the globe. Such undertakings make it possible to apply the results of scientific research and to evaluate treatments. Most important, they provide learning opportunities for local professionals.

Projects have involved archaeological sites and historic buildings, from European cathedrals and Mediterranean mosaics to ancient Egyptian tombs, Mayan cities in Mexico and Central America, and thousand-year-old Buddhist caves along the Silk Road in China. Problems can include not only exposure to destructive natural forces but also looting and vandalism. Even tourism can create unexpected threats. An overall preservation strategy and master plan for a site requires diverse expertise. Comprehensive site management has been a major emphasis of the Institute's work, as has conservation for archaeologists.

The Institute has also undertaken research and field projects related to specific issues, such as adobe preservation, site preservation and reburial, and conservation of properties in humid, tropical environments. The tradition of building with earth, for instance, is evidenced the world over, but many significant sites are threatened. The Conservation Institute has collaborated with international partners to address such problems as the composition of mud bricks and to develop strategies to minimize damage to adobe structures from earthquakes and the elements.

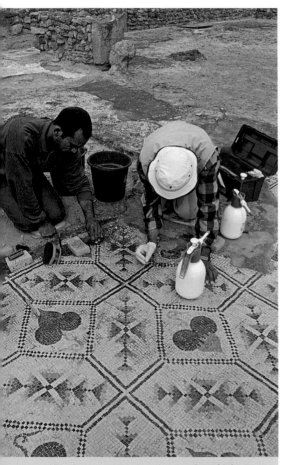

Mosaic pavements constitute a shared inheritance from the Roman world throughout the Mediterranean region, but many are at risk. The Institute started the Mosaics in Situ project to enhance the conservation and management of these treasures.

MEXICO: RETABLO OF SANTO DOMINGO

Built in the late sixteenth century, the main retablo of the Church of Santo Domingo in Yanhuitlán, Mexico, is constructed of gilded and painted wood and contains a number of sculptures and panel paintings. Nearly sixty-five feet high, it has sustained serious earthquake-related damage over the years. The Conservation Institute has collaborated with local and national Mexican organizations in documenting and providing a structural analysis of the altarpiece. The project included the involvement of Yanhuitlán community members who will be responsible for the long-term maintenance and security of all the retablos in the church.

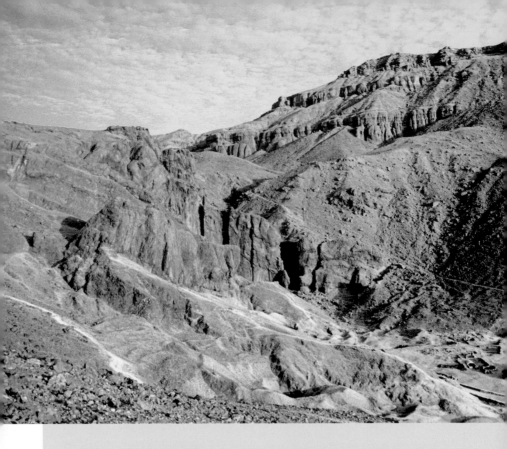

EGYPT: TOMB OF NEFERTARI, VALLEY OF THE QUEENS, AND CAIRO

The Conservation Institute's first field project focused on the thirty-two-hundred-year-old tomb of Queen Nefertari in the Valley of the Queens, on the west bank of the Nile near Luxor, Egypt. In collaboration with the Egyptian Antiquities Organization, a multidisciplinary, international group of experts conducted an intensive six-year campaign—beginning in 1986—which included condition assessment, analysis, emergency treatment, and conservation of the extraordinary wall paintings in the tomb. Training for conservators from Egypt and other countries was part of the project.

Another collaboration between the Conservation Institute and Egypt's Supreme Council of Antiquities focused on the conservation and management of the Valley of the Queens. The program involved the assessment of some eighty ancient tombs. Threats to the site included both natural forces (particularly flooding) and tourism. An important part of the project provided training for Egyptian professionals.

Other collaborative work with Egyptian authorities has included an environmental monitoring study of the Great Sphinx at the Giza Plateau outside Cairo and preparatory work for the conservation of the tomb of King Tutankhamen.

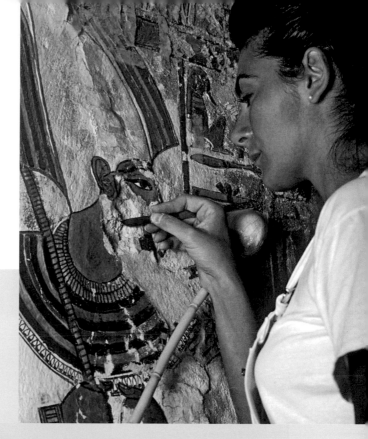

The Valley of the Queens in Egypt (left) was the site of the Conservation Institute's work on the tomb of Nefertari (above). The goal of the treatment was to stabilize the wall paintings, which over the centuries had been pushed out from the wall by salt deposits. Other projects in Egypt have included an environmental monitoring study of the Great Sphinx at the Giza Plateau (below).

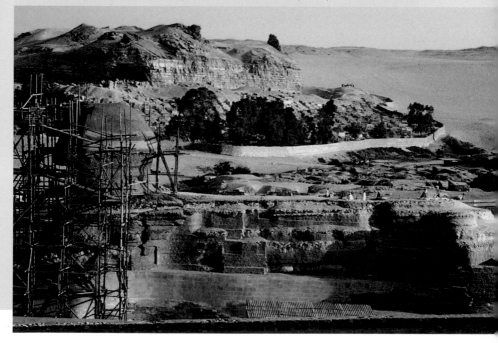

PRAGUE: ST. VITUS CATHEDRAL

The Conservation Institute and the Office of the President of the Czech Republic collaborated on the conservation of *The Last Judgment* mosaic on St. Vitus Cathedral in Prague from 1992 to 2003. Located on the south facade of the building, the mosaic encompasses eighty-four square meters (904 square feet). It was completed in 1371 at the request of Charles IV, king of Bohemia and Holy Roman Emperor, who, during his reign, made Prague the empire's center of power, religion, and knowledge. Thirty-one shades of colored glass, plus gilded tesserae, can be found in the approximately one million glass pieces that compose the mosaic. Originally, the entire background of the work was gilded.

Despite attempts to restore the mosaic to its original appearance—the first as early as the fifteenth century—the corrosion continued into the twentieth century without a long-term solution. The problem was the composition of the mosaic's glass. The glassmakers used potash (potassium carbonate) extracted from the ash of burned wood in preparing the glass. When exposed to water, the potassium in the mosaic's glass leached out, interacting with air pollutants and resulting in the corrosion layer.

BEFORE TREATMENT

AFTER CLEANING

AFTER REGILDING

For most of its existence, *The Last Judgment* mosaic on St. Vitus Cathedral in Prague has had its brilliant colors rendered invisible by a layer of corrosion (left) that has formed after each cleaning. In consultation with leading Czech art historians and conservators, the Conservation Institute and its partners from the Department of Material Science and Engineering at UCLA developed a system of coatings to protect the surface after cleaning (center) and prevent further corrosion. Other measures included regilding (right) and establishing a regular monitoring and maintenance plan.

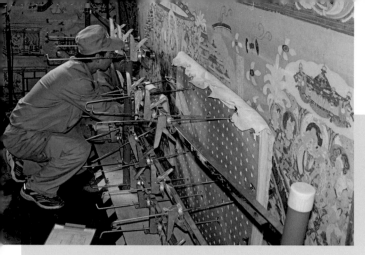

Chinese members of the project team work to conserve a wall painting in Cave 85—one of some 490 remaining temples at the Mogao grottoes.

CHINA: MOGAO GROTTOES

A major field project of the Conservation Institute involved the ancient Buddhist sites at the Mogao grottoes in the Gobi Desert in northwest China.

The ancient caravan routes linking China with the West, known in modern times as the Silk Road, once stretched 7,500 kilometers (4,660 miles) across the vast deserts of Central Asia. At the beginning of the first millennium, Buddhism traveled east from India along the trade routes and took root in China. In Dunhuang, an oasis town and gateway to China, Buddhist monks dug hundreds of temples into a cliff face—the earliest in 366, the last around 1300. Nearly five hundred of these grotto temples remain, and lining their walls are paintings on

clay plaster depicting legends, portraits, sutras, customs, costumes, and the arts. Some two thousand painted clay figures are also found within the grottoes.

Mogao was abandoned for centuries, and windblown sands smothered the grottoes, while decay overtook the wooden temple facades built on the cliff face. Working with the Dunhuang Academy at the Mogao grottoes, Conservation Institute activities included installing fences to reduce the effects of the windblown sand, monitoring the environment, training to check the color stability of the wall paintings' pigments, and surveying the structural stability of the cliff face.

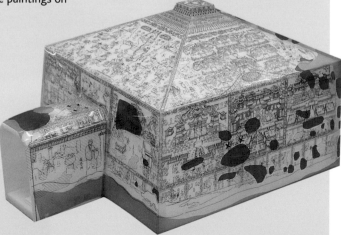

This three-dimensional model of a cave grotto records an analysis of water damage (in red).

7 The Getty Foundation

AS THE PHILANTHROPIC DIVISION OF the J. Paul Getty Trust, the Getty Foundation (known until 2004 as the Getty Grant Program) provides grants to increase the understanding and preservation of the visual arts. The Foundation, established in 1984, funds both individuals and organizations—including museums, archives, universities, and other cultural entities—working in the visual arts around the world. Their contributions help strengthen the practice of art history and conservation, often focusing on creating access to important collections and knowledge. Other projects help nurture the development of current and future leaders in the visual arts. The results of all these efforts ultimately benefit both professional and general audiences.

Each summer the Foundation provides grants for more than 150 Multicultural Undergraduate Interns, who gain experience working at Los Angeles–area museums and visual arts organizations. Recipients from 2006 are shown here on the Museum steps.

The breadth of the Foundation's funding in the visual arts is intended to complement and further the work of the J. Paul Getty Museum, Getty Research Institute, and Getty Conservation Institute. Foundation projects encompass the visual arts in all their dimensions and from all time periods—from Mayan murals to medieval illuminated manuscripts to modern architecture. The Foundation's funding is also geographically broad, spanning more than 175 countries and seven continents.

HOW ARE GRANTS AWARDED? Each year, the Foundation receives many more inquiries and applications than it can support. With expertise in art history, conservation, scholarly access, and leadership training, the Foundation's staff evaluates proposed projects and makes final grant decisions. Applications are also submitted for peer review by experts in art history, conservation, and related fields.

Individuals and organizations interested in applying for Foundation support are encouraged to visit www.getty.edu/foundation/initiatives for specific information about current grant categories, deadlines, application instructions, and past grant awards.

A view of the southern face of the East Building, home to the Getty Foundation.

129

RESEARCH GRANTS

Research grants are awarded for projects that strengthen the practice of art history, with an emphasis on strategies that encourage academic exchange and interdisciplinary research. Projects that make important museum and archival collections accessible are also a priority. Many research grants support activities—such as cataloguing or conservation research—that are not visible to the public but provide the basis for new scholarly work and innovative projects.

In recent years, research grants have provided in-depth training on the conservation of Old Master paintings executed on wooden panels, called panel paintings, so that techniques and knowledge can be passed on to the next generation of curators engaged in the care of these cultural treasures. Closer to home, the initiative *Pacific Standard Time: Art in LA 1945–1980* granted awards to more than fifty cultural institutions throughout Southern California to support exhibitions, programming, and research exploring Latin American and Latino art.

THE ARTS IN LATIN AMERICA

A research grant from the Getty brought together an international team of scholars to plan the critically acclaimed exhibition *The Arts in Latin America, 1492–1820*. The show, which opened at the Philadelphia Museum of Art in 2006 and traveled in 2007 to Mexico City and Los Angeles, looked beyond national boundaries created in the early nineteenth century in order to explore artistic interchange throughout colonial Latin America. While on view at the Los Angeles County Museum of Art, the exhibition was accompanied by a host of public programs—supported by another Getty grant—including a film festival, symposia, lectures, concerts, and family programs, all designed to engage Los Angeles audiences.

Luis Niño, *The Virgin of the Rosary with Saint Dominic and Saint Francis of Assisi*, ca. 1737. Oil on canvas. Museo de la Casa Nacional de Moneda, Fundación Cultural BCB, Potosí, Bolivia.

CONSERVATION GRANTS

Ensuring that works of art are preserved for future generations is the goal of the Foundation's conservation grants, which support the preservation of museum objects as well as historic buildings and sites. One of the hallmarks of these grants is their emphasis on advancing conservation practice through interdisciplinary research and training.

At the Victoria and Albert Museum, London, an innovative project brought together Japanese and English conservators to preserve the Mazarin Chest, one of the finest surviving examples of seventeenth-century Japanese export lacquer. In Egypt, at the foot of Mount Sinai, Getty grants have helped conserve the magnificent sixth-century mosaics in the central apse and the Burning Bush Chapel of the Holy Monastery of Saint Catherine. Like other Getty-supported conservation efforts, both projects integrated new research with established conservation standards in order to preserve important works.

UNVEILING OF THE SAN SILVESTRO CHAPEL AT THE SCALA SANTA

The results of Getty-funded conservation planning and treatment projects at the Pontificio Santuario Scala Santa in Rome were unveiled in the summer of 2007. Visited by more than two million people a year, the Scala Santa contains an ancient marble staircase believed to be the steps Christ ascended to receive his judgment by Pontius Pilate. The stairs lead to the San Silvestro Chapel, where the extensive frescoes decorating the walls and ceiling had become so darkened that there was little hope of their survival. Following extensive research and planning, as well as a painstaking conservation process, the project team of conservators and art historians revealed the original paintings in astonishing clarity and color. To share the results of the project, the Foundation is also supporting the publication of a book about the work.

Fresco of *Pope Sixtus V as Saint Sylvester*, ca. 1589, in the San Silvestro Chapel, after conservation, 2006.

PROFESSIONAL DEVELOPMENT

The Foundation nurtures and equips current and future leaders in the visual arts through grant funding as well as through the programs of the Getty Leadership Institute, which provides intensive training for senior museum staff and board members. Grant funds support the professional development of museum curators, emerging scholars, and young people exploring careers in the visual arts through internships and a variety of research fellowships. Other grants have supported summer institutes for scholars in the United States and abroad and training opportunities for conservators from developing countries.

Undergraduate intern handling a fragile political poster during his internship at the Center for the Study of Political Graphics in Los Angeles.

SPECIAL INITIATIVES

Because of the flexibility of its initiatives, the Foundation occasionally takes on special local, national, and global projects that are in line with the Getty's mission but require more immediate consideration and assistance.

LOS ANGELES Complementing its international scope, the Getty Foundation maintains a special relationship with its home city of Los Angeles through programs that support area organizations. Since 1992, the Getty Marrow Undergraduate Internship program has funded approximately 3,300 summer internships for college students at over 161 local arts institutions, including the Getty. The program inspired a public-private partnership with the Los Angeles County Arts Commission to establish undergraduate internships in the literary and performing arts. Together, these initiatives represent the largest paid arts internship program in the country.

ARCHITECTURAL CONSERVATION Keeping It Modern is an international grant initiative funding the conservation of twentieth-century architecture. Modern architecture often employed cutting-edge building materials or untested structural systems for which scientific data and conservation protocols are lacking. Conservation projects have been funded throughout the United States as well as in Japan, Brazil, India, Ghana, and the United Kingdom. The initiative freely disseminates its plans and technical reports online.

FUND FOR NEW ORLEANS Launched in the wake of Hurricane Katrina's devastation, the Getty Fund for New Orleans helped revitalize the city's cultural institutions through grants allowing organizations to assess damage to their collections and adapt to the city's changed arts environment. Twenty-two grants totaling $2.9 million were awarded to museums and arts organizations of all sizes. In 2015, a study undertaken by the Foundation to determine the impact of its donations concluded that all institutions receiving Getty grants had survived and, a decade later, most were thriving.

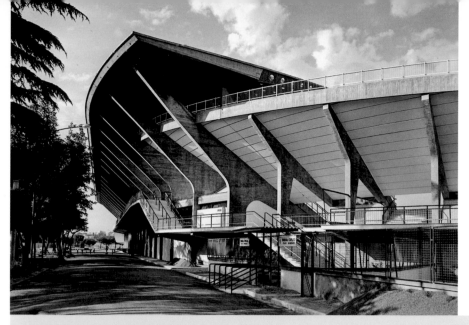

External view of Stadio Flaminio, Rome. Designed by architect Pier Luigi Nervi in 1960, this Roman landmark received a 2017 grant from the Keeping It Modern initiative.

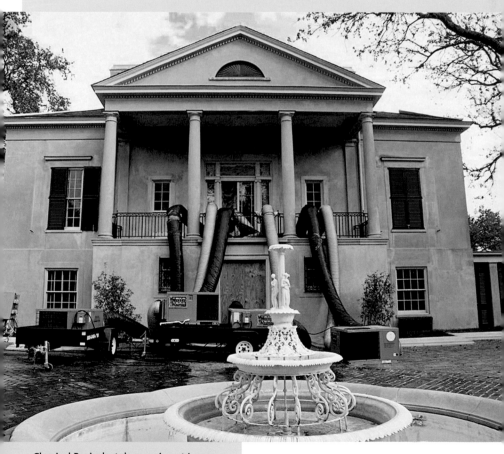

Classical Revival–style mansion at Longue Vue House and Gardens during post–Hurricane Katrina moisture mitigation, New Orleans, 2005.

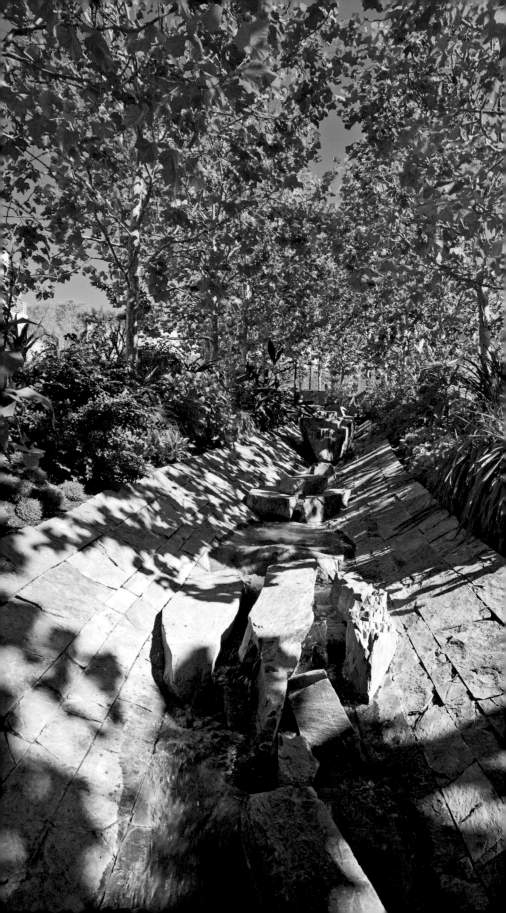

8 The Getty Outside and In

VISITORS TO THE GETTY CENTER AND the Getty Villa are usually there to see the buildings and the masterpieces of art contained within them. It is possible, though (but not necessarily encouraged), for visitors not to enter a single gallery and still be richly rewarded. At the Center, the Central Garden, described by its creator, the artist Robert Irwin, as "a sculpture in the form of a garden aspiring to be art," offers a feast for the senses. There are also two sculpture gardens with twentieth-century pieces by Henry Moore, Mark di Suvero, and Alexander Calder, among others. Commissioned works by such contemporary artists as Martin Puryear, John Baldessari, Ed Ruscha, and Alexis Smith can be found both inside and outside buildings at the Center.

Meanwhile, the Getty Villa features gardens and fountains, where visitors can escape from their cares into the beauty of nature. Opposite the Villa's Fleischman Theater, the East Garden contains a replica of a fountain from Pompeii, decorated with mosaics of stone and glass tesserae as well as seashells. Visitors to the Outer Peristyle can stroll the shaded colonnades, enjoying the open air and ever-changing views of sky, plants, fountains, and statuary. The Outer Peristyle's trompe l'oeil wall paintings, created by the artist Garth Benton, were inspired by examples excavated in the homes of wealthy Romans.

Both sites contain many areas, both inside and out, that are not seen by the general public. At the Villa, Getty's original Ranch House now contains modern offices, a library, and meeting and study rooms. Below the Museum galleries and Entrance Hall at the Center is a veritable hive of activities. This mini city includes curatorial offices, fabrication workshops, design and photography studios, an internal post office, conservation and computer labs, art storage rooms, security headquarters, and more. Outside on the Getty Center grounds are a helicopter pad (for emergencies), a million-gallon firefighting water reservoir, and a plant nursery. In 2005 the Center became the first facility in the nation to achieve LEED-EB (Leadership in Energy and Environmental Design–Existing Buildings category) certification from the U.S. Green Building Council—a sign of the Trust's commitment to the environment and to managing its resources efficiently.

The sycamore-lined stream in the Getty Center's Central Garden, designed by the artist Robert Irwin. The rocks in the streambed are green chert from the Gold Country in northeastern California.

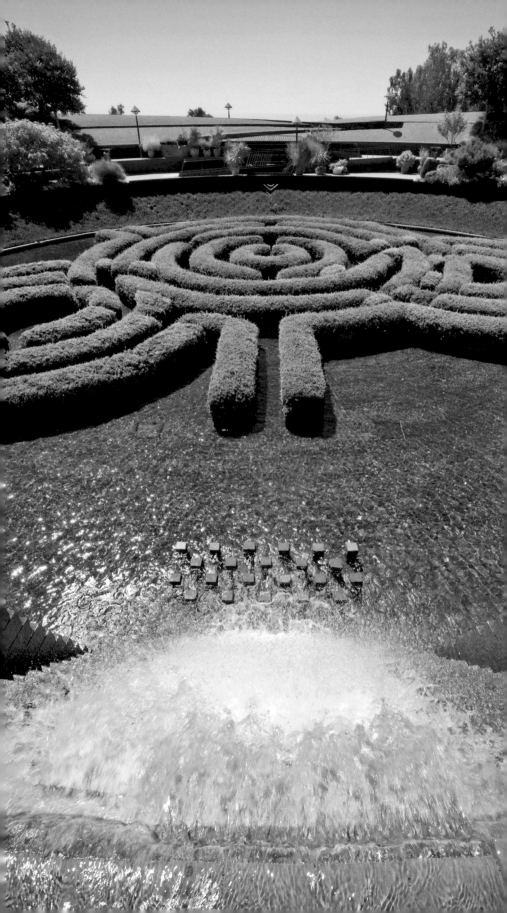

GARDENS AT THE GETTY CENTER

THE CENTRAL GARDEN Designed by the artist Robert Irwin, the Central Garden lies at the heart of the Getty Center. The garden's 134,000-square-foot design reestablishes the natural ravine between the Museum and the Research Institute, with an inviting, tree-lined walkway that leads visitors down to a plaza and an azalea maze that seems to float. Around the pool is a series of specialty gardens, each with a variety of plants.

Robert Irwin in the Central Garden.

A native of Southern California, Irwin started out as a painter interested in color and perception. He first came to prominence in the late 1960s as a proponent of the California Light and Space movement. During this period, he created a series of subtly painted, convex aluminum discs that, strategically illuminated by spotlights on the ceiling and floor, seemed to float in space. Many of the issues that first interested him in the 1960s persist in his design of the Getty's Central Garden.

The garden walkway traverses a stream that descends to a plaza with bougainvillea arbors (below). The stream continues through the plaza, passes below a steel bridge, and seems to end in a cascade of water over a stone waterfall into a pool with an azalea maze (left). What most people don't know, however, is that for drainage reasons, the upper watercourse and the waterfall are actually two separate systems. The stream water runs its course, drops down into a catch under the bridge, and is then sent back up via an underground channel to the top of the garden. On a different track, the water for the waterfall is pumped in just before it plunges over the wall, then mingles around the azalea planters before being piped back up to the bridge.

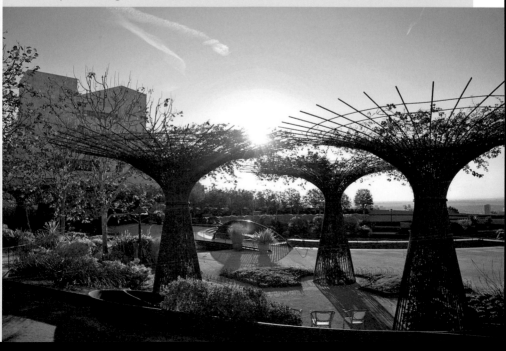

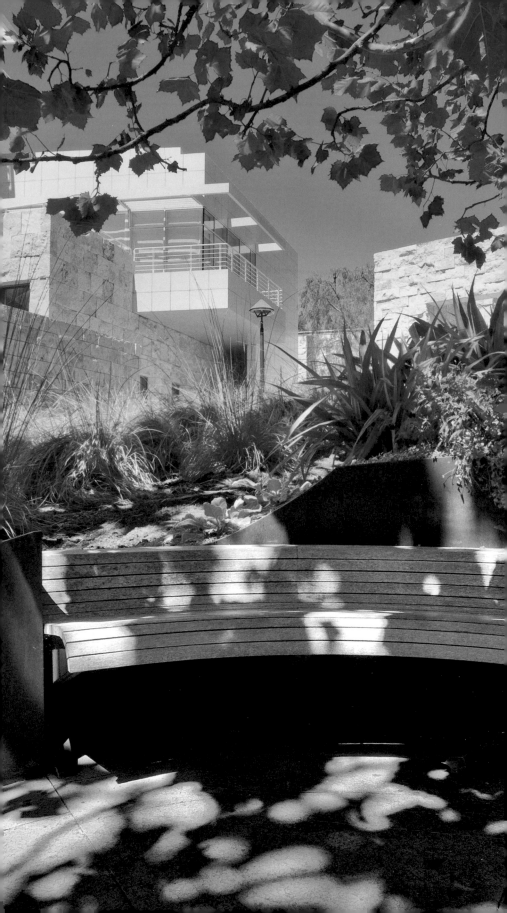

In his design, Irwin integrated the slope of the ravine as an active part of the garden, giving it enough scale to play a strong role and incorporating a walkway lined with Yarwood sycamores that crosses a small stream edged with a variety of grasses. The sycamores are pruned monthly during the summer growing season to maintain the experience of dappled light as the visitor walks through the upper garden. The visitor passes over the stream five times during the descent into the garden, and each time the sound of the water varies due to Irwin's purposeful placement of boulders to affect the speed and cascade of the flow.

Irwin selected his materials for their visual qualities, such as pattern, color, texture, and capacity to reflect light. In Irwin's garden, these geometries are compounded by repetition until they are perceived as patterns, and, in turn, patterns are repeated until they are experienced as rich layers of textures.

A teak bench in the upper garden offers a quiet, shady place of reflection (left). The plants situated along the Central Garden's zigzag walkway were broken by Irwin into four groups, each with expressly designed qualities; those at the bottom of the walkway (above) are the most vibrant, verdant, and richly textured.

SEASONAL CHANGES

A change in plantings in the specialty gardens around the azalea pool is one way the seasons are marked in the Central Garden. Poppies (top left) in the spring (February to June) are followed by a profusion of dahlias in many shades of yellow and red (middle left) for the summer planting (June to November). (There is no planting rotation for fall.) The "red sticks" of wintering dogwood (bottom left) are the dramatic addition for the winter season (November through February). A freak storm (below) in January 2007 even brought snow to the Central Garden. The sycamores along the upper garden drop their leaves in the fall (right), which creates a very different experience than the dappled light of the summer garden.

OTHER GARDEN SPACES The other gardens around the Getty Center not only balance the natural and the man-made but also define the spaces between buildings. The landscape architecture firm Olin Partnership, led by founding partner Laurie Olin, contributed to the Center site plan an overall design that combined formal and informal courtyards planted with trees, shrubs, and flowering plants. The landscaping and gardens tie untouched outlying chaparral both to the ordered plantings surrounding the Center and to the carefully structured gardens inside the campus proper. Native, drought-tolerant materials (cactus and succulents) and transplants from other locales (Italian stone pines and tropical palms) work sometimes in harmony with, and sometimes in counterpoint to, the architecture. Cool colors on the shady northern slopes grow warmer as the site opens to the sun and then deepen into a desert palette at the southernmost promontory.

The South Promontory's cactus garden (left), a re-creation of a desert landscape, recalls the city's preurban state. The palm garden (right), tucked between the East and North Buildings, gives passersby a rare treat of seeing trees from overhead. This sunken garden also allows sunlight to fill the below-grade offices through windows in the buildings' perimeter walls.

Many gardeners use containers to hold their plants. At the Getty Center, container planting is taken to an extreme. Because there are offices and corridors below much of what visitors see, plants are not placed directly in the ground. Even this stand of four Italian stone pine trees (right) on the Arrival Plaza is situated in a large—and contained—planting bed.

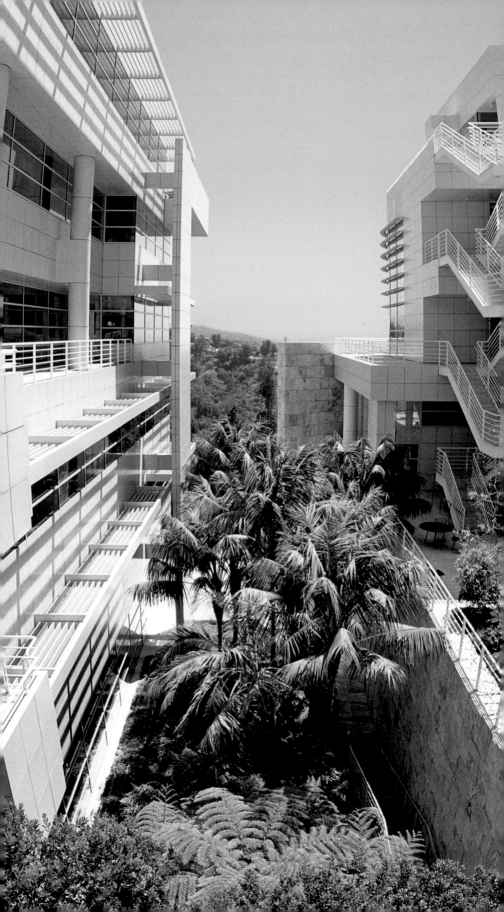

GARDENS AT THE GETTY VILLA

The many garden spaces at the Getty Villa are meant to echo those found in Roman antiquity, a task made easier by the fact that the climate at the location is remarkably similar to that of the Bay of Naples. Gardens were an important part of life in the ancient Roman countryside: often house and garden were so closely integrated that it was difficult to tell where one ended and the other began. Even the most humble dwelling had a small walled-in space in which to grow herbs and greenery. Roman homeowners worked, played, ate, and relaxed in their gardens, which, like those at the Villa, caught cooling breezes and made the most of pleasant vistas. The varieties of plants and flowers in the Villa's gardens mirror those planted in ancient Greece and Italy.

OUTER PERISTYLE The Outer Peristyle is reached from the triclinium through two bronze doors and is one of the most dramatic spaces at the Villa. Eight stately Corinthian columns look out onto a grand expanse. Smaller Doric columns adorn the three other sides of the garden, which is ornamented with hedge-lined pathways and circular stone benches. Plants favored by the ancient Romans, such as bay laurel, boxwood, myrtle, ivy, and oleander, are planted around a spectacular 220-foot-long reflecting pool.

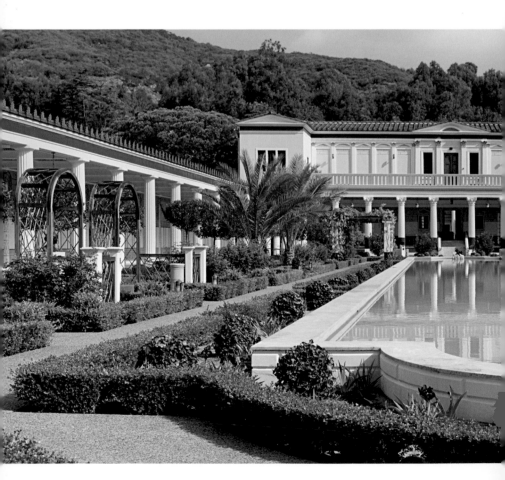

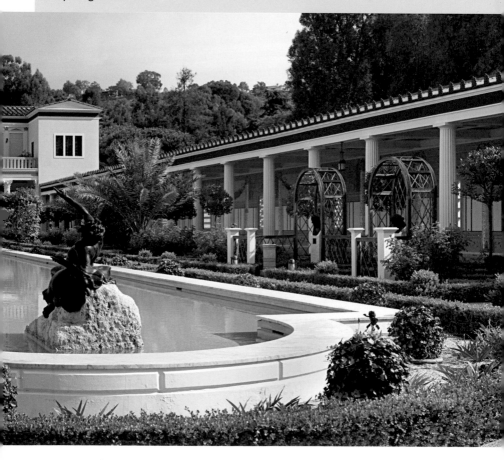

The Herb Garden features numerous plants known in antiquity, such as Corsican hellebore (above), which was used for medicinal purposes. Among the florae in the Outer Peristyle (below) are lavender, thyme, bellflowers, irises, acanthus, grapevines, fan palms, date palms, and pomegranate trees.

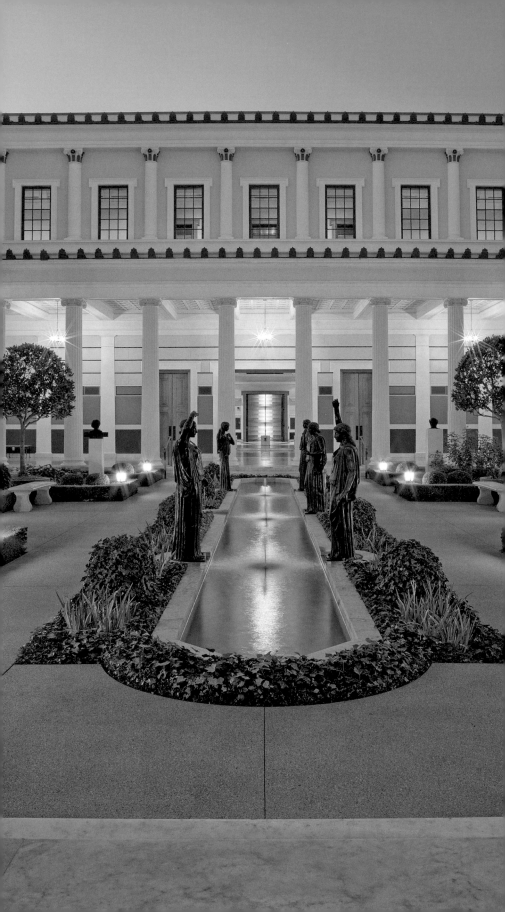

HERB GARDEN Most Roman residences had both a decorative garden and one for household use. The Herb Garden is a re-creation of a Roman kitchen garden and is planted with species known from the ancient Mediterranean—fruit trees, flowering shrubs, and herbs used in cooking and for medicine. It contains mint, dill, coriander, oregano, marjoram, chamomile, and several kinds of thyme. Fennel, radishes, and other vegetables are planted among the herbs. Fruit trees—apple, peach, pear, fig, and citrus—and grapevines abound. A typically Mediterranean olive grove stands on the terraces above the garden.

INNER PERISTYLE The garden in the Inner Peristyle features laurel, viburnum, and myrtle as well as rosemary hedges, lavender, and ruscus. It is surrounded by thirty-six Ionic columns, whose capitals were inspired by the curling leaves of the acanthus plant, examples of which can be found in the Inner Peristyle as well as the East Garden.

EAST GARDEN The East Garden offers one of the most tranquil spaces at the Villa. It features a replica of an ancient fountain from the House of the Large Fountain in Pompeii, decorated with stone and glass tesserae, shells, and theater masks. In the center of the garden is a circular basin with bronze civet-head spouts copied from those discovered in the atrium of the Villa dei Papiri.

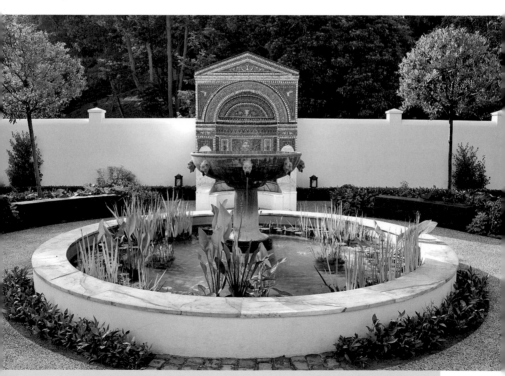

The Inner Peristyle lit at night (left). The East Garden (above) contains both a circular fountain and a mosaic fountain (in the background).

OUTDOOR ART AT THE GETTY CENTER

THE FRAN AND RAY STARK SCULPTURE COLLECTION The twenty-eight twentieth-century sculptures that constitute the Fran and Ray Stark Sculpture Collection were generously donated in 2005 to the J. Paul Getty Trust by the Trustees of the Fran and Ray Stark Revocable Trust and are installed throughout the Getty Center in the city where the Starks made their home for more than sixty years. Many of the century's foremost sculptors are represented, including Alexander Calder, Alberto Giacometti, Barbara Hepworth, Ellsworth Kelly, Roy Lichtenstein, Aristide Maillol, Joan Miró, Henry Moore, and Isamu Noguchi. Integrated with the environment and architecture of the site, these works are an impressive addition to Richard Meier's celebrated design and a rich complement to the renowned collections of the J. Paul Getty Museum.

Richard Meier's elegant modernist architecture provides a context well suited to the display of the Fran and Ray Stark Collection of twentieth-century sculpture, including Giacomo Manzù's *Seated Cardinal* (above), Mark di Suvero's *Gandydancer's Dream* (top right), and Ellsworth Kelly's *Untitled* (bottom right).

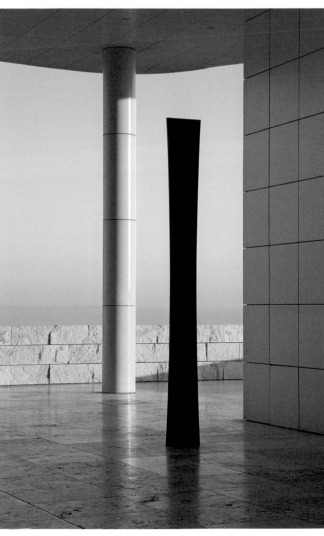

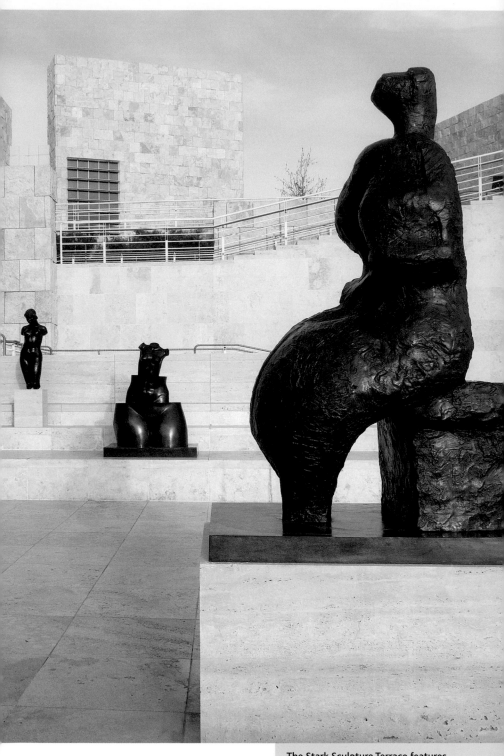

The Stark Sculpture Terrace features (above, left to right) Aristide Maillol's *Torso of Dina*, René Magritte's *Delusions of Grandeur*, and Henry Moore's *Seated Woman*, among other works.

THE STARK COLLECTION: BEHIND THE SCENES

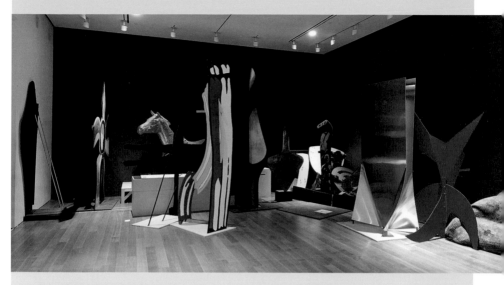

These life-size mock-ups (above) of the Stark sculptures, made by Getty exhibition design staff, were used to plan the placement of the real works. From a distance these "fakes"—made from plywood, foam core, and photo reproductions—turned out to be very convincing facsimiles. Visitors were surprised to see these stand-ins being dragged all over the Getty Center.

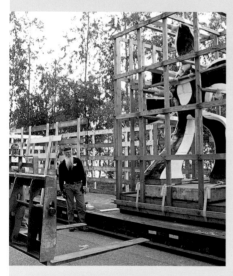

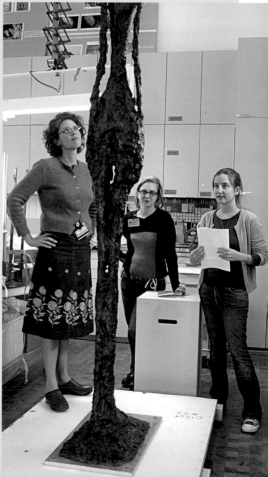

Once at the Center, sculptures such as Fernand Léger's *Walking Flower* (above) were first inspected and unloaded by preparators. The works—including Alberto Giacometti's *Standing Woman I* (right)— were then examined by Museum staff to record their condition and, if necessary, undergo any conservation treatments prior to their installation.

OUTDOOR ART AT THE GETTY VILLA

Outdoor sculptures, many based on those excavated from the Villa dei Papiri, are located in each of the four primary gardens at the Getty Villa. A grouping of modern bronze reproductions in the Inner Peristyle depicts both men and women from antiquity, including a copy of Polykleitos's *Doryphoros* (Spear-bearer). In and around the large central pool and throughout the garden of the Outer Peristyle are bronze statues and busts, which, like those in the Inner Peristyle, were cast in Naples after sculptures found in the Villa dei Papiri. Two graceful deer flank the steps leading down into the garden from the Museum colonnade. Renderings of gods, heroes, rulers, poets, and athletes, in a variety of styles, are symmetrically placed throughout the garden. At the north end of the pool a beardless young satyr sleeps on a rock, while an older drunken satyr rests at the other end. At the far end of the garden is a seated figure of the messenger god Hermes.

In the East Garden, adorning the mosaic-and-shell niche fountain, are two marble theater masks, one depicting Herakles wearing his lionskin, the other portraying his cousin, Dionysos, the patron god of theater. The Herb Garden contains an amusing sculpture of a Silenos riding a bulging wineskin—a copy of a statuette from the Villa de Papiri—which forms a spout through which water runs into a large pool below.

Many of the wall paintings in the Outer Peristyle were inspired by those discovered in well-known ancient Roman homes. Throughout the Villa the artist Garth Benton—who, thirty years prior, had painted the original murals—

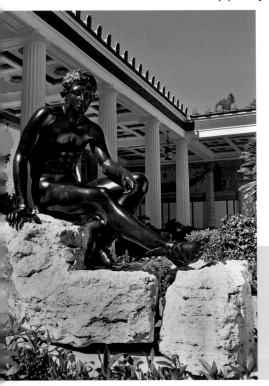

repainted and retouched the works, which deftly combine elements from numerous paintings in antiquity, so that, while his creations are true in spirit to those from long ago, none are mere copies. The walls of the north, east, and west porticoes of the Outer Peristyle are decorated with illusion-istic paintings of a style fashionable in the first century B.C. and depict architectural details, animals, fruits, and flowers, all using colors that match paint specimens found in antiquity.

In the Villa's Outer Peristyle, a modern replica (left) of a bronze statue from the Villa dei Papiri portrays the messenger god Hermes (or Mercury, as the Romans called him). At right, a detail from one of the artist Garth Benton's frescoes in the Outer Peristyle mirrors the natural beauty of the Villa gardens.

CONTEMPORARY ART

While the Getty Museum primarily collects antiquities and pre-twentieth-century European art, the Getty Center also features contemporary works. Over the years, the Getty has commissioned artists such as Martin Puryear, Ed Ruscha, Bill Viola, Tim Hawkinson, Alexis Smith, and John Baldessari to produce pieces that are site-specific or respond to works in the Getty's collection. Puryear's distinctive *That Profile*, one of the first things visitors see as they exit the tram, dramatically plays against its surroundings, both natural and man-made. Hawkinson's massive *Überorgan* (see pages 84–85) made its West Coast debut in 2007 in the Museum Entrance Hall, where it amused and surprised visitors as much for its sheer size as for the deep, often jarring music that it made. The contemporary art programming is a reflection of the Getty's support of living artists and the local artistic community.

A plate from Alexis Smith's *Taste* installation in the Getty Center Restaurant.

A dramatic Los Angeles sunset seen against Martin Puryear's *That Profile*.

Ed Ruscha's painting *Picture Without Words* in its permanent home in the lobby of the Harold M. Williams Auditorium.

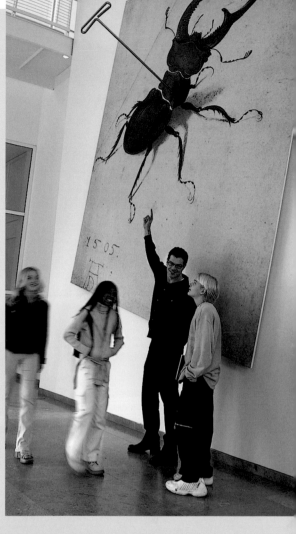

Works commissioned by the Getty have included Bill Viola's video *Emergence* (above left); Andy Goldsworthy's untitled temporary installation (above middle) in the Research Institute's lower level; John Baldessari's *Specimen (After Dürer)* (right); Nicole Cohen's *Please Be Seated* (below left), in which visitors sit in modern reproductions of eighteenth-century French chairs and are "transported" via video to a period room; and Tim Hawkinson's *Bat* (below), made from plastic RadioShack bags and twist ties.

DINING AND SHOPPING

Visitors to the Getty Center can enjoy meals at either the casual Cafe, the elegant Restaurant, or the outdoor Garden Terrace Cafe. The Cafe at the Getty Villa serves Mediterranean fare and has indoor and outdoor seating and views of the Museum and Fleischman Theater.

The Museum Store at the Center is filled with a wide variety of books, gifts, and educational toys relating to the collections and programs of the Getty. Smaller stores dot the Center site and offer products that reflect exhibitions and gallery themes. A children's shop caters to the many school groups that visit. The Museum Store at the Villa features publications on the ancient world as well as products inspired by the Museum's collection of antiquities.

At the Museum Store at the Getty Villa (above) visitors can purchase books, prints, cards, gifts, and jewelry with an ancient twist. The Museum Store at the Getty Center (top) offers books covering the spectrum of art history. The Garden Terrace Cafe at the Getty Center (right) overlooks the Central Garden.

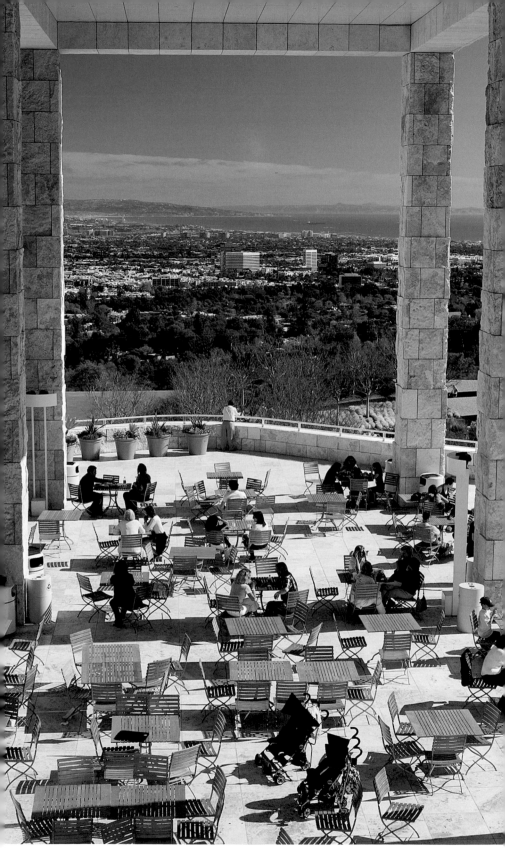

SECRET SPACES AT THE GETTY CENTER

TUNNELS

More than half the space of the Getty Center is underground. The buildings are linked by a network of subterranean corridors used for a variety of purposes, including the moving of works of art, books, and scientific equipment. The placement of the water pipes within the corridors was part of the overall design, to keep them out of storage and office spaces.

WALL OF HANDS

The Wall of Hands was created on the occasion of the opening of the Getty Center. Staff members were invited to put their handprint into thirty-inch squares of wet plaster. Many individuals signed or personalized their imprint in some way.

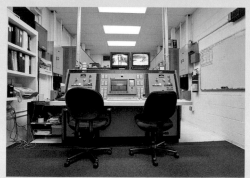

TRAM CONTROL ROOM

The tram control room is located below the Museum. Inside is the brain that controls the wheels and cables that move the two unmanned trams up and down the hill.

EMPLOYEE ART SHOW

Held every other year, the employee art show, called "Getty Underground," is an opportunity for staff to share their artistic talents. The exhibition is mounted in one of the many underground tunnels.

BOILER ROOM

The Center's boiler room is located four floors underground in the Museum building. The boilers supply hot water for domestic purposes and to heat the buildings; and steam for humidification. At least one boiler is running twenty-four hours a day, 365 days a year.

GOATS AT THE GETTY CENTER

The Getty Center occupies only twenty-four acres of the 110-acre developed site. The remaining land has been left in its natural state or planted with consideration for erosion and fire control. Brush clearance is part of the landscape maintenance program, and most areas can be cleared by staff. There are canyon spaces, however, that are too difficult to reach safely. The Getty initially experimented with bringing in a herd of 250 goats each spring for a period of two weeks to get in and take care of these areas.

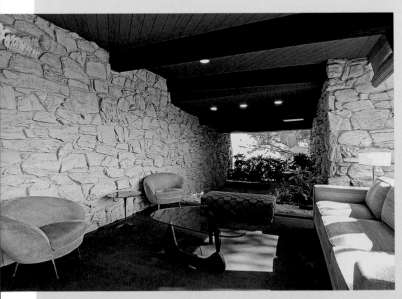

THE TRUSTEE HOUSE

When the Getty bought the land for the Center, this modern house on the property was part of the purchase. Originally built in 1965 by the architect Harry Gesner for the famed inventor J. R. Scantlin, the home features a 180-degree view of Los Angeles and a lap pool that leads from outside directly into the master bathroom. Richard Meier lived in the Scantlin House during the building of the Center. Now referred to as the Trustee House, it is used primarily for meetings.

NURSERY

Fresh plant stocks for the Getty's Central Garden and other gardens are kept at a nursery on-site. Seasonal plants are also stored here.

WILDLIFE

The Getty site is home to many forms of wildlife, such as deer, hawks, ravens, owls, and coyotes.

EMERGENCY HELIPAD

On September 24, 2007, a Los Angeles Fire Department helicopter landed on the Getty's helipad, near the North Building, on the occasion of a town hall meeting held at the Getty on fire safety and disaster response.

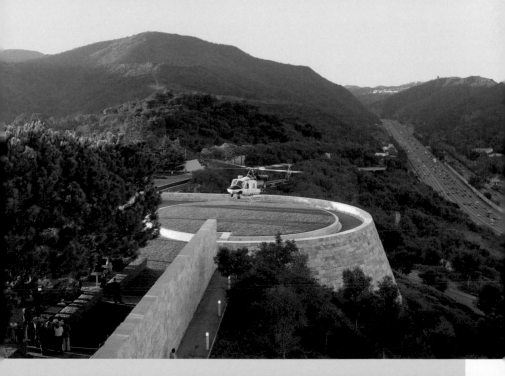

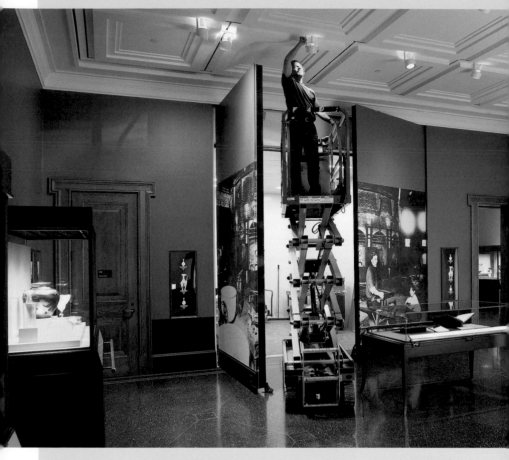

LARGE HIDDEN ELEVATOR

This elevator, hidden behind a gallery wall, is used to transport machinery, cases, and works of art to and from the Museum galleries.

FIREPLACES

This fireplace is the original one in the living room/salon of Getty's Ranch House. It has fluted pilasters with swags of grapes and capitals in the form of women's faces, which support a classical-order-entablature mantel.

MONKEY FOUNTAIN

This marble fountain, referred to informally as the "Monkey Fountain," is located in the courtyard outside the conservation labs, just south of the Ranch House. It is a replica of a fountain by Giovanni da Bologna (1524–1608) in the Boboli Gardens, Florence. A trio of monkeys adorns its base.

VIP ROOM

This meeting room, with dramatic Pompeiian red walls, is located on the first floor of the Museum.

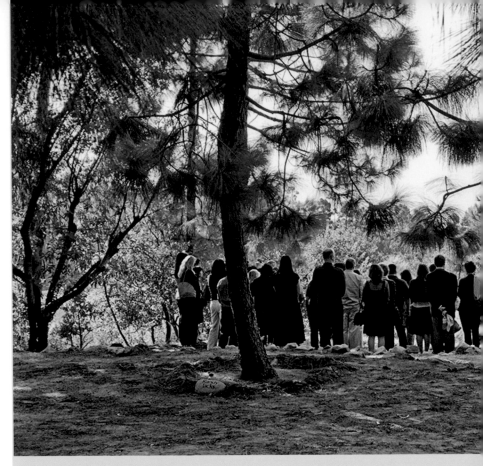

MEMORIAL GROVE

Established in the 1980s, the Memorial Grove was created to honor staff members who passed away as employees of the Trust. Their names are inscribed into rocks, which are placed beneath trees.

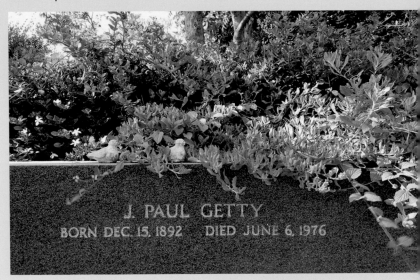

J. PAUL GETTY
BORN DEC. 15, 1892 DIED JUNE 6, 1976

J. Paul Getty is buried at the Getty Villa—on a bluff overlooking the Pacific Ocean. Two of his sons, George and Timothy, are also laid to rest here.

REDWOOD GROVE

J. Paul Getty was especially fond of this grove of redwood trees, originally brought down from Oregon in the 1940s and located just south of the Museum.

BUNGALOWS

This bungalow (one of a pair) was home to John and Minnie Batch, who were hired as caretakers of the property by J. Paul Getty. The large painting depicts John, who also acted as Getty's bodyguard.

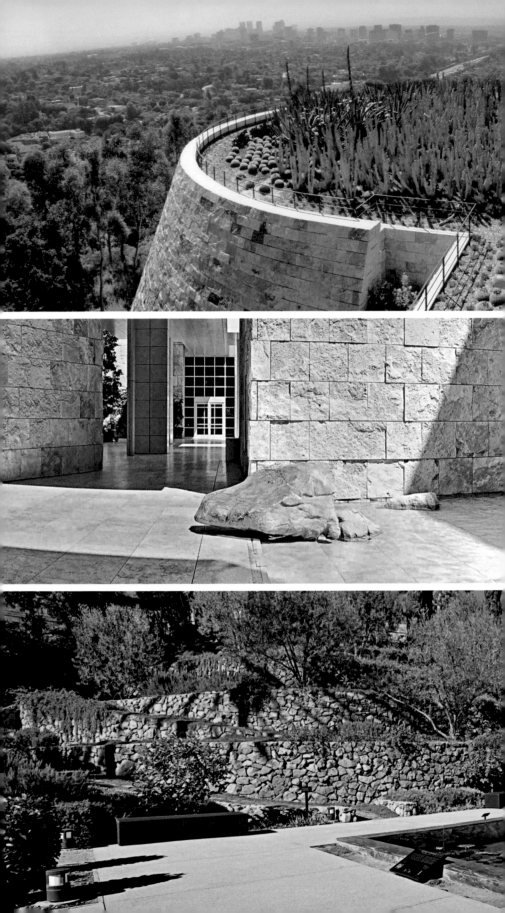

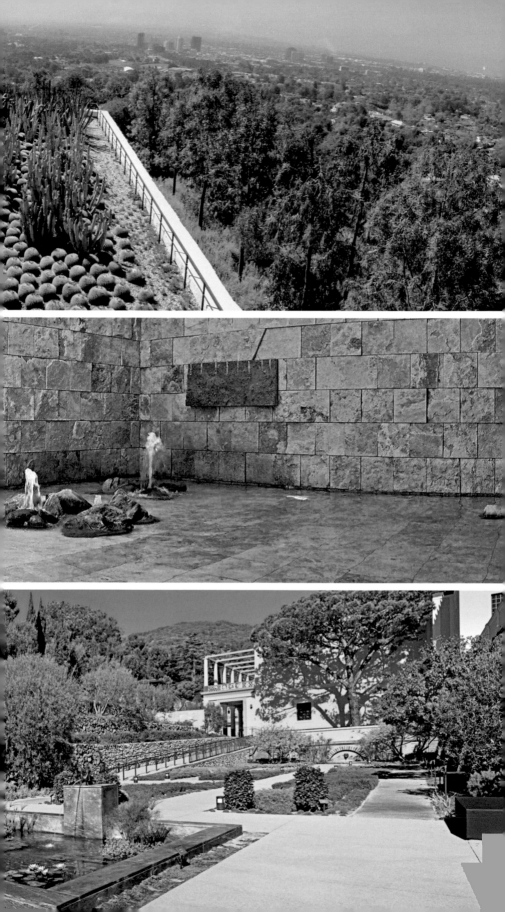

9 A Day at the Getty

FOR VISITORS, A DAY AT THE GETTY Center or Villa is an escape from everyday worries and the stress of modern city life. One can take in priceless works of art, eat a great meal, relax in a verdant garden, and enjoy a stimulating performance. However, there are many other facets of the institution that the public does not see. To maintain and operate both sites requires many dedicated people and resources. The following sequence of pictures represents just some of the daily activities that take place at the Getty's two busy campuses. It is by no means comprehensive but aims to give readers a glimpse into life at the Getty.

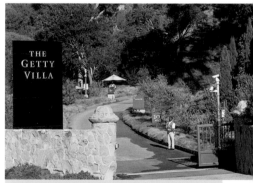

WELCOME TO THE VILLA
The Getty Villa plays host to more than one thousand visitors a day.

VISITOR SERVICES
The Museum's Visitor Services Department welcomes visitors to both sites, gives directions, and answers such questions as "Where's *Irises*?"

GROUNDS CREWS
A gardener (left) waters the azalea maze in the Central Garden. More than three dozen gardeners work at the Getty Center. A full-time crew cares for the Central Garden. An additional crew handles mowing and ponds and another specialized crew manages all big tree work. In addition, the Getty Villa has its own grounds crew of about a dozen employees.

SECURITY OFFICERS
The Getty Security team meets for its morning briefing.

UMBRELLA, ANYONE?

Umbrellas are provided to visitors as protection from the rain or, more often, the sun.

INSTALLATION WIZARDS

The Getty employs preparators who are specially trained to handle and install works of art and ready galleries for exhibitions.

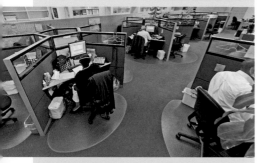

CALL CENTER

The Getty's call center fields hundreds of requests every day.

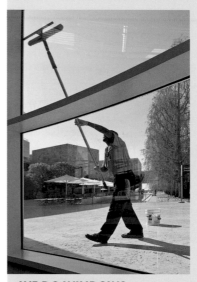

WE DO WINDOWS

Just one of the many responsibilities of the Facilities department is the upkeep and maintenance of the Getty sites, including the big task of window washing.

SUNNY SKIES

The Getty Center's on-site weather station monitors the climate conditions around the property and relays information to the Grounds Department, which utilizes the data to regulate water use. This photo shows the former weather station, now replaced by newer technology.

INTERNAL POST OFFICE

All mail received at the Getty is screened by a logistics technician before being delivered to recipients.

FILMS ON ART
The Getty commissions films to accompany some exhibitions. These movies may be shot on location, as shown here at the Holy Monastery of Saint Catherine, Sinai, Egypt, to bring an added dimension to the visitor experience.

EMERGENCY PREPAREDNESS
All Getty staff must attend emergency training seminars and drills in anticipation of a catastrophic event. Both the Center and the Villa maintain ample supplies in case of a disaster.

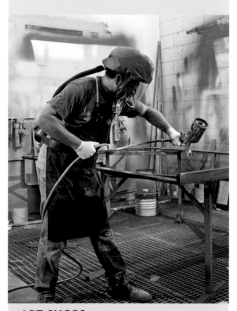

ART SHOPS
Both the Center and Villa have fully equipped shops for woodworking, mount making, framing, and painting.

OFFICE SPACE
Cubicles at the Center adhere to Richard Meier's thirty-inch working grid.

VILLA SCHOLARS
Research Institute scholars utilize the resources in the Villa's Research Library, located in J. Paul Getty's old residence, the Ranch House.

ELEVATOR CALL
The Otis Elevator Company has maintenance staff on-site to oversee the Getty Center's thirty-seven elevators and the tram.

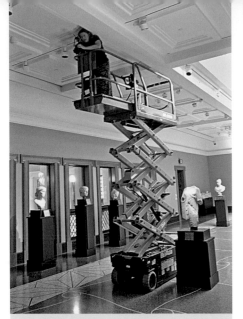

THE GETTY ONLINE

Content experts across the Getty—working with a central team of strategists, designers, and technologists—oversee the Getty's digital platforms, including its website, www.getty.edu.

BETTER THAN A TRIPOD

The Imaging Services Department includes both photographers and image technicians. Here, a staff photographer shoots an ancient sculpture in the Villa galleries.

FOUR-LEGGED SECURITY OFFICER

Stationed at the Center's south service entrance, members of the Getty's elite canine unit were trained to look for potentially dangerous materials, and even wore a blue staff ID badge.

BANNERS

Street banners, which promote Museum exhibitions throughout the city, are designed by the Museum's Exhibition Design Department and printed at an off-site location.

ART IS EVERYWHERE

Playful handmade signs alert staff to the ubiquity of art. Works might be in laboratories, imaging stations, or study and collection areas.

GOING UNDERGROUND
Two underground warehouses at the Getty Center provide storage space for books from Getty Publications and merchandise sold in our museum shops and the Getty's online store.

MARATHON OF BOOKS
The Research Institute is continually acquiring books for its library and special collections.

EXHIBITIONS FOR MICE
The Museum employs exhibition designers who devise and produce the often-complex designs for Museum shows. The planning usually begins with a miniature model of the artworks in the galleries.

INFORMATION CENTER
The Getty Conservation Institute's Information Center provides an integral resource for the conservation community.

KEEPING THE GETTY GREEN
The Grounds Department at the Center prepares to lay down turf on the lawn between the Exhibitions Pavilion and the Central Garden.

ANCIENT COOKERY
The Villa offers occasional culinary workshops that pair food with themes about art.

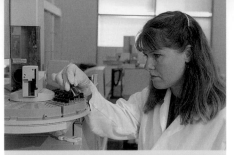

CAUTION: SCIENTISTS AT WORK

A Conservation Institute scientist prepares a sample to be analyzed in one of the Institute's laboratories.

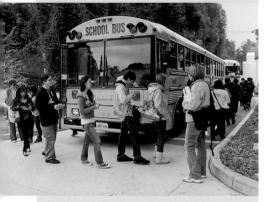

FIELD TRIP TO ANTIQUITY

The Villa hosts 50,000 K–12 students each year.

TABLE FOR TWO THOUSAND, PLEASE

Bon Appétit Management Company, which runs the Getty's food operations, feeds more than two thousand people a day at the Center.

HANDLE WITH CARE

A work of art is packed, crated, and sent off to its next destination.

SOUND CHECK

An engineer supervises a performance from the sound booth in the Harold M. Williams Auditorium at the Center.

THE LAST TRAM

Good night, *Irises*. Good night, *Still Life with Apples*. Good night, *Armorial Plate with the Flaying of Marsyas*. Good night, *Gandydancer's Dream*...

ACKNOWLEDGMENTS

When I was handed the task of creating a "guide to the Getty," I was perplexed. Our two campuses are huge, many of their buildings closed to the public, and their surrounding parkland not easily explored. Moreover, maps, guides, handbooks, and brochures are plentifully available and regularly updated. So, what to do?

The answer, once conceived, seemed obvious and even fun: show our visitors, and our potential visitors, what they cannot normally see—scientists in their laboratories; librarians cataloguing their books; armies of conservators, mount makers, curators, designers, and art handlers setting up an exhibition; and even goats munching chaparral to help prevent brush fires—that is, take everyone on a trip they simply cannot arrange for themselves, and while doing so, explain to them what we all do here in the service of the mission that our President so clearly describes in his foreword.

To accomplish this, a photographer and a publications person had to disturb all these people by barging into their offices and laboratories, prying into their work, and flashing lights in their faces. We are both grateful for their equanimity and in awe of their skill. We also thank the program directors— Michael Brand, Thomas Gaehtgens, Deborah Marrow, and Timothy Whalen —and their associates for first submitting to our interviews and then so thoroughly and sensitively reviewing the text and illustrations.

Richard Ross was commissioned to take the special photography we required, and when, inevitably, we found ourselves in need of more pictures long after he had completed his work, the photographic staffs and archivists at the Museum, the Foundation, and the Research and Conservation institutes stepped in. The beauty of the illustrations and the visual drama of, say, a storeroom or a test tube are due to the artistry of Richard and of our own photographers.

My last words, of course, must be to William Hackman, who wrote the text, and to the Getty Publications team, who, with skill, imagination, and enthusiasm, breathed life into this little book. Editor Patrick Pardo shaped this book with a sculptor's hands. Copyeditors Gregory Dobie and David McCormick corrected and polished the text. Elizabeth Zozom exercised a preternatural patience in laying out a complex production schedule—more than once! Most especially, Jim Drobka designed a book whose every page delights, surprises, and makes sense, while Elizabeth Kahn—who knows where every existing picture of the Getty resides—with the assistance of Karen Shields searched and searched again for just the right picture: they made it happen.

All of these people have given us a book that, we hope, reflects the excitement of the Getty adventure. It is an experience we are delighted to share with you.

Mark Greenberg

ILLUSTRATION CREDITS

B Bottom
L Left
M Middle
R Right
T Top
A All

Neville Agnew: p. 125B

David Albanese: p. 157TR (work shown: © John Baldessari 2000)

Guillermo Aldana: pp. 124, 125T

Lori Anglin: p. 123

Eleanor Antin: p. 113ML, Courtesy of Eleanor Antin

Bart Bartholomew: pp. 52, 93T

Jane Bassett: p. 117M, Courtesy of Bayerisches Nationalmuseum, Munich

Jobe Benjamin: pp. 104T, 104–5B

Marina Berlozerskaya: p. 10T

Tom Bonner: p. 50B

Gilbert Borreul: p. 174MR

Elsa Bourguignon: p. 122

Paula Carlson: p. 174TR

Nicole Cohen: p. 156B

Christopher Coniglio: p. 174BL

Brian Considine: pp. 151BL (work shown: Gift of Fran and Ray Stark / © 2019 Artists Rights Society [ARS], New York / ADAGP, Paris), 151BR (work shown: Gift of Fran and Ray Stark / © 2019 Alberto Giacometti Estate / VAGA at Artists Rights Society [ARS], New York / ADAGP / FAAG, Paris)

Corbis: p. 48 (© Bettmann /CORBIS)

Tahnee Cracchiola: pp. 22–23T, 58–59B, 59T, 83B, 94–95B, 145T, 146, 148 (work shown: Gift of Fran and Ray Stark / © Inge Manzù), 149T (work shown: Gift of Fran and Ray Stark / Courtesy of Mark di Suvero and Spacetime C.C.), 149B (work shown: Gift of Fran and Ray Stark / © Ellsworth Kelly), 150 (works shown: Gift of Fran and Ray Stark / L, © 2019 Artists Rights Society [ARS], New York / ADAGP, Paris; M, © 2019 C. Herscovici, London / Artists Rights Society [ARS], New York; R, © Henry Moore Foundation / Reproduced by Permission of the Henry Moore Foundation), 164B, 166T, 167B, 175BR, 176ML

Jim Drobka: pp. 88B, 140TL, 163T

Patrick Frederickson: p. 88MB

Juan M. Garcia: p. 163M

Getty Imaging Services: pp. 61T, 64, 68B, 70T, 73R, 74T, 75T (David Hockney, Pearblossom Hwy., 11–18th April, #2, 1986 [second version], 1986, photographic collage, 71½ x 107 in., Gift of David Hockney / © David Hockney)

Getty Research Institute, Visual Media Services: p. x, 840006; p. 4TL, 1992.IA.3-1; p. 5TL, Hewins 1986.IA.10-6; p. 5M, Hewins 1986.IA.10-4; p. 5BR, 2004.R.10, photograph by Julius Shulman; p. 8T, 1987.IA.15; p. 8M, 2006.IA.22, Box 1; p. 8B, 2006.IA.22, Box 4; p. 9, 1997.IA.10; p. 10L, 1987.IA.24; Board 121; p. 11T, 1987.IA.24; p. 11B, 1987.IA.24, Board 147; p. 12T, 2006.IA.22, Box 5; p. 14, 2004.IA.06, illustration by Max Driven; p. 17ML, 1987.IA.24; p. 24, 1997.IA.10, Box 20, Binder 7, The Benjamin and Gladys Thomas Air Photo

Archives, Spence Collection, UCLA Department of Geography; p. 25M, 1997. IA.10, Box 71, photograph by Joe Deal; p. 26, 1997.IA.10-52; p. 27A, 1997.IA.10-74; p. 28, 1997.IA.10-60, photograph by Tom Bonner; p. 29TL, 29TR, 1997.IA.10-60; p. 29ML, 1997.IA.10-39; p. 29MR, 1997.IA.10-60, photograph by Grant Mudford; p. 29B, 2003.IA.08-1, photograph by Jock Pottle/Esto; p. 30, 1997.IA.10-39, photograph by Stephen Rountree; p. 31A, 2003.IA.08-1, photograph by Jock Pottle/Esto; p. 32, 1997.IA.10-74; p. 33TL, 1997.IA.10-39; p. 33TR, 1997.IA.10-61; pp. 34B, 35T, 1997.IA.10-63, photographs by Stephen Rountree; p. 35M, 1997.IA.10-63, photograph by Vladimir Lange; pp. 36–37, 1997.IA.10-22, photograph by Vladimir Lange; pp. 38–39T, 1997.IA.10-65, photograph by Dennis Keeley; p. 38B, 1997.IA.10, photograph by Howard Smith; p. 39B, 1997.IA.10-69, photograph by Joe Deal; p. 41TR, 1997.IA.10-60, photograph by Vladimir Lange; p. 42A, 1997.IA.10-22, Binder 13, photograph by Vladimir Lange; pp. 44–45A, 1997.IA.10-27, photographs by Linda Warren; pp. 46–47A, 1997.IA.10-66, photographs by Bruce Bourassa; p. 48A, 1997.IA.10, Box 68, 48TL photographs by Robert Irwin, 48MR photograph by Tom Bonner; p. 49A, 1997.IA.10, Box 68, photographs by Dennis Keely; p. 50ML, 1997.IA.10-22, photograph by Vladimir Lange; p. 51TL, 1997.IA.10-44, photograph by Robert Pacheco; p. 51TR, 1997.IA.10, photograph by Vladimir Lange; p. 98; p. 99T (work shown: © Association Marcel Duchamp / ADAGP, Paris / Artists Rights Society [ARS], New York, 2019); p. 99B, photograph by Julian Shulman; p. 100A; p. 101T, photograph by Robert Cassoly; p. 101B, (work shown: © Coop Himmelb[l]au, photograph by Tom Bonner)

Andy Goldsworthy: p. 157TL (work shown: © Andy Goldsworthy)

Ronny Jacques: p. 2

Dennis Keeley: pp. 175TR, 176TL

John Kiffe: pp. 105T, 107

Peter Kirby: p. 173TL

Tony Labat: p. 113BL, Courtesy of Tony Labat and Gallery Paule Anglim

Mark Leonard: p. 81T

Michael Lloyd: p. 5TR

Longue Vue House and Gardens: p. 133B, Courtesy of Longue Vue House and Gardens

Craig Matthew: p. 92B

Ryan Miller / Capture Imaging: p. 82L

Naveen Molloy: p. 83T

Motor Racing Magazine: p. 4TR

Patrick Pardo: p. 175TL

Kira Perov: p. 113MR, Courtesy of Nancy Buchanan

Chris Petrakis: p. 173ML

Francesca Piqué: p. 127T

Brenda Podemski: pp. 140MR, 140BR, 161MR

Patti Podesta: p. 113BR, Courtesy of Patti Podesta

Pontificio Santuario Scala Santa: p. 131, Courtesy of Pontificio Santuario Scala Santa, Rome

Ellen Rosenbery: pp. 7, 17T, 17MR, 18T, 18M, 19T, 20B, 22–23M, 80T, 144–45B, 147, 152, 158B, 164T, 165A, 167R, 168–69B, 171MR, 172TR, 173MR

Jack Ross: pp. 41BL, 51B, 63B, 65, 86T (with Anthony Peres), 88T, 88MT, 89TL, 89MTL, 89MBL, 89BL, 89MR, 90–91A, 129M, 156T (with Christopher Foster and Anthony Peres; work shown: © Bill Viola), 161B, 162T, 171ML, 171BR, 172ML, 172MR, 172BL, 172BR, 173BL, 173BR, 175MR, 175BL, 176TR, 176MR, 176BL

Richard Ross, © Richard Ross: half-title page A, title page T, back cover; pp. viii–ix A (works shown: T, Staatliches Museum Schwerin; B, Gift of Fran and Ray Stark / BL, BR, © Henry Moore Foundation / Reproduced by Permission of the Henry Moore Foundation; BM, © 2019 Artists Rights Society [ARS], New York / ADAGP, Paris), 15A, 16, 18B, 19B, 20–21T, 34T, 35BR, 40, 41TL, 41BR, 43B, 54–55A (work shown, 54–55B: Gift of Fran and Ray Stark / © 2019 Artists Rights Society [ARS], New York /ADAGP, Paris), 56, 57A, 60–61B, 62A, 66–67, 68T, 69A, 71, 72, 73L, 74–75B (works shown: Gift of Nancy and Bruce Berman), 76T, 76MR, 77A, 78–79, 80B, 81B, 89TR, 89BR, 94–95T, 94–95M, 96, 97, 102–3, 106, 108, 109A, 110–11A, 112–13T, 114, 115, 116, 117T, 117B, 118, 119L, 120–21A, 128, 129T, 134, 136, 137T, 138, 139, 140ML, 140BL, 142A, 143, 151T (R, © 2019 Calder Foundation, New York /Artists Rights Society [ARS], New York), 153, 154T (work shown: © Alexis Smith, courtesy the artist and Garth Greenan Gallery, New York), 155 (work shown: © Ed Ruscha), 158T, 160, 161T, 161MT, 162B, 166B, 168–69T, 168–69M, 170, 171T, 172TL, 173TR, 174BR, 175ML, 176BR

Oscar Savio: p. 133T, Courtesy Pier Luigi Nervi Project Association, Brussels

Elon Schoenholz: pp. 92T, 93B

Julius Shulman: title page B, pp. vii, 12M

Christopher Sprinkle: front cover

Stanley Smith: pp. vi, 25T

Laurie Steiner-Halpern: p. 132

Stacey Rain Strickler: pp. 63T, 87BL, 87BR, 141, 159

Rebecca Truszkowski: pp. 22–23B, 82R

University of Southern California, Specialized Libraries & Archival Collections: p. 10BR

Rebecca Vera-Martinez: pp. 70B, 84–85B (work shown: © 2000 Tim Hawkinson, courtesy Pace Gallery, collection of Andrea Nasher), 87T (works shown: middle, University of Iowa Museum of Art, Gift of Peggy Guggenheim. Reproduced with permission; right, Bernard Schardt), 157B (work shown: © 2007 Tim Hawkinson, courtesy of the artist; work commissioned by the J. Paul Getty Museum, Los Angeles)

Gerard Vuilleumier: pp. 85T, 86B, 174TL

Sarah Waldorf: back cover

Linda Warren: p. 6

Lillian Elaine Wilson: pp. 135, 137B, 154B (work shown: © Martin Puryear, Courtesy Matthew Marks Gallery)

Lorinda Wong: p. 127B

J. Zastoupil: p. 126A

THE LURE OF ITALY

Grote de pausilipo

The Lure of ITALY

Artists' Views

JULIAN BROOKS

with the assistance of Alessandra Nardi

The J. Paul Getty Museum, Los Angeles

Dedicated to the memory of TGMB, my beloved Italophile father

This publication is issued on the occasion of the exhibition *The Lure of Italy: Artists' Views*, on view at the J. Paul Getty Museum at the Getty Center, Los Angeles, from May 9 to July 30, 2017.

© 2017 J. Paul Getty Trust

Published by the J. Paul Getty Museum, Los Angeles
Getty Publications
1200 Getty Center Drive, Suite 500
Los Angeles, CA 90049–1682
www.getty.edu/publications

Beatrice Hohenegger and Rachel Barth, *Project Editors*
Katya Rice, *Manuscript Editor*
Jeffrey Cohen, *Designer*
Suzanne Watson, *Production*

Distributed in the United States and Canada by the University of Chicago Press
Distributed outside the United States and Canada by Yale University Press, London

Printed in China

Library of Congress Cataloging-in-Publication Data
Names: Brooks, Julian, 1969- author. | Nardi, Alessandra, editor. | J. Paul Getty Museum, host institution, issuing body.
Title: The lure of Italy : artists' views / Julian Brooks ; with the assistance of Alessandra Nardi.
Description: Los Angeles : J. Paul Getty Museum, [2017] | "This publication is issued on the occasion of the exhibition The Lure of Italy: Artists' Views, on view at the J. Paul Getty Museum at the Getty Center, Los Angeles, from May 9 to July 30, 2017." —ECIP galley. | Includes bibliographical references.
Identifiers: LCCN 2016037210 | ISBN 9781606065198 (hardcover)
Subjects: LCSH: Italy—In art—Exhibitions. | Art, European—Exhibitions. | Italy—Civilization—Exhibitions.
Classification: LCC N8214.5.I8 B76 2017 | DDC 709.45—dc23
LC record available at https://lccn.loc.gov/2016037210

Front jacket: Richard Parkes Bonington, *Riva degli Schiavoni, from near San Biagio, Venice*, 1826 (detail, fig. 15)
Back jacket: Jean-Pierre-Louis-Laurent Hoüel, *View of the Ruins of the Temple of Ceres in the Valley of Agrigento*, 1776–79 (fig. 40)
Page i: Pieter Moninckx, *View of Civitavecchia with the Harbor Wall*, ca. 1660 (detail, fig. 3)
Pages ii–iii: James Holland, *The Saint Mark's Basin, Venice*, ca. 1860 (detail, fig. 16)
Page iv: Claude-Joseph Vernet, *The Entrance to the Grotto at Posillipo*, ca. 1750 (detail, fig. 48)
Page viii: Giovanni Battista Piranesi, *An Ancient Port*, 1749–50 (detail, fig. 34)
Page x: Map of Italy by David L. Fuller, DLF Group
Page 76: Jean-Honoré Fragonard, *Ruins of an Imperial Palace, Rome*, 1759 (detail, fig. 31)
Page 78: Giovanni Battista Lusieri, *A View of the Bay of Naples, Looking Southwest from the Pizzofalcone toward Capo di Posillipo*, 1791 (detail, fig. 14)
Page 84: Ernst Fries, *Via Appia Antica with the Tomb of Cecilia Metella*, 1824 (detail, fig. 53)

CONTENTS

FOREWORD

For so many artists over the centuries a study visit to Italy was a period of formation, awakening, or inspiration. Many Italian artists also benefited from the spell that their country cast on visitors, and used their talents to create highly desirable artworks as souvenirs. In the history of Western art, this vital reciprocation has yielded works of an extraordinary visual poetry. Some of the finest examples of such works from the Getty Museum collection illustrate this book, which stands as a happily readable introduction to the subject.

Simple sketches, finished drawings, exquisite watercolors, exhibition paintings, and a handful of photographs together here reflect the creativity inspired by some of the landscapes, cityscapes, and artworks so central to the history of Western art. While the epic scale of collecting and trophy-hunting in the golden age of the Grand Tour marked the undisputed zenith of artistic production for the tourist trade, it is easy to forget the wider context for this activity in preceding and succeeding ages, as elucidated in this book.

I would like to thank Julian Brooks, senior curator and head of the Drawings Department, who has conceived and curated this exhibition, assisted by Alessandra Nardi, former graduate intern, and Annie Correll, current graduate intern; Beatrice Hohenegger, senior editor, and Rachel Barth, assistant editor; Jeffrey Cohen, senior designer, and Suzanne Watson, senior production coordinator; as well as the rest of the team at Getty Publications. They have produced this beautiful little book, which does much to evoke the lure that Italy has had, and continues to have, for art lovers the world over.

TIMOTHY POTTS
Director, The J. Paul Getty Museum

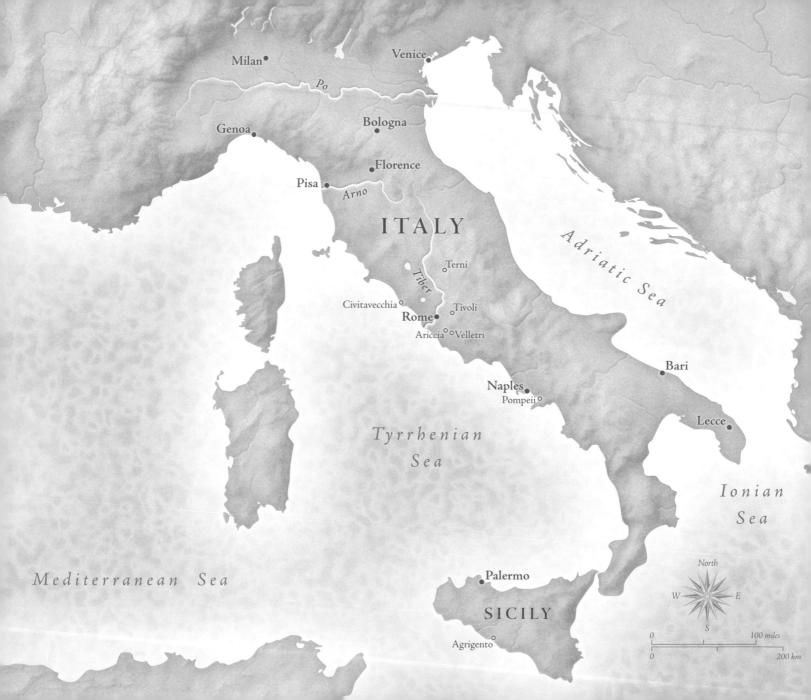

Milan

Venice

Po

Genoa

Bologna

Florence

Pisa

Arno

ITALY

Terni

Tiber

Civitavecchia

Tivoli

Rome

Ariccia Velletri

Adriatic Sea

Bari

Naples

Pompeii

Lecce

*Tyrrhenian
Sea*

*Ionian
Sea*

Mediterranean Sea

Palermo

North

W E

SICILY

S

0 100 miles

Agrigento

0 200 km

INTRODUCTION

Think of Italy. What comes to mind? Monuments, works of art, scenery? Italian food or wine, music, opera, science, design, sunshine, fashion, literature, cinema? Trying to pin down the essence of any country is almost impossible; doing so with Italy seems just pointless, especially since it was until 1871 a collection of different city-states.

Yet when one considers why artists across the centuries became so enamored of Italy, threads start to emerge, and we can assess these through their many surviving drawings and sketchbooks. Aspects that loom large are the remains of the fabled Roman Empire, which dominated the continent—and beyond—for so long: the landscape, often naturally dramatic or scenic, dotted with fortresses, ruins, and hill towns that fire the imagination; historic cities such as Rome, Florence, and Venice, with their roles as cradles of Renaissance culture; and the buildings, classical sculptures, and monuments in cities across the peninsula that emerge from layers of history. Visiting artists and tourists could record these aspects easily with sketches, and for centuries a sojourn in Italy was regarded as a key—almost obligatory—part of a young artist's training. As time went on, Italian artists created enchanting works of art as souvenirs for visitors, and there ensued a mainly happy dance between art and commerce.

With these aspects as its themes, this little book is a narrated assemblage of beautiful images that can transport the reader effortlessly to Italy, rekindling memories, setting intentions, or provoking curiosity. The book is not intended to be exhaustive or exhausting. Given the vast subject matter, omissions abound; of the millions of images worldwide, only a tiny sample is included here, all from the collection of the J. Paul Getty Museum. The book thus inevitably reflects the nature of one specific collection, with an emphasis on drawings. The Museum does not collect American drawings and paintings, so this transatlantic angle is omitted, nor does it collect prints, so the huge corpus of prints pertinent to the theme is not covered. Nevertheless, it is hoped that the selection will give pleasure as an introduction to an extraordinary topic. A list of suggested further reading is provided at the back for those who wish to continue their virtual travels.

Cityscapes

Yes, I have finally arrived in the First City of the World!...
All the dreams of my youth coming to life...
Only in Rome is it possible to understand Rome.

—JOHANN WOLFGANG VON GOETHE, *Italian Journey*, 1786–88

Italy has some of the most distinctive and recognizable cityscapes in the world, in particular those of Venice, Florence, and Rome. These cities and views, although constantly evolving and changing, have largely avoided the catastrophes of war, and medieval or Baroque landmarks continue to dominate the skyline. While the canals of Venice combine with the Gothic style of the Doge's Palace and the Baroque Santa Maria della Salute, the image of Florence is marked by the early Renaissance Duomo, the Palazzo della Signoria, and the Arno River bisecting the city. Rome, with the Tiber River at its heart, boasts classical remains, Saint Peter's, and the natural feature of the seven hills. These evocative cityscapes and vistas became the focus of much artistic attention, and artists' renditions of them have been a staple of the souvenir trade from the moment they took shape.

Filippo Brunelleschi's dome for the cathedral of Florence, which became the grandest structure on the Italian peninsula on its completion in the mid-1400s, appears at the right of Giovanni Stradanus's *The Arno with Fishermen* (FIG. 1). This design for a tapestry, one of a

Figure 2 · Federico Zuccaro, *View of Saint Peter's*, 1603

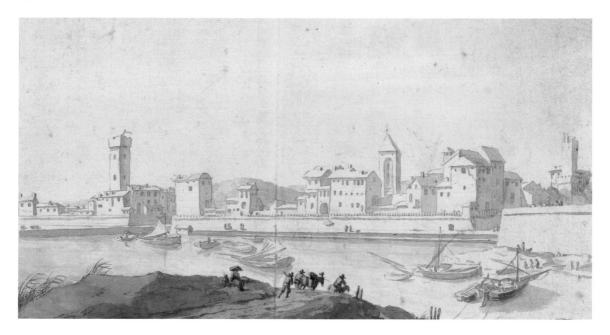

series of hunting and fishing scenes, was drawn in rich media with washes and opaque water-color. The focus is on the fishermen working at low tide, but the cityscape places the action in Florence; the artist added a patch at the lower center to include a classically allusive river god as a personification of the Arno.

While the towering dome of Saint Peter's, designed by Michelangelo and others, was intended to be grander than the Duomo of Florence, it is easy to forget the part now played in this grandeur by Carlo Maderno's facade of the early 1600s and Gian Lorenzo Bernini's two colonnades in front (the embracing "arms"). Federico Zuccaro's sketch of 1603, seemingly made for his own casual interest, shows the jumble of buildings that existed beforehand (FIG. 2). Its red chalk medium, convenient and functional, is in stark contrast to the pen-and-ink and watercolor technique used by the Dutchman Pieter Moninckx for his view of Civitavecchia, the port of Rome (FIG. 3). The washes capture the warmth of sunlight rather

than architectural details, and the careful placement of travelers in the foreground adds extra human activity.

By far the greatest surge in the production of views (*vedute*), by both Italian and visiting artists, occurred in the 1700s, when the growing numbers of wealthy travelers to Italy on the Grand Tour created a huge demand for souvenirs. For many young, mainly British, noblemen, the Grand Tour was considered the completion of their education; cultural experience was believed to foster maturity, judgment, and taste. The Tour, which typically lasted from twelve to twenty-four months, almost invariably included sojourns in the major cities in Europe, but the ultimate goal was generally Italy, whose greatest attractions were the cities of Florence, Rome, Naples, and Venice. The painted, drawn, or engraved *veduta* triggered Grand Tourists' memories of a city, enabling them to recall specific sights and places, and when displayed, also demonstrated their cultural sophistication.

The city that became almost synonymous with the genre of the *veduta* was Venice, *La Serenissima* (the most serene) republic, and every visitor seemed determined to take home a view of the extraordinary city. The father of the *veduta* in Venice was Luca Carlevarijs, who was often employed to paint scenes of the grand civic ceremonies to which visiting dignitaries were invited. The worthies were generally given a painting to take home, a practice that nourished the overseas fascination with the grandness and opulence of Venice. In one painting Carlevarijs recorded the preparations for the annual symbolic marriage of the city of Venice to the Adriatic Sea, featuring the magnificent two-story Bucintoro, or Boat of State, in front of the Doge's Palace (FIG. 4).

The most celebrated practitioner of the *veduta* was Giovanni Antonio Canal, called Canaletto, whose work was sought after by travelers on the Grand Tour. A painting of the Grand Canal from the late 1730s, when Canaletto was at the height of his powers, shows the trademark precision that so effectively captured the details of aging palazzi and their reflections in the water in the crystal-clear Venetian light (FIG. 5). His nephew Bernardo Bellotto became his apprentice and worked in a similar style; the example here shows a view looking out from the entrance of the Grand Canal, with the Baroque dome of Santa Maria della Salute dominating the composition (FIG. 6).

If the work of Canaletto and Bellotto seems photographic to modern eyes, this is partly because Canaletto used an optical device, the camera obscura, to help him capture his scenes. A drawing of the Campo San Basso, close to San Marco (FIG. 7), shows the resulting linear

Figure 5 · Canaletto (Giovanni Antonio Canal), *The Grand Canal in Venice from Palazzo Flangini to Campo San Marcuola*, ca. 1738

Figure 6 • Bernardo Bellotto, *View of the Grand Canal: Santa Maria della Salute and the Dogana from Campo Santa Maria Zobenigo*, ca. 1743

Figure 7 • Canaletto, *The Campo S. Basso: The North Side with the Church*, 1740s

Figure 8 • Canaletto, *A Market Scene*, 1740s

style. Yet his reliance on devices such as this was not total, and the appearance of verisimilitude in the drawing is deceptive; the church bells at the upper right of the drawing actually belong to a rooftop two buildings away. The inscription written by Canaletto at the upper left, with the word *volta* (turn), is a reminder of the sketch on the verso, which features a lively market scene, with vendors selling fruits and vegetables from baskets (FIG. 8).

Manipulation of scenes, often to the extent of choreographing buildings or uniting composite viewpoints in a single painting, is found frequently in Canaletto's work. His keen eye for composition may have derived from his training as a designer of theatrical sets; it is notable that several other prominent Italian *veduta* painters of the period, including Giovanni Battista Piranesi and Giovanni Paolo Panini, also began their careers in that way. The crossover between the two crafts involved not only a deep awareness of composition but also the use of oblique perspective and dramatically focused light and shade for enhanced optical illusion.

Canaletto's work was particularly valued by English Grand Tourists, whom the Italians referred to as the *milordi*. When the number of visitors to Venice dropped in the 1740s as a result of the War of the Austrian Succession, Canaletto turned his talents to producing etchings, easier to sell at a distance and less risky to ship (being multiples and less valuable). He produced thirty-four different etching designs of the highest quality, selling the products principally in bound volumes. In 1746 Canaletto moved his studio to London, still producing Venetian *vedute* for English patrons but also making Italianate views of England. He remained there for ten years.

Venice was once dear, the pleasant place of all festivity,
the revel of the earth, the masque of Italy.

—LORD BYRON, *Childe Harold's Pilgrimage*, 1812–18, canto IV

Francesco Guardi, a similarly prolific painter of Venetian *vedute* for Grand Tourists, instead remained in and around Venice all his life. He generally used a more muted palette, and his style tended to be more restless and fidgety, even when painting the calm Grand Canal in the early morning (FIG. 9). The prominent palazzo at the left is the Palazzo Bembo; the

two-toned nature of its facade reveals a recent addition to the Renaissance structure. As a draftsman, Guardi's style was energetic and light, and he used the white of the paper to effectively convey the crystal-clear light of the city. His *Regatta on the Grand Canal* (FIG. 10) encapsulates the sheer elegance and pomp of such events, in a manner calculated to appeal to his Grand Tourist clientele. But like Canaletto, Guardi often manipulated the buildings, spaces, and perspectives of his views to improve the composition. His drawn view of Campo San Polo, for example, makes the square seem larger and grander than in reality (FIG. 11). The spectacularly delicate use of brown wash animates the scene with mobile effects of light. These same effects were brought to Guardi's renowned painted and drawn *capricci*, composite or entirely artificial scenes in which he could give his imagination entirely free rein (FIG. 12). In this case he imagined a Venetian-style lagoon with ships and a fortress. The limits of the composition are demarcated by neat ruled lines, signaling its role as a finished work of art to be sold, rather than a preliminary sketch; such *capricci* were avidly collected by Grand Tourists.

For much of the eighteenth century, Italian artists created small works in opaque watercolor (often called bodycolor or gouache, its opacity due to the addition of lead white); these were produced as small souvenirs, perfectly portable for the traveling Grand Tourist. Marco Ricci, the nephew of the Baroque artist Sebastiano Ricci, painted a work of this kind on dark brown tanned leather, the darkness of which lent additional drama to his image of a storm (FIG. 13). He may have adopted the use of leather as a support following a sojourn in England—he had escorted the Grand Tourist Lord Montagu there from Venice in 1708.

While the use of *opaque* watercolor was not uncommon, very few eighteenth-century Italian artists adopted the medium of *pure* watercolor, which some British artists, such as John Robert Cozens, had pioneered on their visits to Italy. But one Italian artist, Giovanni Battista Lusieri, became famous for his use of it. Lusieri began his career in Rome but moved to Naples in 1782 as a result of intense competition among *veduta* painters. He developed a format of large-scale watercolor *vedute*, observed and depicted with extraordinary precision. His breathtaking panoramic view of the Bay of Naples, made on six large sheets of paper joined together, measures nearly nine feet across (FIG. 14). It evokes the beauty of the famous view not only through scale and accuracy (the details all painstakingly drawn in pencil) but also through the subtle and atmospheric use of watercolor. Painted for Sir William Hamilton, British envoy to the court of Naples, it was created over a period of two years in a top-floor room at the

Figure 10 · Francesco Guardi, *A Regatta on the Grand Canal*, ca. 1777

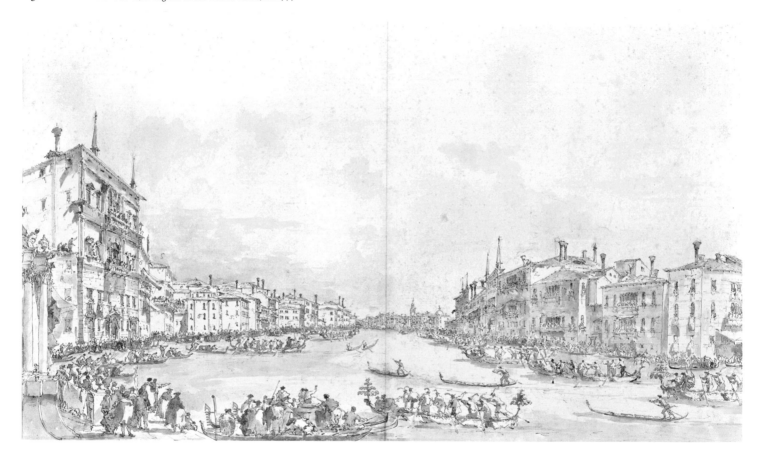

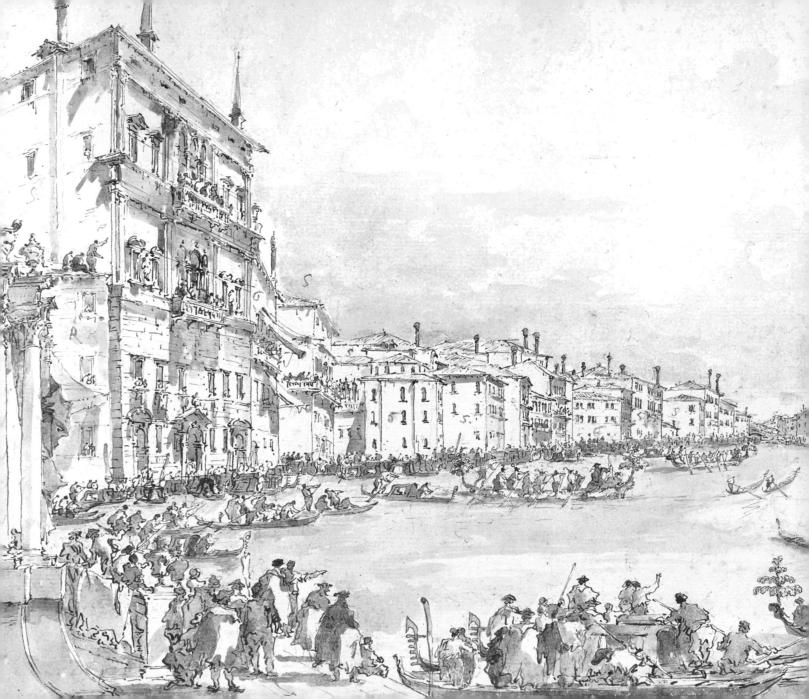

Figure 11 • Francesco Guardi, *View of Campo S. Polo,* ca. 1790

Figure 12 • Francesco Guardi, *An Imaginary View of a Venetian Lagoon, with a Fortress by the Shore,* ca. 1750–55

Figure 13 • Marco Ricci, *Fishing Boats in a Storm*, ca. 1715

Palazzo Sessa, his residence in the city. Although this particular view was made from the comfort of an interior space, most of Lusieri's views were created in the open air, with the artist even applying the watercolor washes there, to the astonishment of his contemporaries (who expected artists to work in their studios on the basis of pencil sketches made outside). It has been speculated that Lusieri used a camera obscura, but none of the many eyewitness accounts of his working practice mention this.

Figure 15 • Richard Parkes Bonington,
Riva degli Schiavoni, from near San Biagio,
Venice, 1826

If we move to Richard Parkes Bonington's watercolor of Venice of about thirty years later, it is clear that we have entered a different age. In the interim, the Napoleonic Wars had wreaked havoc with the continent and made travel difficult. In 1817, two years after the wars ended, Bonington moved to France and fostered a new style of watercolor painting. In England the medium had undergone a boom as a result of the development and production of commercial watercolor cakes, a major convenience. Tiny and jewellike, Bonington's watercolor of Venice features loose yet deftly controlled washes that capture the city's effects of light and water with unprecedented freshness (FIG. 15). The grand Doge's Palace is relegated to the background; the principal subject, while ostensibly a large docked ship, is actually the water and the sky.

Bonington visited Venice only once in his short life—in the spring of 1826, when he was twenty-three years old (he died at twenty-five of tuberculosis)—but he pioneered a new artistic visualization of the city that dominated nineteenth-century depictions and was central to John Ruskin's later promotion of it. Such works satisfied the desires of a generation of armchair travelers and collectors who frequented the various watercolor exhibition societies in London. The continuing inspiration of this aesthetic is evident in James Holland's larger panoramic view made from a similar spot nearly thirty-five years later (FIG. 16). In it, the American flag flown by a ship at the right reminds us of the shifting nationalities of visitors to Venice.

Of course the master of the imagining of Europe, and especially Italy, in the nineteenth century was J. M. W. Turner, who worked, like Bonington, in both watercolor and oil. Arguably unrivaled in both media at creating a sense of atmosphere beyond topography, Turner created in his oil of Rome's Campo Vaccino an essay on the power of color and light (FIG. 17). Envisioned through a veil of memory—he had not visited the city for ten years—the ruins around the Forum and the neighboring Baroque churches dissolve into the evening haze, caught between the sunset and the rising moon at left.

Even if Turner was curious about—and perhaps concerned by—the arrival of photography, he could never have predicted how ubiquitous it would become. By the second half of the nineteenth century, many artists were exploring its uses and capabilities. James Anderson, a Scottish painter and sculptor who moved to Rome in 1838 at age twenty-five, made reproductions of works of art as well. Renowned for their fidelity, these images were exhibited across Italy and came to fill the role that engravings and etchings had played for centuries. Anderson also experimented with views and vistas, such as that of Naples (FIG. 18). Compared

Figure 16 · James Holland, *The Saint Mark's Basin, Venice*, ca. 1860

Figure 18 · James Anderson, *Naples Panorama*, ca. 1845–77

with Lusieri's view, the bay is seen from the opposite direction, with Vesuvius in the right background.

The three brothers Leopoldo, Giuseppe, and Romualdo Alinari founded the Fratelli Alinari in Florence in 1854, specializing in portraits and photographic reproductions of works of art. A view of the Palazzo Vecchio (or Palazzo della Signoria) in Florence documents it with

Figure 20 • Fédèle Azari, *Piazza San Marco, Venice,* 1920s

Figure 21 • Fédèle Azari, *Aerial Shot of an Airplane over Venice,* 1920s

rare serenity (FIG. 19). Michelangelo's *David* is seen with a protective structure above, before its transfer to the Galleria dell'Accademia in 1873. The Alinaris' work was widely circulated and became the core of many *fototeche,* the photographic archives of images that facilitated the comparison of works of art in different locations. These in turn drove the practice of connoisseurship and early art history while further advertising the original works of art and bringing visitors to see them.

Yet nothing can capture the excitement of using the new photographic technology better than two images by Fédèle Azari, a former World War I fighter pilot, who combined it with the fledgling phenomenon of powered aerial flight (FIGS. 20, 21). His majestic view of the Piazza San Marco in Venice used photography to instantly crystallize views that four hundred years earlier the painter and printmaker Jacopo de' Barbari had created through three years of intense labor and calculation. Azari's view is now witnessed by the scores of visitors to Venice who arrive every day by air, lured by the magical mix of experiences and sights offered by the city.

Art, Ancient and Modern

*These speaking ruins have filled my spirit with images
that accurate drawings, even such as those of the immortal Palladio,
could never have succeeded in conveying,
though I always kept them before my eyes.*

—GIOVANNI BATTISTA PIRANESI, *Prima Parte di architetture e prospettive*, 1743, dedication

One of the pleasures of becoming acquainted with the history of European art is witnessing the cross-cultural influences in the visual arts and seeing the way that these shift, rebound, and echo over the centuries. Visits to Italy, by both artists and patrons, were a key factor in this process. And certainly one of the principal appeals of Italy to artists was—and is—the ready availability of ancient and modern artworks to serve as both inspiration and model. From Renaissance times the traditional training of an artist included studying works by ancient and modern masters, generally by making drawn copies. Artists assimilated the style and forms of antique statues and the work of masters such as Raphael, Michelangelo, and Leonardo da Vinci in order to educate themselves and to expand their visual repertoires, just as Michelangelo as a youth had learned by copying the works of Masaccio and others. Drawing was considered a process of research and a way of understanding the form and expressive potential of the human figure.

Many of the works deemed worthy of study by Renaissance artists are featured in a series of twenty drawings made by Federico Zuccaro showing the peregrinations of his older brother, Taddeo Zuccaro, as he sought an artistic apprenticeship in Rome in the 1540s. Key to Taddeo's studies were the ancient statues, extraordinary relics of Rome's glorious past, that were dug from the soil of the city, much to the excitement of artists and connoisseurs. These constituted for many a canon of beauty and perfection. In one sheet Federico depicted his brother in the Vatican's Belvedere Court, home to the papal collection of antiquities, sketching its most famous marble statue: the group of Laocoön, the Trojan priest and his sons violently struggling to free themselves from two serpents seeking to devour them (FIG. 22). Discovered in Rome on January 14, 1506, this Hellenistic masterpiece became the icon of human agony in Western art. Three other celebrated antique sculptures are also shown, all of which were discovered in the span of a few years: the Apollo Belvedere, considered an

Figure 23 • Federico Zuccaro, *Taddeo Drawing after the Antique; In the Background Copying a Facade by Polidoro*, ca. 1595

Figure 24 • Federico Zuccaro, *Taddeo Copying Raphael's Frescoes in the Loggia of the Villa Farnesina, Where He Is Also Represented Asleep*, ca. 1595

exemplar of aesthetic perfection, on the left, and the Nile and the Tiber in the center. The papal collection of antiquities contained the choicest works and seems to have been made available to artists and other selected visitors, but there were also many private aristocratic collections of antiquities, often assembled not only for the owner's personal enjoyment but also as sources of inspiration for painters and poets.

Another drawing from the series shows Taddeo in the entrance hall of a private palazzo, copying a classical Roman torso set on a carved pedestal with a relief (FIG. 23). In the background he is seen copying a decorated palace facade by Polidoro da Caravaggio, who specialized in enlivening facades with monochrome frescoes that imitated ancient marble or bronze reliefs. The Renaissance vogue for such painted facade frescoes, with their public locations on streets and piazzas, was a boon for young artists, who could study them whenever they liked. Contemporary accounts note how avidly copied they were, and numerous surviving drawn copies—generally unsigned and by artists unknown—also testify to their popularity. A number of the drawings in the Early Life of Taddeo Zuccaro series show Taddeo studying painted facades, an aspect perhaps emphasized because his own first major commission was for the facade of the Palazzo Mattei. That fresco, in common with scores of similar works in many Italian cities, suffered the ravages of the weather and time, and no longer survives.

Thankfully fully preserved, given its semi-indoor location opening onto the garden at the back of the Villa Farnesina, is the loggia of Cupid and Psyche, painted by Raphael and his assistants. Freely accessible to artists throughout the sixteenth century, the loggia also features in the Zuccaro series: Federico depicts his brother copying Raphael's frescoes by the light of a crescent moon (FIG. 24). The striking effects of moonlight give an almost religious appearance to the scene. Taddeo, completely bathed in light, looks up in rapt attention, as if experiencing a mystical vision. In the background the exhausted artist has fallen asleep, his sketching board still on his knees.

Through the centuries, Raphael's Farnesina frescoes continued to fascinate artists, even if their approaches varied. Pieter van Lint, a Flemish artist who visited Rome in 1633, produced a series of detailed drawings after Raphael's spandrel decorations for the Loggia di Psyche in the Villa Farnesina, probably made as designs for prints (which in turn spread the fame of the frescoes). In a twist on the subject depicted, the rendition of Venus directing Cupid to strike with an arrow of love expresses a combination of Italian and Netherlandish elements (FIG. 25). It shows figures drawn after Raphael, one of the greatest masters of the

Figure 25 • Pieter van Lint, *Venus and Cupid (after Raphael)*, 1636

Figure 26 • Peter Paul Rubens, *Anatomical Studies*, ca. 1600–1605

nude, but at the same time it warns the viewer of the dangers of loving the nude too much, with the—typically Northern—moralizing inscription "Nudity speaks, he who loves me much loses health, goodness, and his soul."

While Raphael's paintings were the source of inspiration for artists interested in elegant and classical forms, Michelangelo's work was admired for its vigorous muscular figures. Even if the Sistine Chapel was a private chapel within the Vatican, the existence of many drawn copies of Michelangelo's frescoes, particularly *The Last Judgment*, with its groups of figures and wild variety of human poses, suggests that there must have been concessions made to artists who wished to study them. The Flemish artist Peter Paul Rubens, who traveled to Italy in the early 1600s when he was in his twenties, was fascinated by the heroic musculature and the flowing energy of Michelangelo's bodies. The influence of the great master is clearly shown in an anatomical study that depicts one monumental male nude seen from the rear and one frontally striding forcefully forward (FIG. 26). The sculptural effect is achieved with a dense and varied hatching; dark brown lines reinforce the contours of the form, the undulations of which also provide movement. The drawing was probably made in preparation for an instructional book on anatomy, which was never published, and was also likely influenced by the work of Leonardo da Vinci, Willem van Tetrode, and Pietro Francavilla in this field.

During his Italian sojourn, Rubens was also particularly struck by Leonardo's earlier explorations into how mental attitude could be conveyed through pose and gesture. The impact of Leonardo's *Last Supper* is evident in a drawing showing the apostles set in three groups in intense conversation (FIG. 27). This drawing is not a slavish copy after Leonardo but rather the result of a process of assimilation and personal invention. The drawing also shows some of Rubens's other inspirations: the seated disciple derives from Caravaggio's *Calling of Saint Matthew* in the Church of San Luigi dei Francesi in Rome; the apostle with his hands in front of his chest recalls Raphael's *Last Supper*, which Rubens knew from an engraving by Marcantonio based on Raphael's design; and the man at the upper right derives from Michelangelo's *Ezechias* spandrel in the Sistine Chapel.

For any aspirational Flemish or Dutch artist of the time, a stint in Italy, especially in Rome, was considered a vital step, providing exposure to the principles of classical art and perhaps giving the opportunity to acquire papal or aristocratic commissions. Northern artists working in Rome about 1620 founded the Schildersbent group, a fraternal organization dedicated to social fellowship and mutual assistance. Its members called themselves

Bentvueghels—birds of a feather—and had individual nicknames that related to their char-
acter or appearance. An early member of the group, Cornelis van Poelenburgh, nicknamed
the Satyr, was among a number who depicted the city with its architectural ruins and sculp-
tural fragments; these were felt to offer poetic meditations on human grandeur and fragility
and the passage of time. In 1623 he drew the Arch of Septimius Severus from an unusual
side angle (FIG. 28). Omitting several architectural features, the artist focused on the con-
trasting patterns of deep shadows juxtaposed with brilliantly illuminated passages created

Figure 28 • Cornelis van Poelenburgh, *The Arch of Septimius Severus, Rome*, 1623

by blank reserves of white paper. Along with other Northern European artists, Poelenburgh tended to be more interested in capturing the southern light and its atmospheric subtleties than in giving a purely faithful representation of classical ruins.

After returning to their countries, these artists transmitted the lessons of antiquity to patrons, colleagues, and scholars in Northern Europe through their sketchbooks, drawings,

and especially prints, often used in private drawing schools or academies. As not everyone had the opportunity to travel, these examples could provide a surrogate for the original artworks. In a particularly curious case, it seems that Jan de Bisschop, who played a major role in disseminating the classical style in the Netherlands via two important series of prints for students to draw from, never went to Italy himself. His prints must have derived from copies made in Italy by friends and from Italian drawings and other models available to him in Dutch collections. In one of his drawings based on antique reliefs, de Bisschop depicted the dramatic myth of Niobe, queen of Thebes, whose seven sons and seven daughters were killed by the Greek deities Apollo and Diana as punishment for her arrogance (FIG. 29). Adopting a horizontal format, he conveyed the scene's drama through energetic motion and the rhythmic repetition of figures and horses. The composition is unified by the adept use of brown wash combined with brilliant reserves of paper, which also serve to heighten the three-dimensionality of the sculpture.

Many French artists also spent time in Rome, filling their sketchbooks with copies after antique and Renaissance models. A central figure was the meditative and intellectual Nicolas Poussin, who lived in Rome between 1612 and 1655. Poussin drew many details from classical sculptures, especially reliefs and sarcophagi, and used these in his classical paintings. In one elaborate drawing he studied a bronze tripod, a draped torso, a sandaled foot, a bust of a Roman boy, and an Etruscan mirror, arranging them on the sheet with an unusual attention to harmony and layout (FIG. 30). Poussin would have been acquainted with some of these objects through the drawings collected by his friend and patron Cassiano dal Pozzo, who brought together more than a thousand copies after the antique as part of the seven thousand sheets in his "paper museum" (other sheets depicted species of animals, birds, flora and fauna, and geological specimens). As time went on, there was an increasing codification of sites and sights—the must-sees for a visiting artist or connoisseur. The Englishman Jonathan Richardson Jr. toured Italy in 1720 and recorded notes of what he saw. The resulting book, *An Account of Some of the Statues, Bas-Reliefs, Drawings, and Pictures in Italy, etc. with Remarks*, was cowritten with his father and published in London in 1722. This text became vital reading for any gentleman or artist traveler.

One of the highest awards for a French artist was the Grand Prix or Prix de Rome, which allowed the most promising students to spend between three and five years at the Académie de France in Rome to complete their education through the assimilation of the principles of

Figure 30 • Nicolas Poussin, *Studies of Antiquities,* ca. 1645

the greatest works of ancient and modern art and through the study of the antique in situ. Among those who were awarded the Grand Prix was Jean-Honoré Fragonard, who spent five years in Rome between 1756 and 1761. One of his elaborate red chalk drawings depicts a view of the northeast corner of the Palatine Hill, with the Farnese Gardens visible above the embankment that separates them from the Roman Forum (FIG. 31). He brilliantly conveyed the subtle interactions between the antique ruins of the imperial palace and the natural world in which they existed. His mastery of the red chalk medium is evident in the range of textures and values he explored by varying the pressure of the chalk, also using the blunt edge of the chalk to suggest shadows and the sharp edge to create details.

During his Italian sojourn Fragonard befriended Hubert Robert, who had arrived in Rome in 1754 and would spend the next eleven years in Italy. Robert produced a series of drawings focused on the unsurpassed Capitoline Collection of ancient sculptures. Thanks to the enlightened policy of Pope Clement XII, it was opened as a public museum in 1734 and became a de facto "ideal academy" where art students could copy from the antique. In one of Robert's compositions, an artist sits on the floor in the center of a long gallery drawing a draped female statue placed in front of a pilaster (FIG. 32). Using red chalk, Robert sensitively rendered the effects of the diffuse light on the objects and the interior space. The row of motionless statues contrasts with the tiny figure of the draftsman, conveying the wonder and excitement that artists no doubt felt in encountering these celebrated ancient Roman works. Archaeological discoveries made while Robert was in Rome nurtured his life-long fascination with ruins, and his sketches of buildings and landscapes became a resource used for his paintings for many years afterward. (Robert made such a specialty of including immense, crumbling ruins as the focus of his paintings that he became known as "Robert des Ruines," Robert of the Ruins.)

After his return to Paris in 1765, Robert became renowned for picturesque views in which he placed ancient monuments in fantastical settings. In one of his watercolors, created as a finished and independent work of art, he incorporated the remains of the ancient Temple of Antoninus and Faustina on the site of the Roman Forum into a pastoral scene animated by peasants and animals (FIG. 33). A soft, diffuse light unifies the imaginary landscape, while touches of colored wash enhance the fantasy.

Giovanni Battista Piranesi, a famed archaeologist, designer, theorist, and etcher, also used ancient ruins as a point of departure for his own inspiration, creating imaginative

Figure 32 • Hubert Robert, *A Draftsman in the Capitoline Gallery*, ca. 1765

Figure 33 • Hubert Robert, *Landscape with Ruins*, 1772

Hubert Robert.

Figure 34 · Giovanni Battista Piranesi, *An Ancient Port*, 1749–50

reconstructions of ancient structures. One such drawing shows his re-creation of an ancient Roman port, a spectacularly assembled *capriccio* of architecture, sculpture, and dramatic atmosphere (FIG. 34). With dazzling effects of smoke and light, this sheet was a design for an etching, and it was through his etchings that Piranesi's vision became widely appreciated.

Piranesi's work was collected by many visitors to Rome on the Grand Tour, which particularly nourished a fascination for the antique. Grand Tourists were often accompanied by an informed guide who helped them explore the manners and monuments of earlier civilizations, which were regarded as having laid the foundations of a common European culture. As a souvenir of their Grand Tour of Italy, wealthy British travelers commissioned portraits of themselves by such eminent painters as Pompeo Batoni. In a painting commemorating his journey, the Englishman John Talbot, later the first Earl Talbot, is depicted informally posed in an open-air setting with the suggestion of a Roman landscape in the background (FIG. 35). The presence of famous ancient Roman sculptures around him—the Ludovisi Mars statue and the Medici Vase—amplifies his image as a learned and leisured aristocrat. The broken capital in the left foreground and the base of a column at the right refer as well to Rome's classical architectural heritage.

The Grand Tour also generated a category of drawings, paintings, and prints made especially to be acquired by these travelers, who demanded pictorial reminiscences not only of the places they had visited but also of the sights they had seen. Canaletto, now better known for the views of Venice that he sold to Grand Tourists, went to Rome as a young man with his father to start a career as a topographer. For a brief time in the 1740s he painted scenes of contemporary life set around the principal monuments of Rome, based on the drawings made during his earlier visit to the Eternal City or on engravings made by other artists. In one of these compositions created for the Grand Tour market, the Flavian Amphitheater, known as the Colosseum for the colossal statue of Emperor Nero that once stood nearby, is seen through the central bay of the Arch of Constantine (FIG. 36). Figures converse, stroll, or carry out daily chores in the vicinity of these ancient buildings. Wealthy tourists and their attendants are seemingly ennobled by the majestic monuments they are observing.

In the 1770s, Francesco Panini, the son of the *veduta* painter Giovanni Paolo Panini, created a series of six drawings of the famous frescoes of about 1600 by Annibale and Agostino Carracci in the gallery of the Palazzo Farnese, Rome. Panini's drawings were to be made into etchings as souvenirs for Grand Tourists, each set of six views of the "Carracci

Gallery" hand-colored with opaque watercolor. The descriptive design for the initial general view encompasses most of the celebrated barrel vault; the few artists admiring them give a sense of scale and emphasize the importance and exclusivity of the frescoes (FIG. 37).

Rome was the base for trips into the countryside in search of ancient classical material along the Appian Way and in scenic nearby hill towns such as Cori, with its temple of the god Hercules from the late first century BC. A visual reminder of its appearance in the late eighteenth century is given by a watercolor by Jacob Philipp Hackert (FIG. 38). Hackert

Figure 38 • Jacob Philipp Hackert, *The Temple of Hercules in Cori near Velletri*, 1783

became famous for his Italian landscapes, which ally a notion of the classical ideal with topographical and archaeological accuracy. Using the medium of opaque watercolor, he depicted with precision the remains of the temple, invaded by vegetation and flanked by modern buildings, including the campanile of the church of San Pietro. The impressive fluted columns of the temple dominate the figure of the elegant traveler, who steps out from behind a door onto a path that leads toward a landscape in the distance.

Excavation of the cities of Herculaneum and Pompeii, completely buried by the eruption of the Vesuvius volcano in AD 79, began in 1737 at Herculaneum and in 1748 at Pompeii. Boosted by the enthusiasm generated by the excavations, many artists and tourists started

traveling to Naples and its surroundings. Charles VII, king of Naples, imposed a ban on artists copying excavated objects—he wished to control their publication—but they were nevertheless often featured in the vast corpus of published literature. These works generally illustrated acknowledged masterpieces of ancient art and newly excavated objects and played an important role in the development of Neoclassicism in Europe. During a visit to the area the French artist Pierre-Adrien Pâris drew furniture and other archaeological objects with great precision and sensitivity. The drawing shown here (FIG. 39)—one of many—was the basis for an aquatint illustration in the important early travel guide to the sights of southern Italy, *Voyage pittoresque by the Abbé de Saint Non*.

The *Voyage pittoresque*, the scope and scale of which made it one of the most ambitious travel books ever published by a private individual, became the model for many later publications, such as Jean-Pierre-Louis-Laurent Hoüel's *Travel picturesque des isles de Sicile, Malte et de Lipari*. This four-volume travel book illustrates the beauty of those islands with panoramic views and describes their history with personal commentary. In the late 1770s Hoüel had spent four years traveling through Sicily, which at that point was a relatively unknown island. Moved by a spirit of discovery, Hoüel made dozens of detailed drawings of the sites and monuments he visited, later using them as models for the prints in his book. His interest in the landscape and culture of Sicily is shown in a panoramic view of the Valley of Agrigento, also known as the Valley of Temples (FIG. 40). The sun-drenched natural scenery contrasts with the man-made chapel of San Biagio, which was built on the ancient ruins of the Temple of Ceres. Renowned for his ability to convey the colors and atmospheric sense of a scene, Hoüel worked mainly in opaque watercolor, a practical and precise technique that used the light and convenient medium of paper but gave the intense colors of oil painting.

The excavations in Pompeii continued to attract visitors in the nineteenth century. Christen Schjellerup Købke was one of many Scandinavian artists to visit the site, where he made lively oil sketches, a then-emerging medium, as well as detailed drawings. After returning to his native Copenhagen, he painted the architectural remains of the forum with sharp precision, reproducing in oil the most subtly observed effects of light and atmosphere (FIG. 41).

In the second half of the century, with the rise of photography, the classical sites and their architectural remains were recorded by this new medium and made available to tourists as a visual reminder of the places they had visited. The Italian firm Sommer & Behles

Figure 40 · Jean-Pierre-Louis-Laurent Hoüel, *View of the Ruins of the Temple of Ceres in the Valley of Agrigento*, 1776–79

produced commercial photographs of the most visited sites and attractions in Pompeii and Herculaneum. Seeing the two-dimensional nature of photographs as a limitation, George Sommer began producing stereo photographs, or stereographs. When viewed through a stereoscope, two almost identical images, placed side by side, were merged into a unique three-dimensional image, creating an awe-inspiring illusion that set the standard for visual records at the time. One of Sommer's dramatic stereograph images was of plaster casts of individuals who had perished at Pompeii when Vesuvius erupted (FIG. 42). It serves as a reminder not only of Pompeii in particular but also of the constant march of technology as we seek to record and recreate aspects of the experience of Italy.

The Landscape

*Once you are in position you must take as the subject of your
drawing or painting what can be encompassed in one glance,
without moving or turning your head. . . . You must copy it as exactly
as possible, both in form and in color,
and do not think you can do better by adding or subtracting.*

— CLAUDE-JOSEPH VERNET, letter, 1765

For many artists visiting Italy in the 1600s, a key adjunct to their city life and study of collections was the possibility of venturing into the countryside and sketching there. But landscape paintings were still considered a minor genre; the nobler endeavor was to paint religious and historical subjects. In Italy, landscape painting was also widely seen as a Northern European specialty, the province of Dutch and Flemish artists in particular. Their role as visitors to Italy is generally viewed as contributing to the rising importance of landscape in the altarpieces and portraits made by Italian artists of the 1400s and 1500s. Landscape was at first used in Italian art as a schematic conveyor of place, but over time it became increasingly naturalistic and played a greater role in the composition. With the rise in the number of examples of painted, drawn, and printed pure landscape scenes came a growing recognition of the possibilities of landscape as a subject.

Figure 43 • Herman van Swanevelt, *A Wooded Landscape*, ca. 1629–43

Although artists in Italy began to sketch outdoors more frequently in the late 1500s and early 1600s, their practice was often driven by particular ruins, features, or sites. No place provided a more consistent and fertile chance to engage with these than the Campagna Romana, the countryside that surrounds the city of Rome. For those of a Romantic sensibility, it was a mythic place, its wooded and desolate landscape littered with antique ruins inspiring melancholic reflections on the fall and transience of worldly life. Favored spots in the Campagna Romana included Tivoli, Palestrina, and the Castelli Romani, southeast of the city.

The Dutchman Herman van Swanevelt moved to Paris in his early twenties and to Rome a few years later, in 1629, remaining there for more than a decade before returning to Paris. Grand Roman families, including the Barberini, collected his painted landscapes. Carefully composed, they drew on sketches of the countryside surrounding the city. One landscape has all the freshness and spontaneity of a drawing made on the spot, but its size and relatively high level of finish may indicate that it is instead an imaginative re-creation from memory (FIG. 43). In terms of technique, the drawing is a master class in how to describe a scene using only a brush with brown wash. Like his countryman Poelenburgh, Swanevelt was adept at using reserves of blank paper to create the impression of strong sunlight. The trees in the center are created by differing densities of wash, while the way in which their slender trunks capture the sunlight is skillfully rendered with long lines made with the point of the brush.

The Antwerp-born artist Sebastian Vrancx, reputed to be the master of Peter Paul Rubens, sketched to the east of Rome near Tivoli. This area boasted the ruins of several ancient Roman villas, most notably the Villa Adriana, but also dramatic natural scenery, wild and rocky, around a series of cascades and waterfalls in the river Aniene (or Teverone). Vrancx focused on the falls and the dilapidated contemporary buildings, using brief penwork for description and wash for the areas of darkest shadow (FIG. 44).

The French artist Claude Lorrain made more than thirty sketches in the same area, focusing on the landscape rather than the village architecture. While there is a structure of black chalk underdrawing beneath the composition of one such sketch, it is with the wash that it comes alive (FIG. 45). Shades of brown are used carefully to bathe the whole scene in a strong light from the left, unifying the composition, a characteristic effect of the artist. Darkened trees at the left are silhouetted against the light background, while others at the center are strongly lit—conveyed with the blank of the paper—against the darkened gorge. The tiny figures of travelers on the road give a sense of the grandeur and scale of the landscape. Claude used the

Figure 44 · Sebastian Vrancx, *View of Tivoli*, ca. 1600

Figure 45 · Claude Lorrain (Claude Gellée), *View of Tivoli*, 1640

immediacy of his drawings to create carefully choreographed landscape paintings, generating a style called the Ideal Landscape, in which he aimed on the canvas to surpass even nature in beauty, harmony, and refinement. The scenes were composed like stage sets, with a foreground, middle distance, and background, while elements such as trees and buildings were disposed with calculation. An example is a coastal view that incorporates in the foreground a moment from the story of the abduction of Europa, taken from Ovid's *Metamorphoses* (FIG. 46).

Claude had arrived in Rome about 1617, studying the landscape painting of Northern contemporaries there. His reputation grew, and from the late 1620s through the 1630s he produced etchings to propagate his fame further; his work became hugely popular with patrons, attracting numerous imitators and even the attention of forgers. The Claudian arrangement of nature on the canvas became a staple in landscape painting for centuries, influencing Richard Wilson and ultimately J. M. W. Turner in England. One of the key links in the chain was Francesco Zuccarelli, whose idyllic landscapes were popular with British Grand Tourists, and who went to work for long periods of his career in England. His paintings adopted a softer, more rococo coloring than Claude's and maintained a playful, carefree atmosphere; his large drawing *Landscape with Shepherds* centers its inaction on a tranquil river valley (FIG. 47). Made not as a sketch but as a work of art in its own right, it is signed with Zuccarelli's monogram at the lower left; nearby is a water bottle made from a gourd (*zucca*), a pun on his name that he often included in his work.

A French counterpart was Claude-Joseph Vernet, who was sponsored by patrons to go to Rome in 1734 and stayed there for nearly twenty years. He regularly sent paintings back to the Salon in Paris, becoming noted for his seascapes. Like Claude Lorrain, he made fresh, open-air sketches to inspire his work, such as one depicting the entrance to the so-called grotto at Posillipo (FIG. 48). The grotto, a tunnel cut by the ancient Romans to link Naples with the town of Pozzuoli, was admired as a feat of Roman engineering and for the drama of the tall, narrow, dark space. With a combination of scratchy penwork and gray and brown washes, Vernet focused instead on the bright approach to the tunnel; he colored the clear sky with a light brown wash so that he could amplify the effect of intense sunlight made with large reserves of blank paper at the right.

Just as artists were fascinated by the waterfalls near Tivoli, so they flocked to sketch those at Terni, to the north of Rome. Such sketches could be used as material for paintings but were also sold to Grand Tourists as works of art in their own right. The low viewpoint

Figure 47 • Francesco Zuccarelli, *A Landscape with Shepherds Resting under a Tree by a Cascade*, mid-1700s

Figure 49 • Louis-François Cassas, *The Cascades at Terni*, 1780

taken by Louis-François Cassas emphasizes the height of the falls and the power of the rushing waters, in keeping with the concept of the sublime, through which powerful natural phenomena could inspire a lofty sense of awe (FIG. 49). One of the leading explorers of the theme, the Romantic writer Johann Wolfgang von Goethe, noted the "unusual beauty" of Cassas's drawings, adding, "I have stolen a lot of ideas from him." Cassas reinforced his focus on the sublime by including tiny figures in antique dress who gesture in amazement at the falls; these characters may also refer to the falls' origin, when the ancient Romans diverted the Velino River into the Nera in 271 BC.

As much as Goethe may have admired Cassas, it was Christoph Henrich Kniep who became Goethe's personal draftsman. Having gone to Italy to study, Kniep based himself in Naples, where fellow landscape painters Jacob Philipp Hackert and Wilhelm Tischbein steered commissions his way and, in 1787, introduced him to Goethe. They became close friends. When Goethe wrote the renowned *Italian Journey* based on their travels, Kniep's drawings illustrated the publication. The imaginary classical landscape of Kniep's *Shepherd and Muses by a Waterfall* was probably derived from sketches made on that trip, but with the superhuman power of nature emphasized (FIG. 50). Antique figures at the lower right are dwarfed by an enormous natural arch framing the composition; in the background a huge waterfall cascades down. The scale of the drawing—it was made on a particularly large sheet of paper—serves the point as well. The artist's detailed depiction of each element of vegetation attests to the burgeoning scientific interests of the German Neoclassicists.

Kniep made numerous drawings and watercolors but very few oil paintings. During the late 1700s, however, a technique that fused the two grew hugely in popularity: painting on paper in oil. A small-scale example, less than half the size of Kniep's drawing, was painted by Jean Joseph Xavier Bidauld during a five-year sojourn in Italy, where his French patron had sent him to study (FIG. 51). In Italy he developed his distinct style in studies made directly from nature with characteristic cool lighting, meticulously painted foliage, and a sweeping vista, all these features conforming to the then-popular precepts of Neoclassical landscapes. Achieving freshness and precision, he paid close attention to the rich variety of greens and to the grays of distant mist and drifting smoke. On his return to Paris, Bidauld continued to work in this manner with great success, counting Charles IV, Napoléon, and Louis XVIII among his patrons. With his style changing little over the subsequent decades, he gradually fell out of favor and eventually died in poverty.

Figure 50 · Christoph Henrich Kniep, *A Shepherd and Muses by a Waterfall*, 1798

The writings of Goethe and his contemporaries, most notably Stendhal, inspired new generations to explore the joys of the Italian peninsula, and artists such as Ernst Fries filled sketchbooks with enchanting views. Just as the artists of the past had focused their attention on the countryside around Rome, so did Fries, staying in Ariccia over the summer of 1824. His sketch of the view from Ariccia treats the trees of the luxuriant forest as its principal subject, conveying their complex forms with a dynamic precision (FIG. 52). The hardness

Figure 52 • Ernst Fries, *View from Ariccia near Albano*, 1824

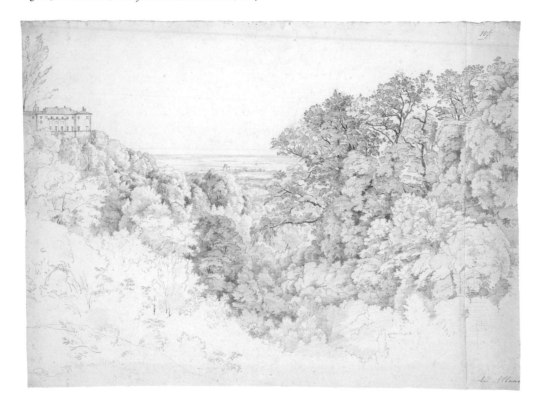

of the simple graphite medium, applied with varying pressure, is perfectly allied with this aim, and the white of the paper is carefully used for highlights. With ghostly poetry, large areas of the sheet are left undrawn. The same clarity of vision is brought to Fries's view of the Tomb of Cecilia Metella, a famous Roman monument on the Via Appia, the ancient road linking the Eternal City to the southeastern part of the peninsula (FIG. 53). Here the varying states of finish are even more pronounced, with the architecture subjected to particularly intense scrutiny and rendered with a beautiful combination of strokes hatched in varying directions.

Figure 55 • Robert Macpherson, *The Campagna near Rome,* 1850s

The Campagna. 4 miles from the Lateran Gate. on the Road to Naples.

Precisely the opposite effect was sought by Franz Albert Venus in his panoramic view from the Via Flaminia, the ancient road that linked Rome to northern Italy (FIG. 54). Ruins of Roman tower tombs, visible in the distance, are bathed in the soft, wintry light. Venus executed this watercolor on the spot, applying the medium with wonderful looseness and coloristic clarity. The composition is structured horizontally through contrasting tonal areas, and the whole conveys the artist's fascination with the unique atmosphere of this countryside.

The Scottish painter Robert Macpherson was also lured to the Campagna to make views, having moved to Rome for his health in 1840. In 1851 he made the transition from painter to photographer, capturing architectural views and romantic landscapes and selling prints to tourists from his shop in Rome. One such print shows the plains with the ruined remains of an aqueduct built by the emperor Claudius, the sporadic arches acting as a counterpoint to the still-used Via Appia Nuova at the lower right (FIG. 55). Elements of human activity stand as details in the foreground, while the background fades to an atmospheric haze. Interestingly, the artist chose to crop the image in an oval format, a nod to a device used by *veduta* painters of the past, with which he would have been familiar as a sometime art dealer.

Travelling is the ruin of all happiness.
There's no looking at a building here after seeing Italy.

—FANNY BURNEY, *Cecilia*, 1782

As tastes and tourists' preferences changed, so did the landscapes; towns and cities spread due to their burgeoning populations and increasing numbers of visitors. Coach tours may still crowd Tivoli, but the landscape of the Campagna is less visited. Following the run of the twentieth century, the hills of Tuscany are now arguably more famous than any other pure Italian landscape. Today visitors gravitate more toward destinations easily accessible by road or specific sites, in contrast with the ramblings undertaken by artists over the past centuries. Yet the widespread proliferation of photographic images makes everything more familiar to us, even as the renderings of the artists of the past can be powerfully evocative of a shifting historical perspective. The lure of Italy will continue and will undoubtedly take on new forms in the coming centuries.

FURTHER READING

Aymonino, Adriano, and Anne Varick Lauder, eds. *Drawn from the Antique: Artists and the Classical Ideal*. Exh. cat. (Sir John Soane's Museum, London, 2015). London: Sir John Soane's Museum, 2015.

Bisceglia, Angela. *Settecento siciliano: Immagine e immagini nel viaggio di Jean Houel*. Palermo: Lombardi, 2002.

Black, Jeremy. *Italy and the Grand Tour*. New Haven: Yale University Press, 2003.

Bon Valsassina, Caterina, Sandrina Bandera, Ada Masoero, and Fernando Mazzocca, eds. *Il fascino e il mito dell'Italia dal Cinquecento al contemporaneo*. Exh. cat. (Villa Reale di Monza, 2015). Milano: Skira, 2015.

Bowron, Edgar Peters, and Peter Björn Kerber, eds. *Pompeo Batoni: Prince of Painters in Eighteenth-Century Rome*. Exh. cat. (Museum of Fine Arts, Houston, 2007). New Haven: Yale University Press, 2007.

Brooks, Julian, ed. *Taddeo and Federico Zuccaro: Artist-Brothers in Renaissance Rome*. Exh. cat. (J. Paul Getty Museum, Los Angeles, 2008). Los Angeles: J. Paul Getty Museum, 2007.

Chaney, Edward. *The Evolution of the Grand Tour: Anglo-Italian Cultural Relations since the Renaissance*. London: Cass, 2000.

Fino, Lucio. *Vedutisti e incisori stranieri a Napoli nella seconda metà del '700*. Naples: Grimaldi, 2003.

Haskell, Francis, and Nicholas Penny. *Taste and the Antique: The Lure of Classical Sculpture, 1500–1900*. New Haven: Yale University Press, 1994.

Kerber, Peter Björn. *Eyewitness Views: Making History in Eighteenth-Century Europe*. Exh. cat. (J. Paul Getty Museum, Los Angeles, 2017). Los Angeles: J. Paul Getty Museum, 2017.

Maffioli, Monica, ed. *Fotografi a Pompei nell'800 dalle collezioni del Museo Alinari*. Exh. cat. (Casina dell'Aquila, Pompei Scavi, 1991). Florence: Alinari, 1990.

Morel, Philippe, ed. *J. H. Fragonard e H. Robert a Roma*. Exh. cat. (Villa Medici, Rome, 1990–91). Rome: Palombi, 1990.

Noon, Patrick J. *Richard Parkes Bonington: The Complete Drawings*. New Haven: Yale University Press, 2011.

———. *Richard Parkes Bonington: The Complete Paintings*. New Haven: Yale University Press, 2009.

Paolucci, Antonio, ed. *La bella Italia: Arte e identità delle città capitali*. Exh. cat. (Reggia di Venaria, Turin, 2012). Milan: Silvana, 2011.

Pedrocco, Filippo. *Il Settecento a Venezia: I vedutisti*. Milan: Rizzoli, 2001.

Redford, Bruce. *Venice and the Grand Tour*. New Haven: Yale University Press, 1996.

Stebbins, Theodore E., and William H. Gerdts, eds. *The Lure of Italy: American Artists and the Italian Experience, 1760–1914*. Exh. cat. (Museum of Fine Arts, Boston, 1992). New York: Abrams, 1992.

Weston-Lewis, Aidan, and Fabrizia Spirito, eds. *Expanding Horizons: Giovanni Battista Lusieri and the Panoramic Landscape*. Exh. cat. (Scottish National Gallery, Edinburgh, 2012). Edinburgh: National Galleries of Scotland, 2012.

Wilton, Andrew, and Ilaria Bignamini, eds. *Grand Tour: Il fascino dell'Italia nel XVIII secolo*. Milan: Skira, 1997.

———. *Grand Tour: The Lure of Italy in the Eighteenth Century*. Exh. cat. (Tate Gallery, London, 1996–97). London: Tate Gallery Publications, 1996.

LIST OF ILLUSTRATIONS

All works are from the collection of the J. Paul Getty Museum, Los Angeles. Works in the exhibition are marked with a dot.

Figure 1
Giovanni Stradanus
Flemish, 1523–1605
The Arno with Fishermen,
between 1580 and 1596
Pen and brown ink, brown and
blue wash, and white opaque
watercolor heightening on gray
paper, irregular section cut out
and replaced at bottom center
20.3 × 30 cm (8 × 11¹³⁄₁₆ in.)
83.GG.380

• **Figure 2**
Federico Zuccaro
Italian, ca. 1541–1609
View of Saint Peter's, 1603
Red chalk
25.9 × 41.3 cm
(10³⁄₁₆ × 16¼ in.)
85.GB.228

• **Figure 3**
Pieter Moninckx
Netherlandish, ca. 1606–1686
*View of Civitavecchia with the
Harbor Wall,* ca. 1660
Watercolor over pen and gray ink
18.1 × 34.3 cm (7⅛ × 13½ in.)
2004.146

Figure 4
Luca Carlevarijs
Italian, 1663–1730
*The Bucintoro Departing from
the Bacino di San Marco,* 1710
Oil on canvas
134.8 × 259.4 cm
(53¹⁄₁₆ × 102⅛ in.)
86.PA.600

Figure 5
Canaletto
(Giovanni Antonio Canal)
Italian, 1697–1768
*The Grand Canal in Venice
from Palazzo Flangini to
Campo San Marcuola,* ca. 1738
Oil on canvas
47 × 77.8 cm (18½ × 30⅝ in.)
2013.22

Figure 6
Bernardo Bellotto
Italian, 1721–1780
*View of the Grand Canal:
Santa Maria della Salute and
the Dogana from Campo Santa
Maria Zobenigo,* ca. 1743
Oil on canvas
139.1 × 236.9 cm
(54¾ × 93¼ in.)
91.PA.73

• **Figure 7**
Canaletto
(Giovanni Antonio Canal)
Italian, 1697–1768
*The Campo S. Basso: The North
Side with the Church,* 1740s
Pen and brown ink over black
chalk
43.2 × 29.2 cm (17 × 11½ in.)
2000.9 (recto)

Figure 8
Canaletto
(Giovanni Antonio Canal)
Italian, 1697–1768
A Market Scene, 1740s
Pen and brown ink over
black chalk
29.2 × 43.2 cm (11½ × 17 in.)
2000.9

Figure 9
Francesco Guardi
Italian, 1712–1793
*The Grand Canal in Venice with
Palazzo Bembo,* ca. 1768
Oil on canvas
47 × 76.5 cm (18½ × 30⅛ in.)
2005.41

• **Figure 10**
Francesco Guardi
Italian, 1712–1793
A Regatta on the Grand Canal,
ca. 1777
Pen and brown ink, brush with
brown wash, over black chalk
42 × 68.7 cm (16½ × 27 in.)
2016.78

- **Figure 11**
Francesco Guardi
Italian, 1712–1793
View of Campo S. Polo, ca. 1790
Pen and brown ink and
brown wash over black chalk
19.2 × 28.6 cm
(7⁹⁄₁₆ × 11¼ in.)
2000.60

- **Figure 12**
Francesco Guardi
Italian, 1712–1793
*An Imaginary View of a Venetian
Lagoon, with a Fortress by the
Shore,* ca. 1750–55
Pen and brown ink, brown
wash, and traces of underdraw-
ing in black chalk
26.7 × 41.3 cm
(10½ × 16¼ in.)
2002.36

Figure 13
Marco Ricci
Italian, 1676–1730
Fishing Boats in a Storm, ca. 1715
Opaque watercolor on leather
31.4 × 45.2 cm
(12⅜ × 17¹³⁄₁₆ in.)
87.GG.39

- **Figure 14**
Giovanni Battista Lusieri
Italian, ca. 1755–1821
*A View of the Bay of Naples,
Looking Southwest from the
Pizzofalcone toward Capo di
Posillipo,* 1791
Watercolor, opaque watercolor,
graphite, and pen and ink on
six sheets of paper
101.8 × 271.9 cm
(40¹⁄₁₆ × 107¹⁄₁₆ in.)
85.GC.281

- **Figure 15**
Richard Parkes Bonington
English, 1802–1828
*Riva degli Schiavoni, from near
San Biagio, Venice,* 1826
Watercolor over graphite,
heightened with opaque
watercolor
18.4 × 17.1 cm (7¼ × 6¾ in.)
2015.51

- **Figure 16**
James Holland
English, 1799–1870
The Saint Mark's Basin, Venice,
ca. 1860
Watercolor over pencil,
heightened with opaque
watercolor
31.8 × 92.7 cm (12½ × 36½ in.)
2008.39

Figure 17
Joseph Mallord William Turner
English, 1775–1851
Modern Rome—Campo Vaccino,
1839
Oil on canvas
91.8 × 122.6 cm (36⅛ × 48¼ in.)
2011.6

Figure 18
James Anderson
English, 1813–1877
Naples Panorama, ca. 1845–77
Albumen silver print
Image: 18.9 × 25.4 cm
(7⁷⁄₁₆ × 10 in.)
84.XP.708.55

Figure 19
Fratelli Alinari
Italian photography studio,
founded 1852
Palazzo Vecchio, Florence,
mid–late nineteenth century
Albumen silver print
Image: 42.7 × 31.5 cm
(16¹³⁄₁₆ x 12⅜ in.)
Mount: 49.2 × 42.5 cm
(19⅜ x 16¾ in.)
84.XP.373.23

- **Figure 20**
Fédèle Azari
Italian, 1895–1930
Piazza San Marco, Venice,
1920s
Gelatin silver print
Image: 11.8 × 16 cm
(4⅝ × 6⁵⁄₁₆ in.)
Sheet: 12.1 × 16.3 cm
(4¾ × 6⁷⁄₁₆ in.)
84.XA.240.40

Figure 21
Fédèle Azari
Italian, 1895–1930
*Aerial Shot of an Airplane over
Venice,* 1920s
Gelatin silver print
Image: 11.3 × 16 cm
(4⁷⁄₁₆ × 6⁵⁄₁₆ in.)
Sheet: 11.7 × 16.4 cm
(4⅝ × 6⁷⁄₁₆ in.)
84.XA.240.30

Figure 22
Federico Zuccaro
Italian, ca. 1541–1609
*Taddeo in the Belvedere Court in
the Vatican Drawing the Laocoön,*
ca. 1595
Pen and brown ink, brush with
brown wash, over black chalk
and touches of red chalk
17.5 × 42.5 cm (6⅞ × 16¾ in.)
99.GA.6.17

Figure 37
Francesco Panini
Italian, 1745–1812
*View of the Farnese Gallery,
Rome*, ca. 1775
Pen and black ink and gray wash
over black chalk, with occasional
touches of white opaque
watercolor; some pinholes
42.5 × 27.6 cm (16¾ × 10⅞ in.)
92.GG.16

Figure 38
Jacob Philipp Hackert
German, 1737–1807
*The Temple of Hercules
in Cori near Velletri*, 1783
Opaque watercolor
34.8 × 47 cm (13¹¹⁄₁₆ × 18½ in.)
2010.68

Figure 39
Pierre-Adrien Pâris
French, 1745–1819
*Vases, Furniture and Objects
Discovered at Herculaneum*, 1777
Pen and black ink, watercolor
22.9 × 37 cm (9 × 14⁹⁄₁₆ in.)
88.GA.26

Figure 40
Jean-Pierre-Louis-Laurent
Houël
French, 1735–1813
*View of the Ruins of the Temple
of Ceres in the Valley of Agrigento*,
1776–79
Opaque watercolor and
black chalk
37.9 × 107.2 cm
(14¹⁵⁄₁₆ × 42³⁄₁₆ in.)
2001.46

Figure 41
Christen Schjellerup Købke
Danish, 1810–1848
*The Forum, Pompeii, with
Vesuvius in the Distance*, 1841
Oil on canvas
70.8 × 87.9 cm (27⅞ × 34⅝ in.)
85.PA.43

Figure 42
Sommer & Behles
Italian photography studio,
1867–1874
*Human Body Casts Found
February 5, 1863*, February 5, 1863
Albumen silver print
Image: 7.2 × 13.9 cm
(2¹³⁄₁₆ × 5½ in.)
84.XC.1625.61

Figure 43
Herman van Swanevelt
Dutch, ca. 1600–1655
A Wooded Landscape,
ca. 1629–43
Brush and brown ink
26.5 × 40 cm (10⁷⁄₁₆ × 15¾ in.)
95.GG.17

Figure 44
Sebastian Vrancx
Flemish, 1573–1647
View of Tivoli, ca. 1600
Black chalk, pen and brown ink,
gray and brown wash
27 × 41.3 cm (10⅝ × 16¼ in.)
86.GG.28

Figure 45
Claude Lorrain (Claude Gellée)
French, 1604 or 1605(?)–1682
View of Tivoli, 1640
Black chalk with brown and
reddish brown wash
21.3 × 31 cm (8⅜ × 12³⁄₁₆ in.)
83.GB.357

Figure 46
Claude Lorrain (Claude Gellée)
French, 1604 or 1605(?)–1682
*Coast View with the Abduction of
Europa*, 164(5?)
Oil on canvas
96.2 × 167.6 cm (37⅞ × 66 in.)
2007.32

Figure 47
Francesco Zuccarelli
Italian, 1702–1788
*A Landscape with Shepherds
Resting under a Tree
by a Cascade*, mid 1700s
Black chalk, pen and brown
ink, brown and gray wash
heightened with white opaque
watercolor
47.8 × 63 cm (18¹³⁄₁₆ × 24¹³⁄₁₆ in.)
2000.61 (recto)

Figure 48
Claude-Joseph Vernet
French, 1714–1789
*The Entrance to the Grotto at
Posillipo*, ca. 1750
Pen and brown ink, with brown
and gray wash, over black chalk
34.4 × 48.9 cm (13⁹⁄₁₆ × 19¼ in.)
97.GG.53

Figure 49
Louis-François Cassas
French, 1756–1827
The Cascades at Terni, 1780
Gray and black ink and brown
wash
50.5 × 36.5 cm (19⅞ × 14⅜ in.)
95.GA.11